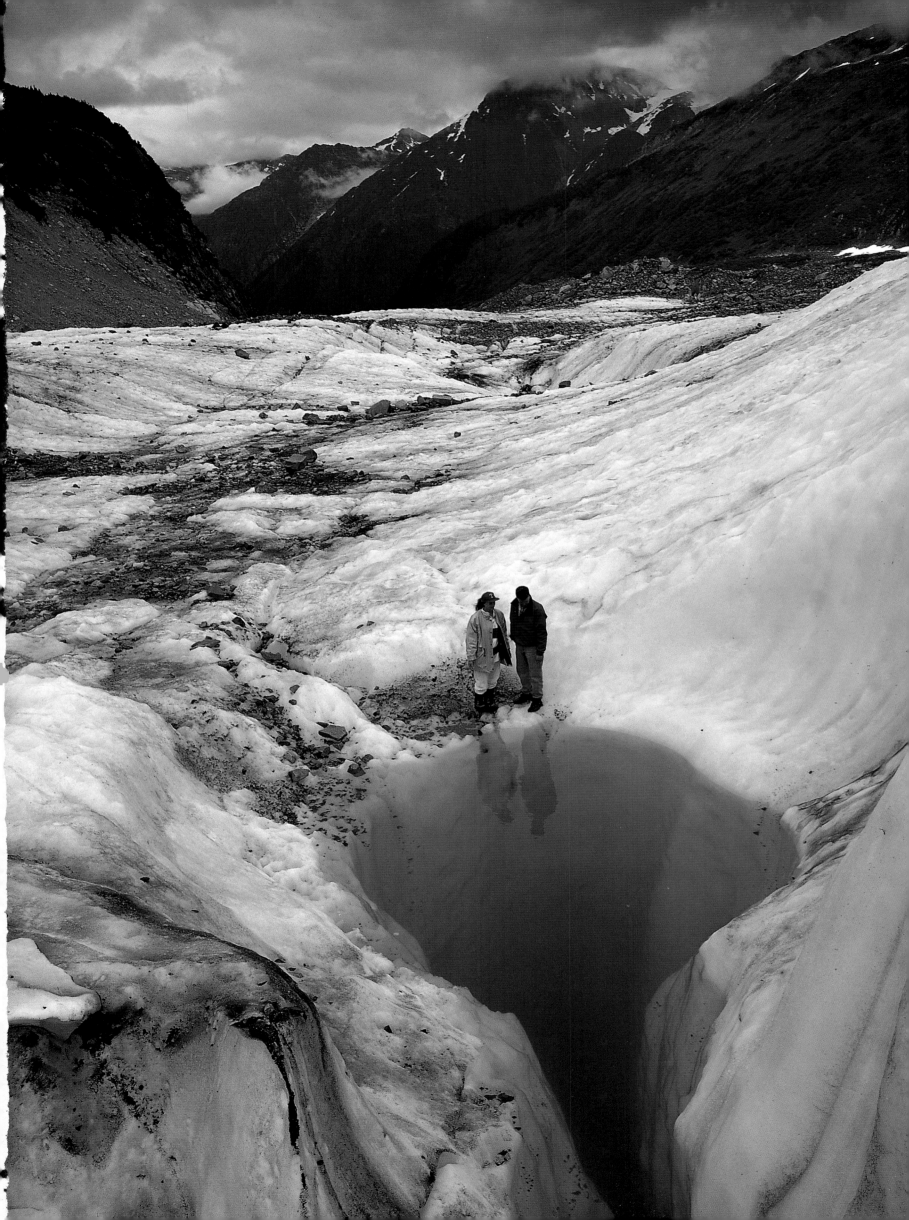

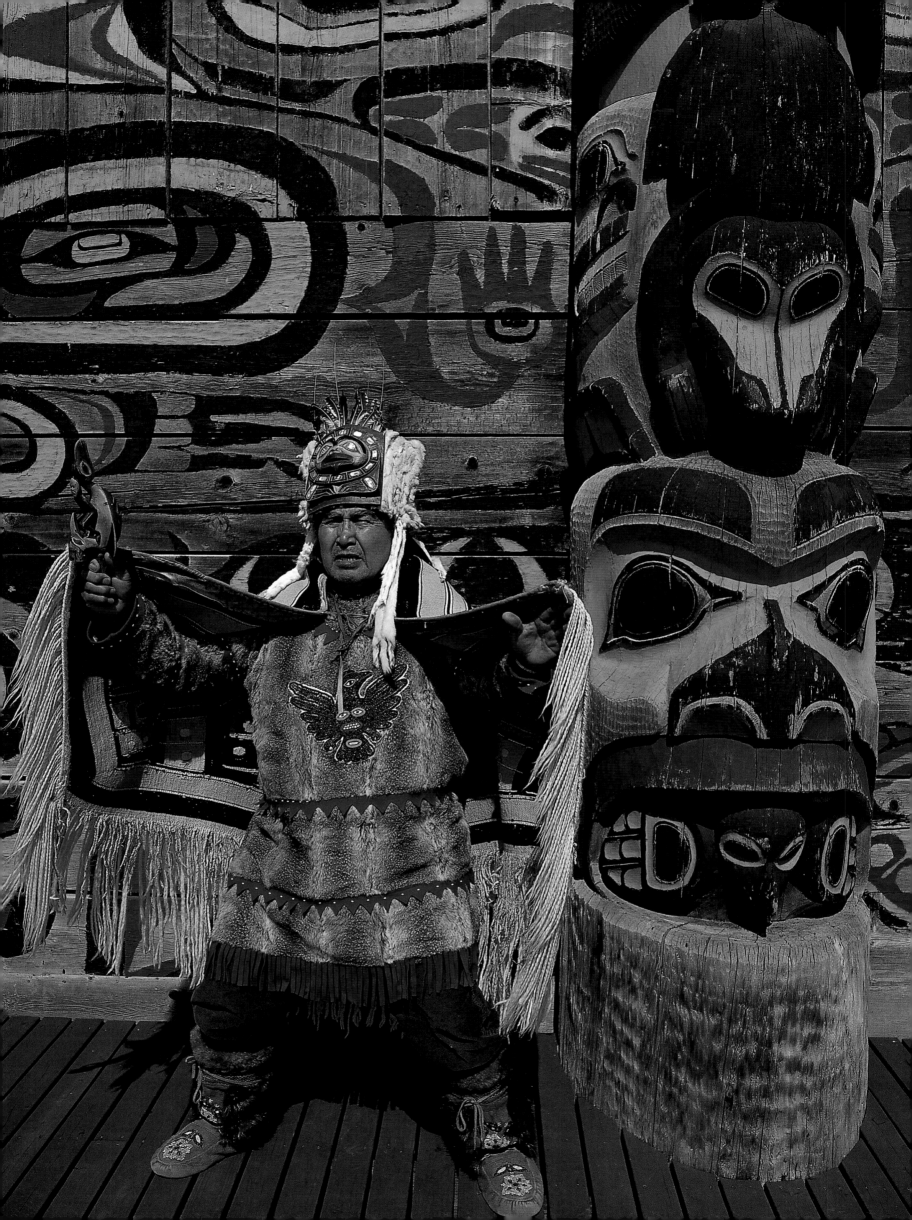

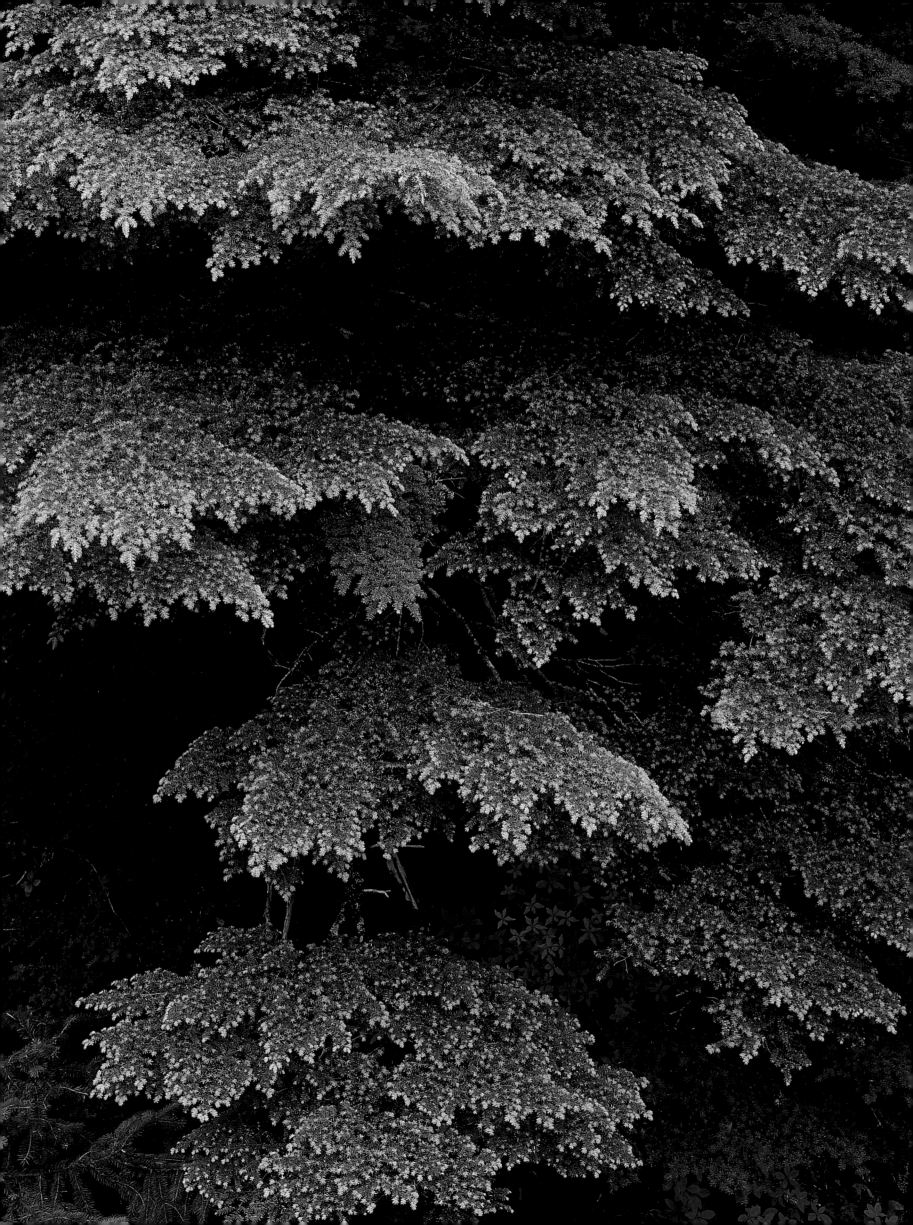

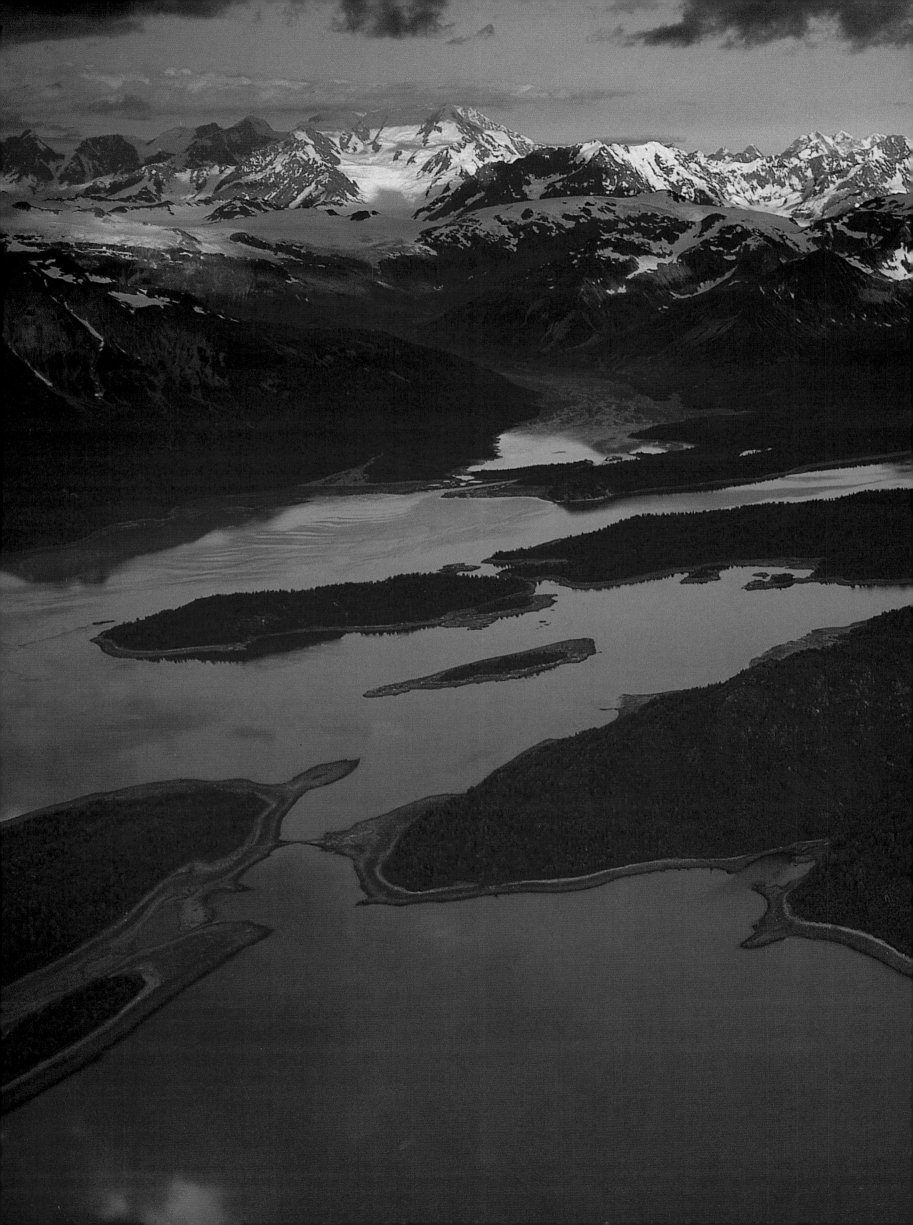

ALASKA'S INSIDE PASSAGE

PHOTOGRAPHY & ESSAYS
BY KIM HEACOX

GRAPHIC ARTS CENTER PUBLISHING

International Standard Book Number 1-55868-307-0
Library of Congress Catalog Number 97-70191
Photographs © MCMXCVII by Kim Heacox
Essays © MCMXCVII by Graphic Arts Center Publishing Company
Published by Graphic Arts Center Publishing Company
P.O. Box 10306 • Portland, Oregon 97296-0306 • 503/226-2402
No part of this book may be copied by any means
without written permission from the publisher.
President • Charles M. Hopkins
Editor-in-Chief • Douglas A. Pfeiffer
Managing Editor • Jean Andrews
Photo Editor • Diana S. Eilers
Designer • Robert Reynolds
Cartographer • Tom Patterson
Production Manager • Richard L. Owsiany
Production • Lincoln & Allen Co.
Printed in the United States of America
Second Printing

To John Muir (1838-1914)
who prized glaciers more than gold,
trees more than timber,
dippers more than dollars.

K I M H E A C O X

Page 1: Hikers investigate a meltwater pool on a glacier near Skagway. *Page 2:* Chilkat Dancer Charles Jimmie Sr. performs at Raven's Fort in Haines. *Page 3:* The branches of a western hemlock offer redemption on Prince of Wales Island, where more than half the old-growth rainforest has been logged. *Pages 4-5:* Early morning light dapples mountains and islands, evoking the intimacy of sea and shore that makes the Inside Passage so inviting. *Pages 8-9:* A cabin and fishing boat speak of escape at Baranof Warm Springs Harbor, on the east side of Baranof Island.

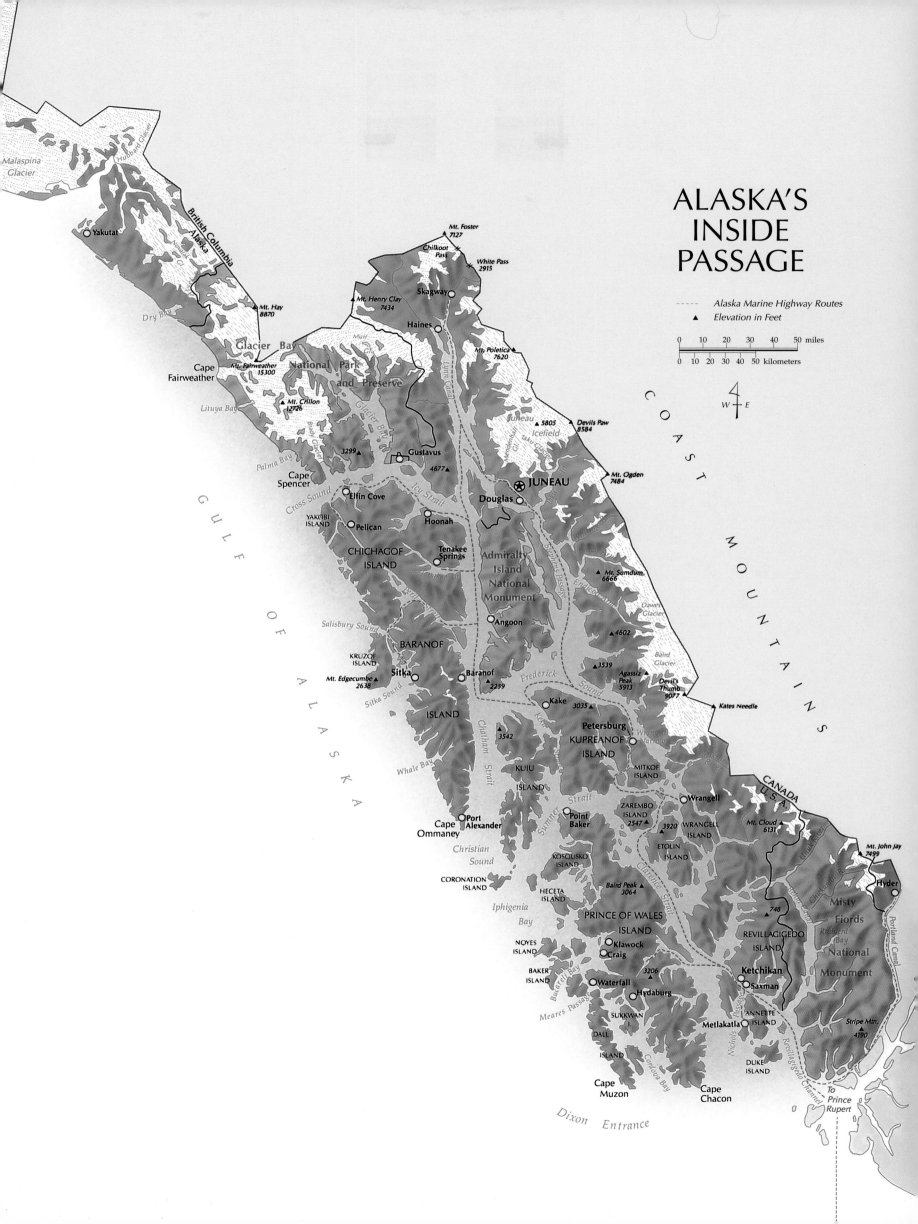

ALASKA'S INSIDE PASSAGE

- - - - - *Alaska Marine Highway Routes*
▲ *Elevation in Feet*

0 10 20 30 40 50 miles
0 10 20 30 40 50 kilometers

Malaspina Glacier

Hubbard Glacier

Yakutat

British Columbia
Alaska

Mt. Foster 7127

Chilkoot Pass

White Pass 2915

▲ *Mt. Hay 8870*

Dry Bay

▲ *Mt. Henry Clay 7434*

Skagway

Haines

Glacier Bay

Muir Gl.

Mt. Poletica 7620 ▲

Cape Fairweather

Mt. Fairweather 15300

National Park

and Preserve

Lituya Bay

▲ *Mt. Crillon 12726*

Glacier Bay

Juneau Icefield

▲ *5805*

Devils Paw 8584

Palma Bay

Brady Glacier

3299 ▲

Gustavus

4677 ▲

Mendenhall Gl.

Taku Glacier

⊛ **JUNEAU**

Mt. Ogden 7484 ▲

Cape Spencer

Cross Sound

Elfin Cove

○ **Douglas**

Icy Strait

YAKOBI ISLAND

○ *Pelican*

○ *Hoonah*

Shilkat Passage

Taku Inlet

Endicott Arm

CHICHAGOF ISLAND

○ *Tenakee Springs*

Admiralty Island National Monument

▲ *Mt. Somdum 6666*

Salisbury Sound

Tenakee Inlet

○ *Angoon*

Dawes Glacier

BARANOF

KRUZOF ISLAND

4602 ▲

Baird Glacier

Mt. Edgecumbe 2638 ▲

○ **Sitka**

○ *Baranof*

Frederick Sound

3539 ▲

Agassiz Peak 5913 ▲

Devil's Thumb 9077 ▲

ISLAND

2259 ▲

Sitka Sound

Chatham Strait

○ *Kake* *3035* ▲

Kates Needle ▲

Whale Bay

3542 ▲

Petersburg

KUPREANOF ISLAND

Wrangell Narrows

KUIU ISLAND

Kupreanof Strait

MITKOF ISLAND

CANADA U.S.A.

Cape Ommaney

○ **Port Alexander**

○ *Point Baker*

ZAREMBO ISLAND

○ **Wrangell**

Stikine River

Mt. Cloud 6131 ▲

Christian Sound

Summer Strait

2547 ▲

3920 ▲

WRANGELL ISLAND

Mt. John Jay 7499 ▲

CORONATION ISLAND

KOSCIUSKO ISLAND

ETOLIN ISLAND

○ **Hyder**

Iphigenia Bay

HECETA ISLAND

Clarence Strait

Baird Peak 3064 ▲

PRINCE OF WALES ISLAND

REVILLAGIGEDO ISLAND

Misty Fiords

Rudyerd Bay

National Monument

NOYES ISLAND

○ *Klawock*
○ **Craig**

748 ▲

Behm Canal

BAKER ISLAND

3206 ▲

○ *Waterfall*

○ *Hydaburg*

Ketchikan
○ *Saxman*

Meares Passage

SUKKWAN I.

Revillagigedo Channel

Stripe Mtn. 4190 ▲

DALL ISLAND

○ *Metlakatla*

ANNETTE ISLAND

Cape Muzon

Cordova Bay

DUKE ISLAND

Cape Chacon

To Prince Rupert

Dixon Entrance

GULF OF ALASKA

COAST MOUNTAINS

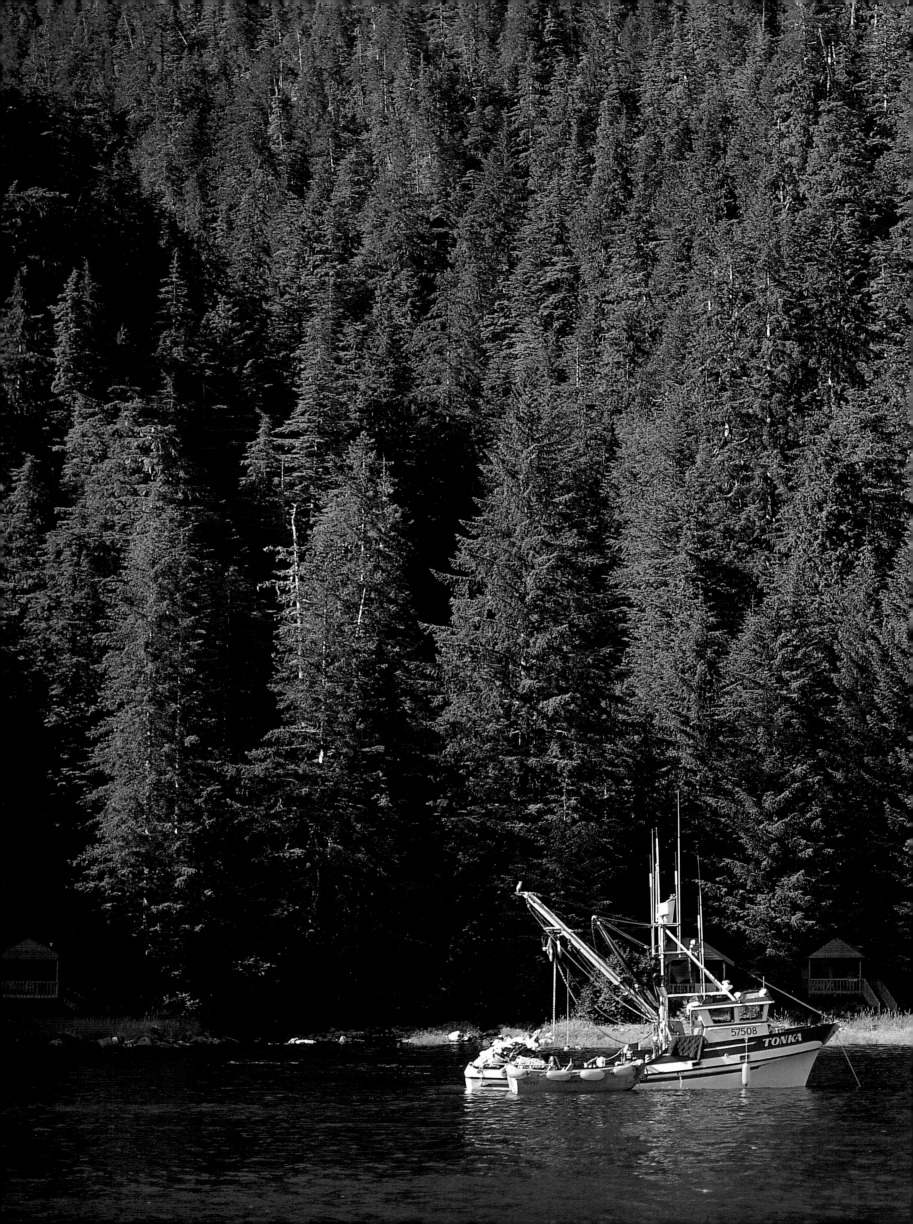

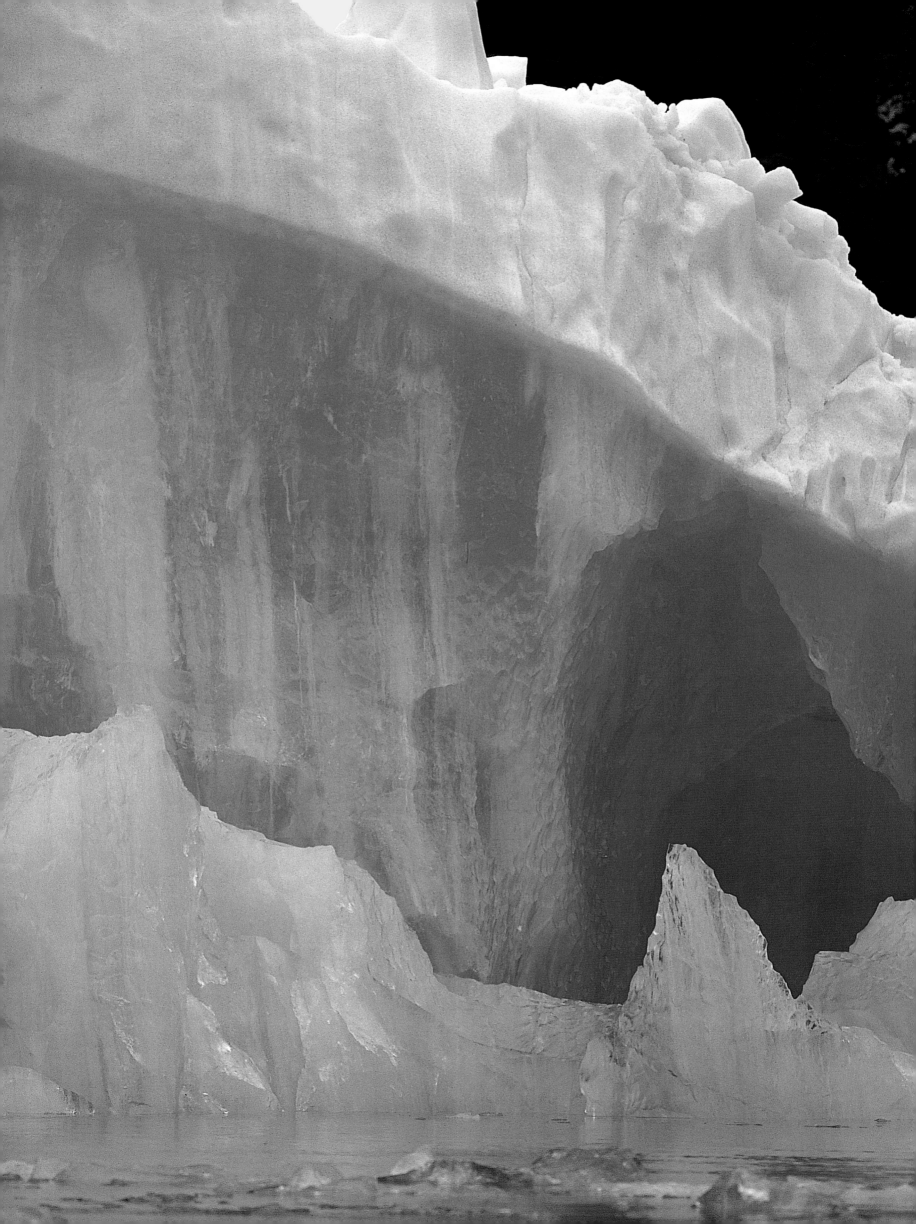

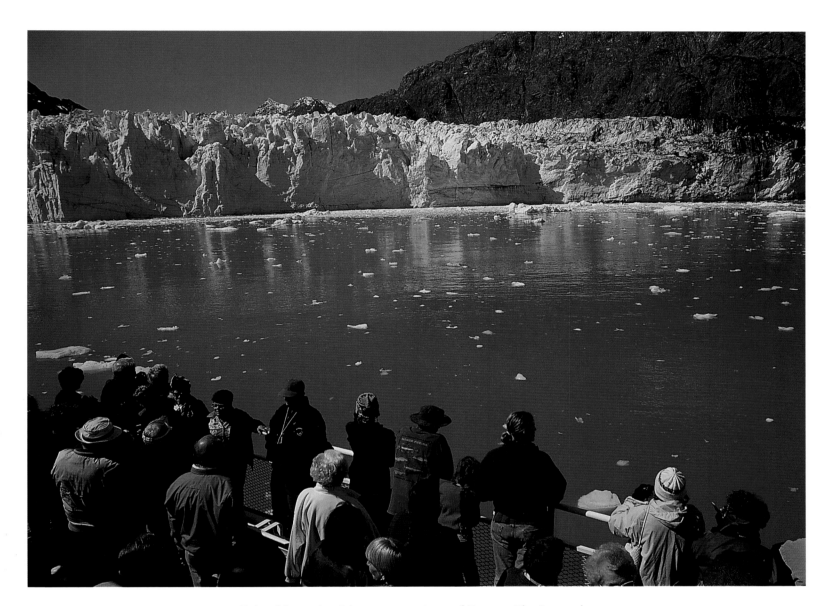

◁ Calved from the tidewater terminus of Dawes Glacier, a phantasmagoric iceberg drifts down Endicott Arm, in Tracy Arm-Fords Terror Wilderness, Tongass National Forest. △ Tourists crowd the railing of a cruise ship to admire Margerie Glacier, in Glacier Bay National Park. ▷ Mendenhall Glacier, called "the most accessible glacier in the world" (you can drive to it from downtown Juneau) advances through the Coast Mountains into Mendenhall Valley, framed by tall fireweed in Brotherhood Park.

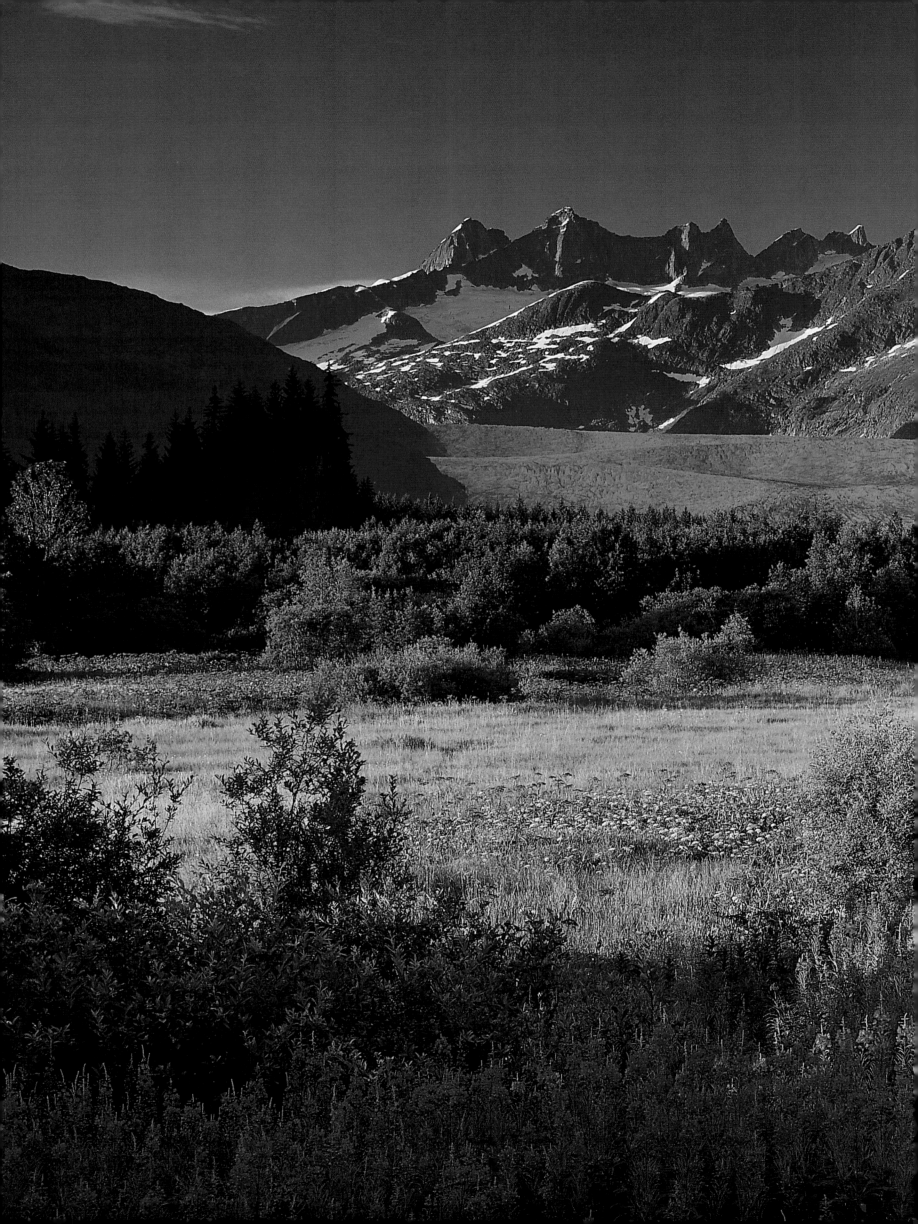

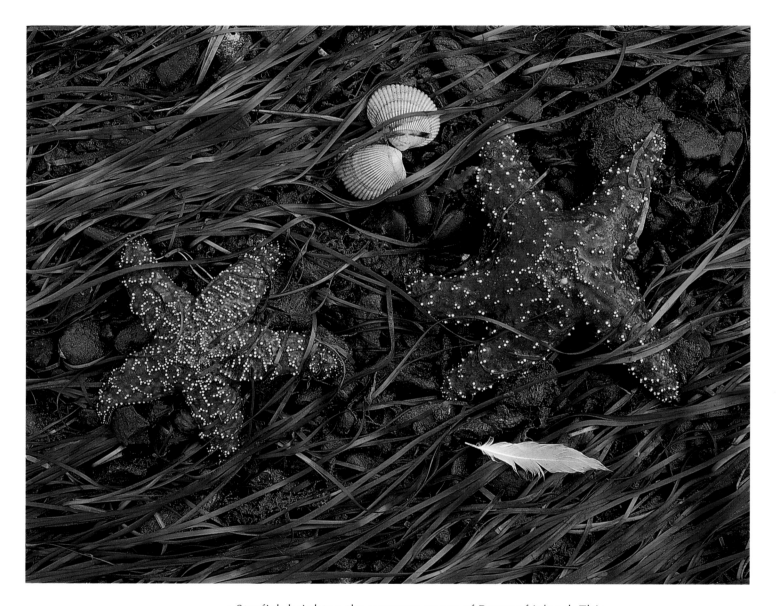

△ Starfish brighten the western coast of Baranof Island. This species, of the genus *Pisaster,* can exhibit many different colors.
▷ Chum salmon crowd into the mouth of Maybeso Creek, on Prince of Wales Island, in preparation for the upstream swim to spawning beds. All five species of Pacific salmon—sockeye, king, coho, pink, and chum—inhabit the Inside Passage and depend on its clean-running streams to reproduce and survive.

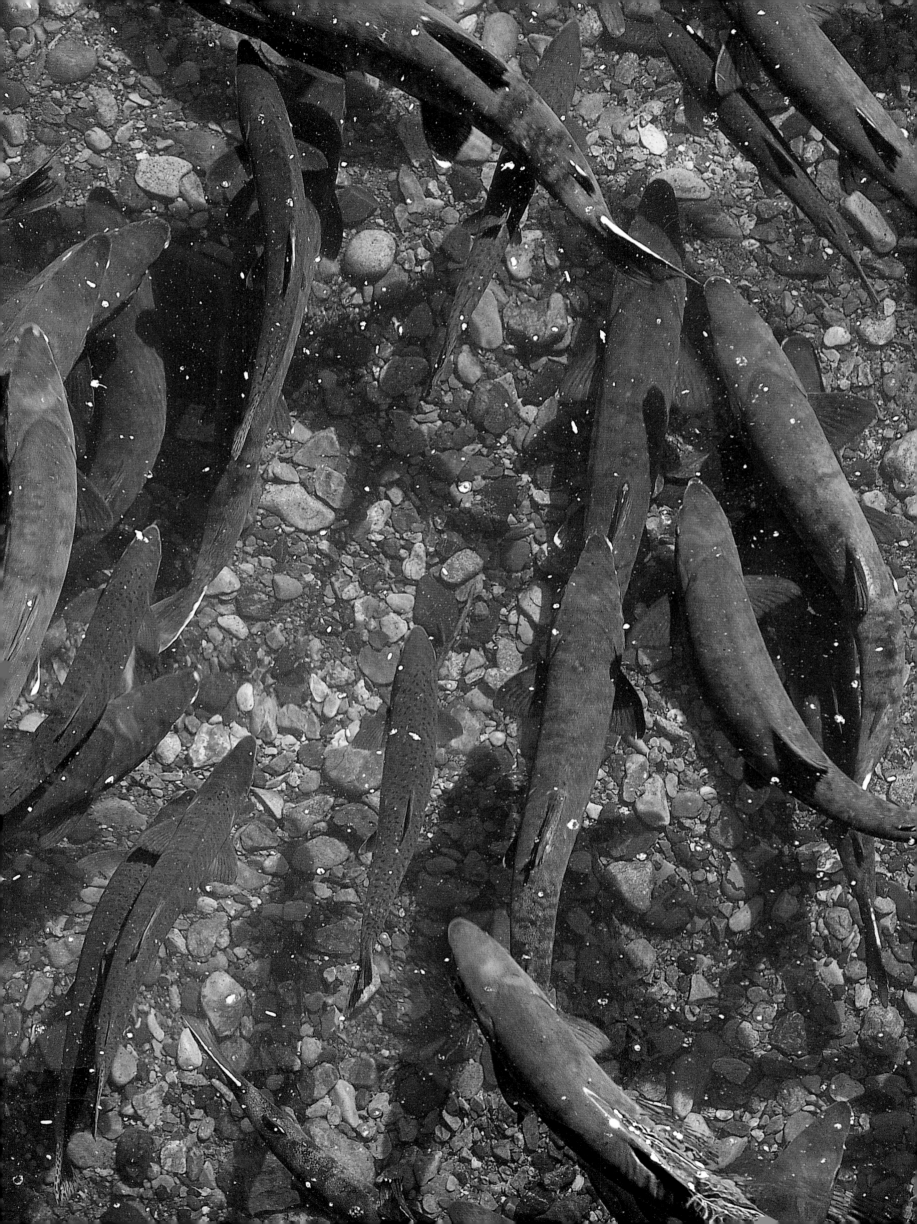

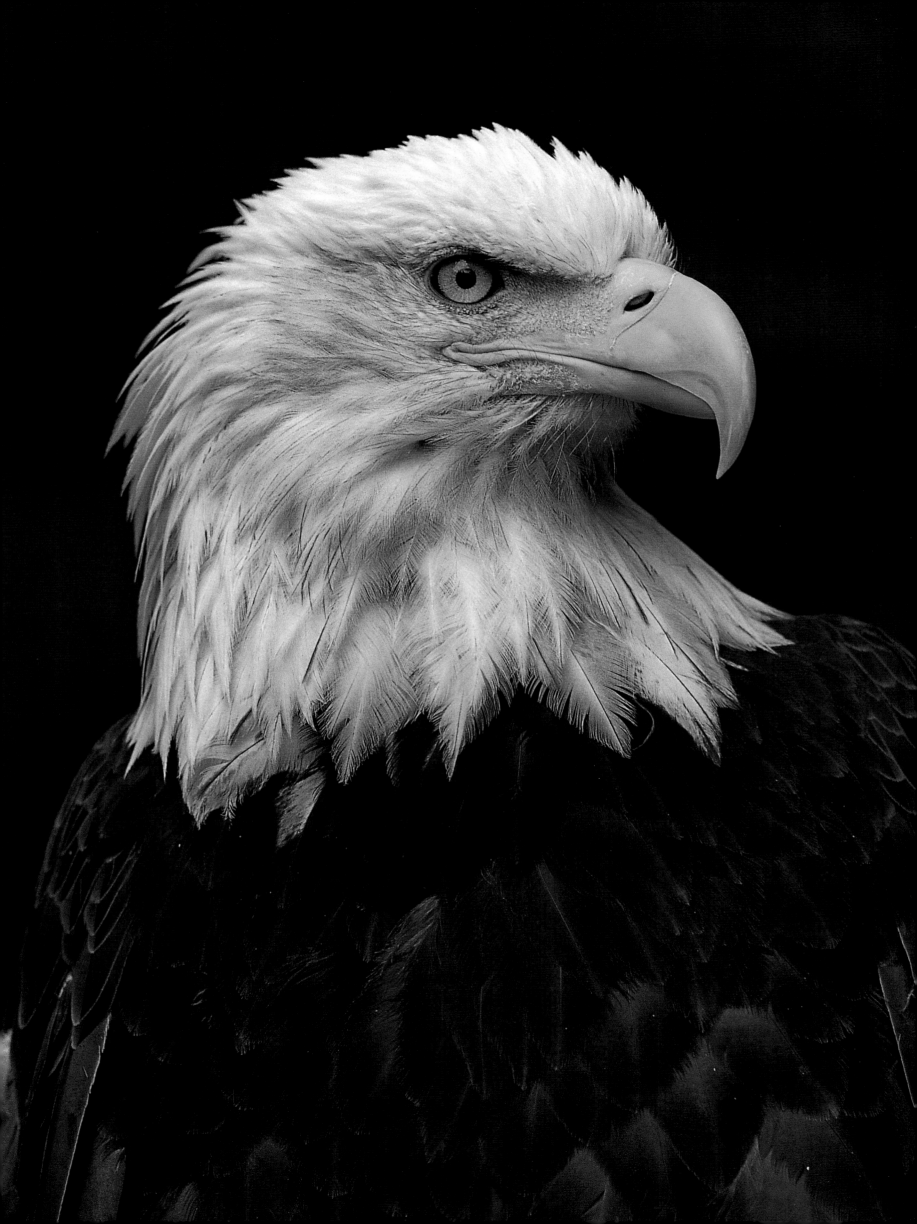

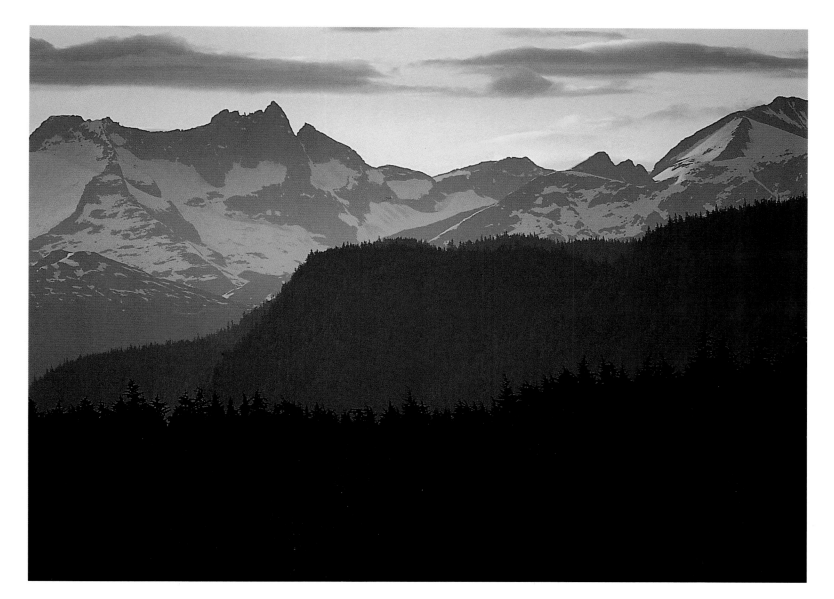

◁ An American bald eagle strikes a regal pose at the Alaska Raptor Rehabilitation Center (ARRC), in Sitka. An estimated fifteen thousand eagles live in Southeast Alaska, the strongest population in North America. A private, nonprofit organization founded in 1980, the ARRC treats more than fifty injured eagles a year, plus other wildlife ranging from bats to mountain goats. △ Mountains and forests provide an elegant backdrop—and essential habitat—for eagles and other wildlife in Alaska.

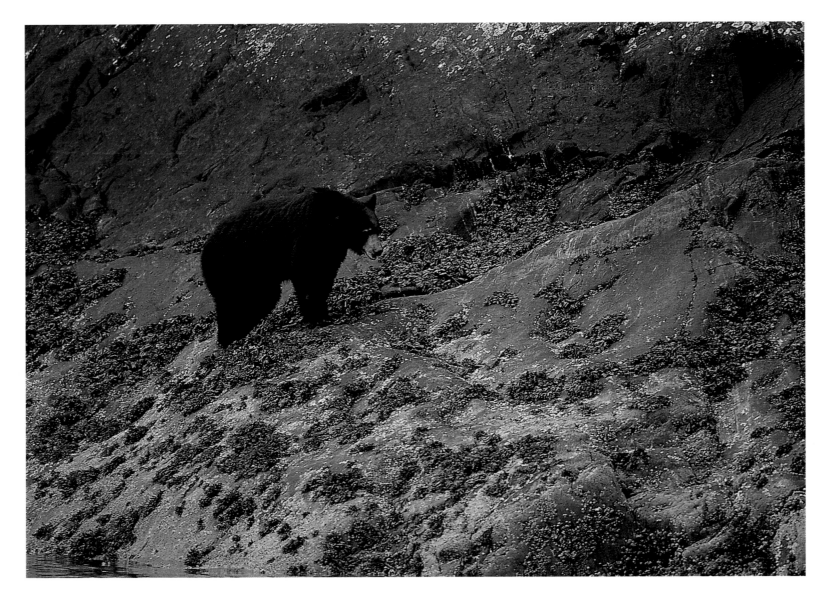

△ A black bear patrols the shore of Endicott Arm in search of barnacles and other edible intertidal life. ▷ A totem pole in Ketchikan speaks of a Native heritage filled with the power of wildlife: eagle, raven, wolf, bear, frog, salmon, and killer whale.

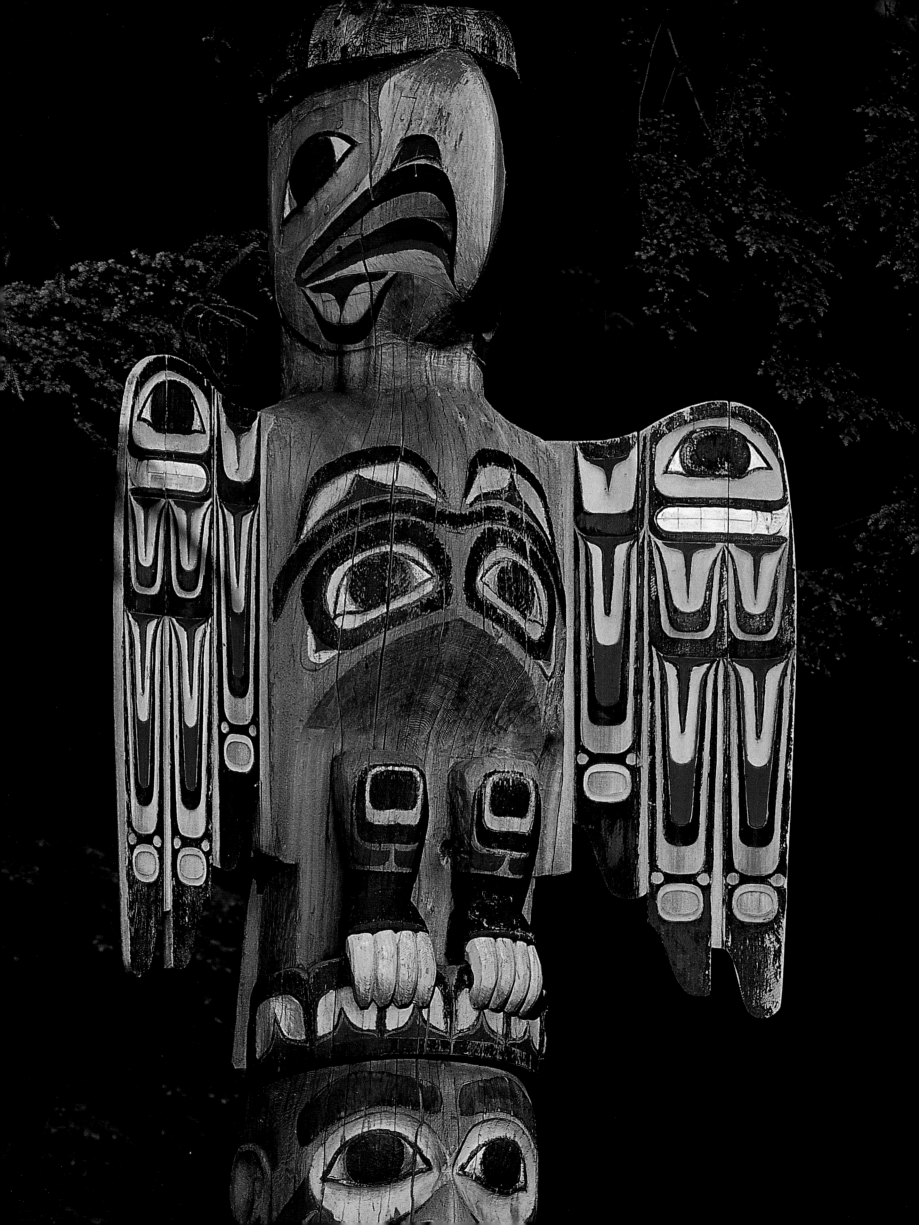

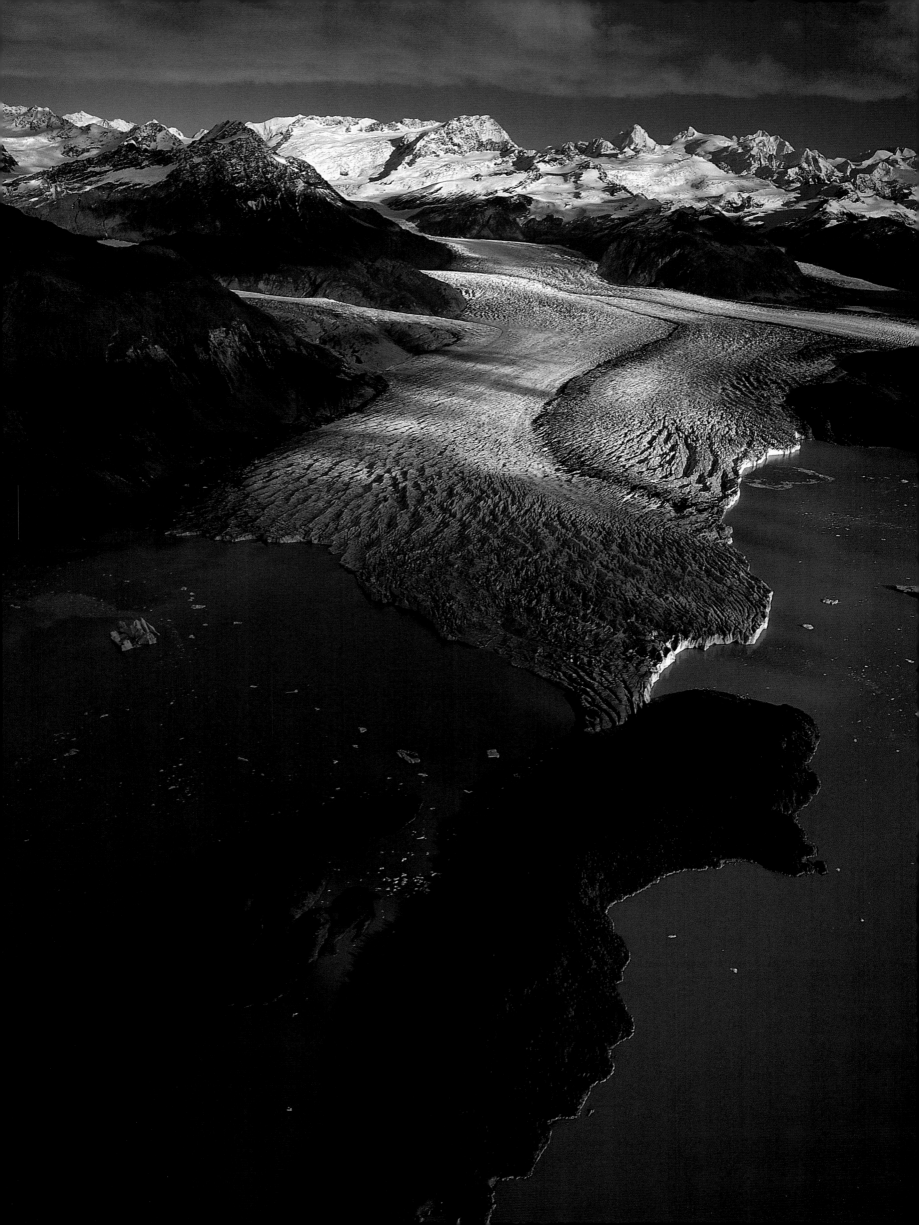

A Gift from Glaciers

He came from Cleveland and knew nothing of this Northern place: the verdant forests, the fang-like peaks, the intoxicating fiords that pulled him into a world where myth and fact became one. Ohio was nothing like this, never would be. He stood at the ship's railing for hours, lost in the immensity. Casual observation was not his style. He studied what he saw: the unbridled sea, the youthful topography, the restless elements of erosion and deposition. He watched for glaciers, the icy architects of this country, and pointed them out to four graduate students who traveled with him. He was a professor of geology from the Case School of Applied Sciences, a likable man with a good sense of humor. Alaskans on board might have considered him misplaced here, dressed in his Oxford tweed and unbroken boots, his city posture misfit in the unforgiving wilds, his fine features made all the more fragile behind rimless spectacles.

How wrong they would have been.

The professor's name was Harry Fielding Reid, and when on July 1, 1890, his steamer arrived off the tidewater terminus of Muir Glacier, in Glacier Bay, he bounded ashore and was thrilled to find camped there two men whose eagerness for Alaska rivaled his own, for one of them was John Muir himself, the famous naturalist whose eyes were no less blue than the glacier named in his honor.

The historical record is incomplete, but their meeting was no doubt lively. And they no doubt discussed glaciers. Both Reid and Muir hungered to learn about the great ice rivers, how they sculpted mountains and excavated fiords; why some advanced while others retreated. How fast did they flow? How old was the ice? So many questions, so little time.

More than twenty years earlier, Muir had theorized that glaciers, not primal cataclysm, had created his beloved Yosemite Valley in California's Sierra Nevada.

To see ice rivers first hand he had traveled to Alaska first in 1879, and together with a Presbyterian missionary and four Tlingits—Native peoples of the area—paddled by dugout canoe from Fort Wrangell to the frigid, berg-filled waters of Glacier Bay, a world that exceeded his deepest longings for wild country. Describing a climb above camp one night near Geike Inlet, Muir wrote, "All the landscape was smothered in clouds and I began to fear that as far as wide views were concerned I had climbed in vain. But at length the clouds lifted a little, and beneath their gray fringes I saw the berg-filled expanse of the bay, and the feet of the mountains that stand above it, and the imposing fronts of five huge glaciers, the nearest being immediately beneath me. This was my first general view of Glacier Bay, a solitude of ice and snow and newborn rocks, dim, dreary, mysterious."

Too dim and dreary for the Tlingits. They spoke of evil spirits and weak hearts, of canoes crushed in ice and sad wives back home who would never see their husbands again. We must turn around, they petitioned Muir; we must leave this treeless place. Muir listened. He was engaged to be married himself the following spring, and thus sympathized with the Tlingits, but he would not be dissuaded. With brilliant oratory he lifted the Tlingits' hearts and inspired them to paddle farther up the bay, deeper into the ice and cold where, with his beard waving wildly in the wind, he extolled the grand works of glaciers.

Now, in 1890, eleven years later, Muir was back. Diagnosed in California with a bronchial cough and nervous indigestion, he had decided to return north and hike again the wild contours he felt would cure him. Camped on his namesake glacier after crossing a labyrinth of crevasses, he wrote, "I am cozy and comfortable here resting in the midst of glorious icy scenery." Near the end of his forty-mile journey, he fell

◁ *Alsek Glacier travels downslope from the St. Elias Mountains to empty into Alsek Lake. Alaska boasts more than one hundred thousand glaciers, most of them small and unnamed. Yet two, the Bering and Malaspina, near Yakutat, are roughly the size of Rhode Island.*

21

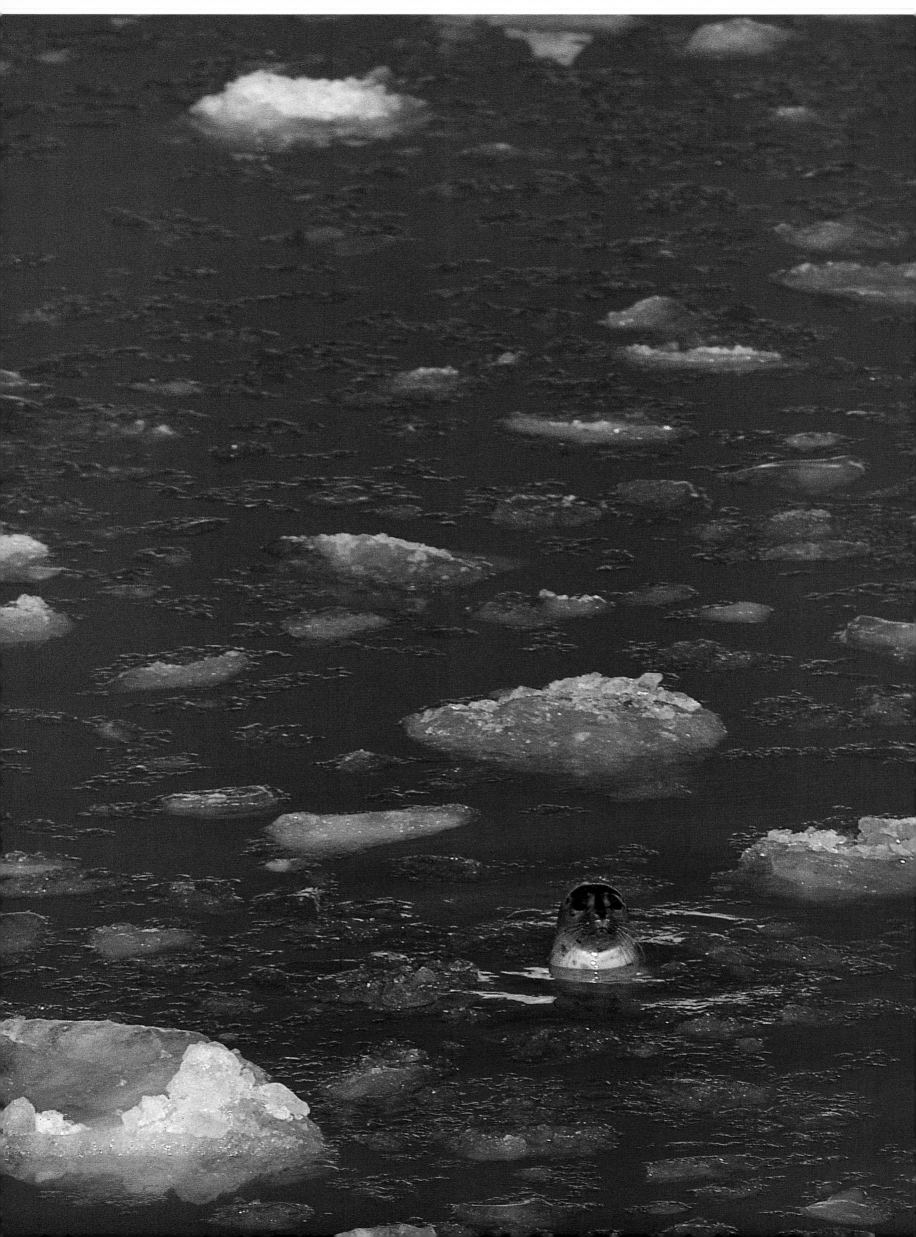

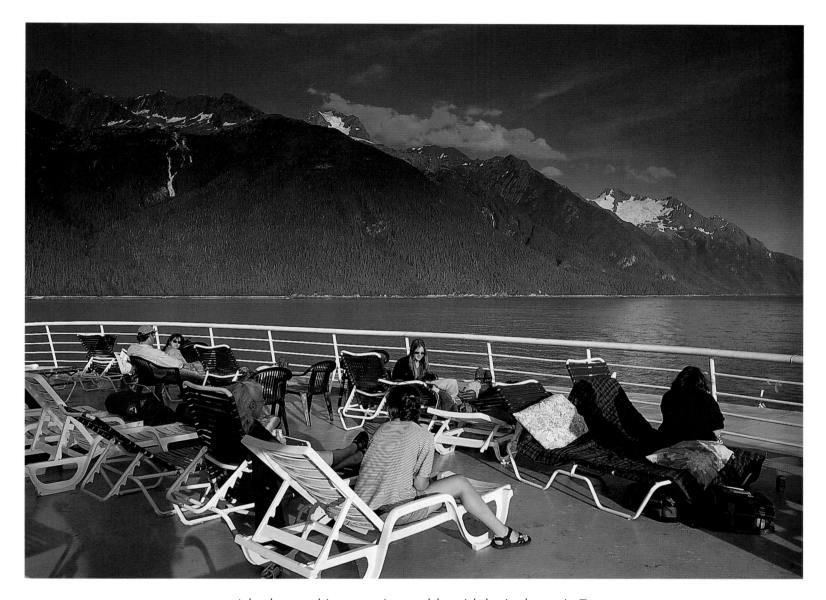

◁A harbor seal inspects its world amid the icebergs in Tarr Inlet, Glacier Bay. △ Passengers relax on the solarium of the M/V *Columbia,* the largest of Alaska's State Ferries, as it travels up Chilkoot Inlet, near Haines. ▷ A Haines Airways Piper Cherokee takes passengers flightseeing over upper Carroll Glacier, in Glacier Bay National Park. Flights over this type of terrain offer great rewards without disturbing the peace and quiet of campers and kayakers along inlet shores.

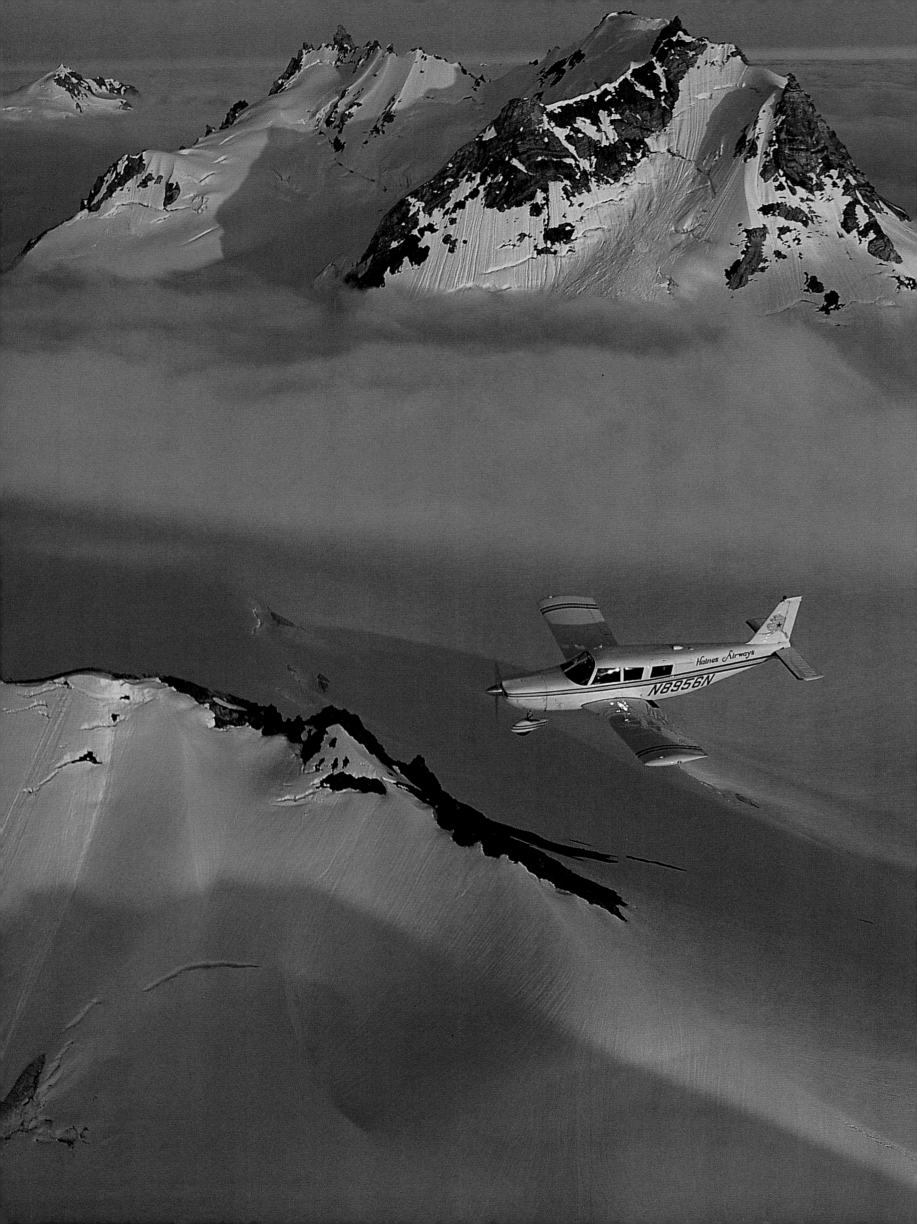

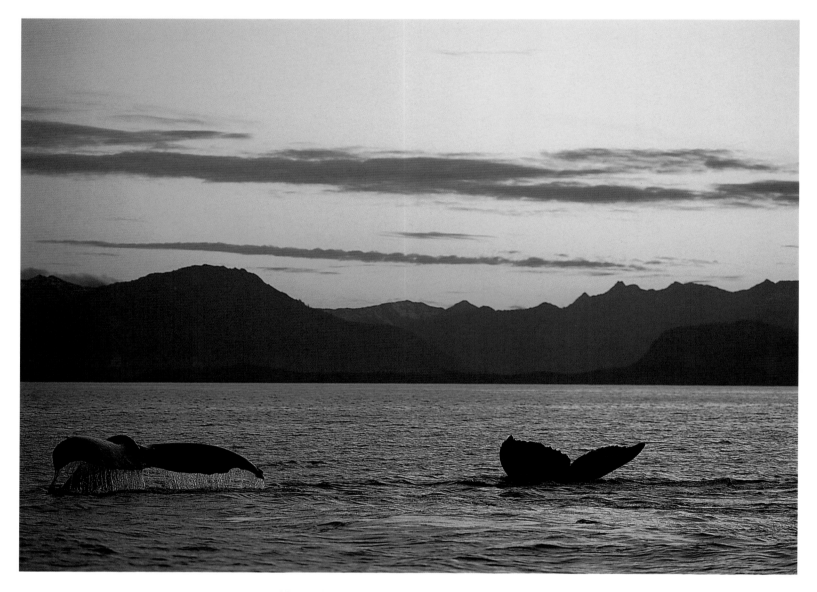

△ A pair of humpback whales show their flukes as they dive at sunset in Chatham Strait. Because their numbers are only about 10 percent of what they were before whaling, humpback whales are protected by the Endangered Species Act and the Marine Mammal Protection Act. Most humpbacks that summer in Alaska spend their winters in Hawaii. ▷ A recent rain anoints shooting stars with pearls of water. Botanists have catalogued more than nine hundred species of vascular plants (trees, ferns, and flowers) in Southeast Alaska.

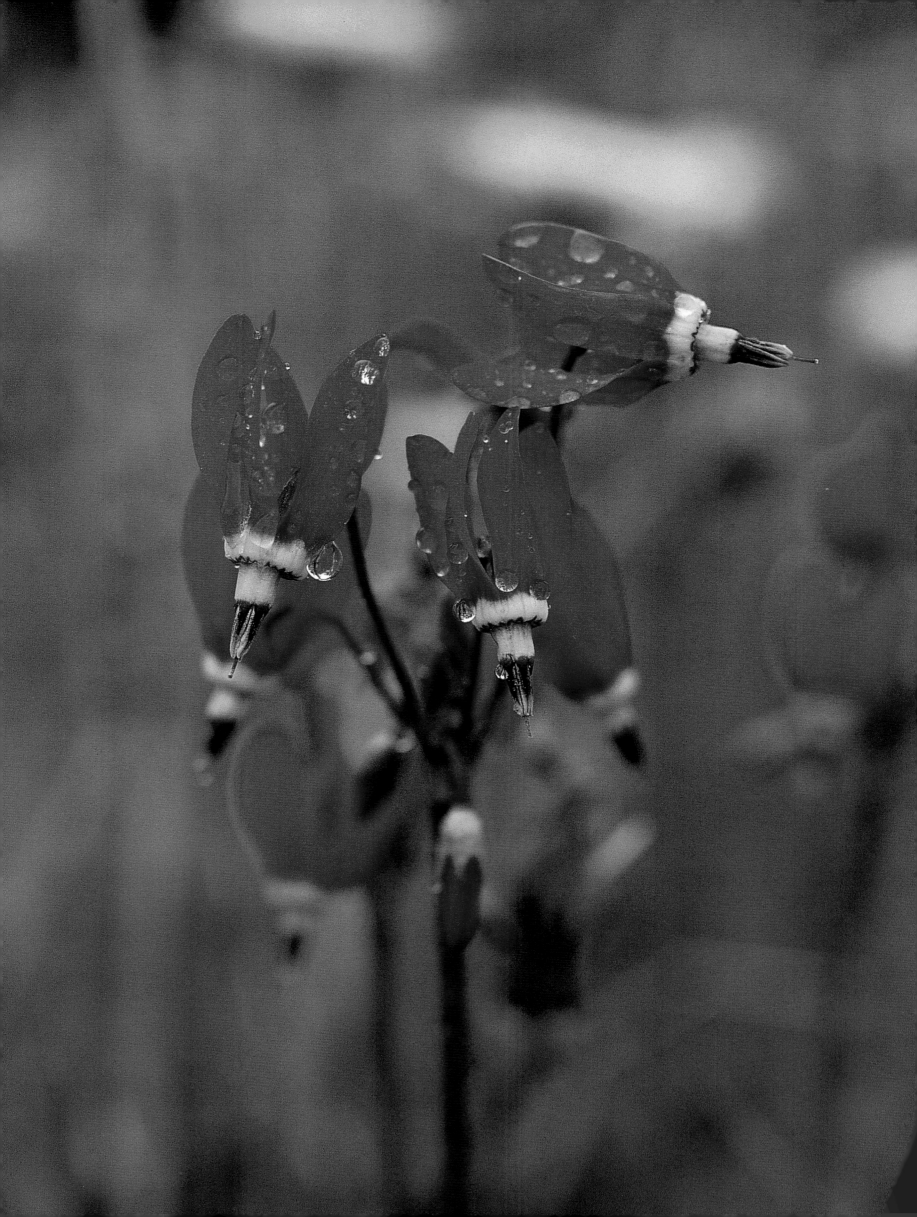

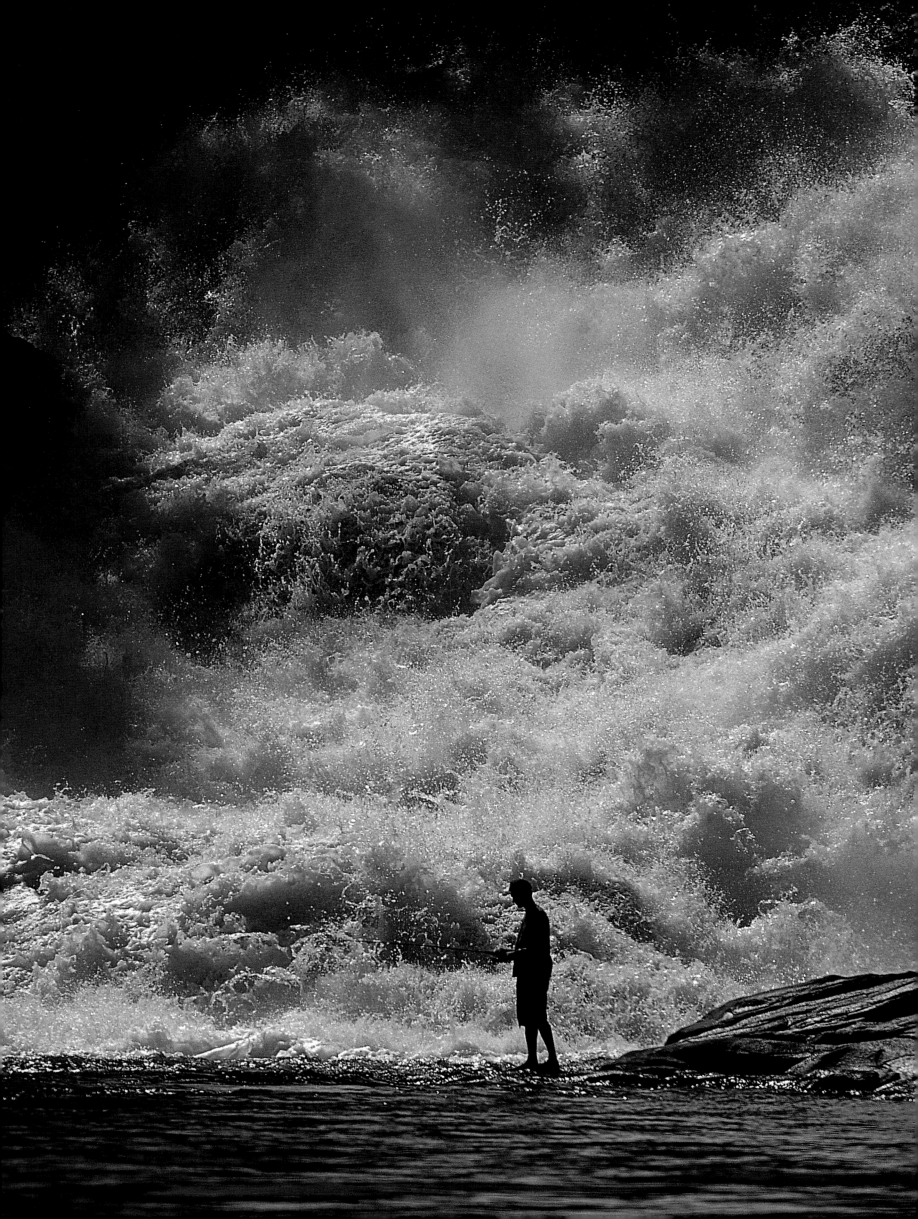

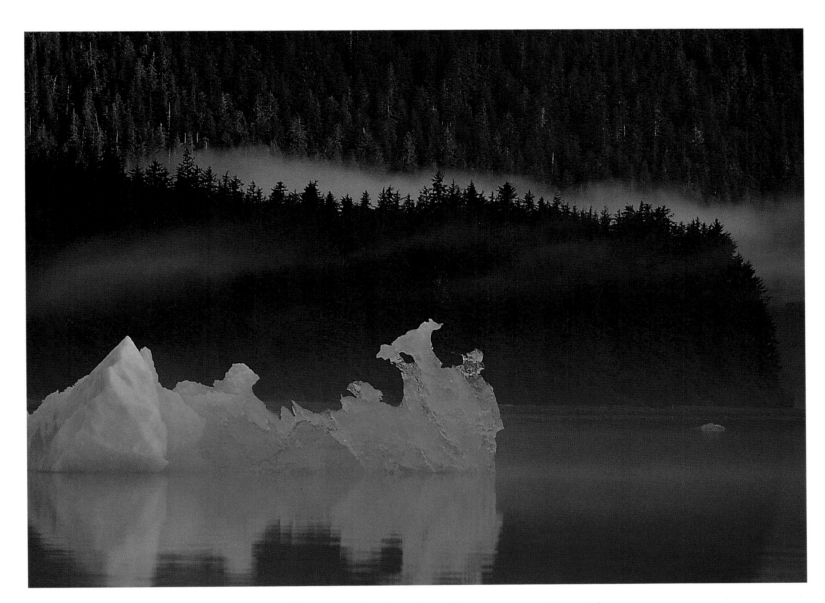

◁ Dwarfed by Baranof Falls, a lone fisherman tests his mettle in Baranof Warm Springs Harbor. Salmon are not the only fish that inhabit these still-vibrant waters; others are trout, sculpin, Dolly Varden char, flounder, halibut, sablefish, herring, sole, smelt, poachers, gunnels, and prowfish (to name a few). Southeast Alaska is home to some three hundred fish species (freshwater and salt), representing sixty-five taxonomic families. △ Morning fog veils forest and iceberg in Endicott Arm.

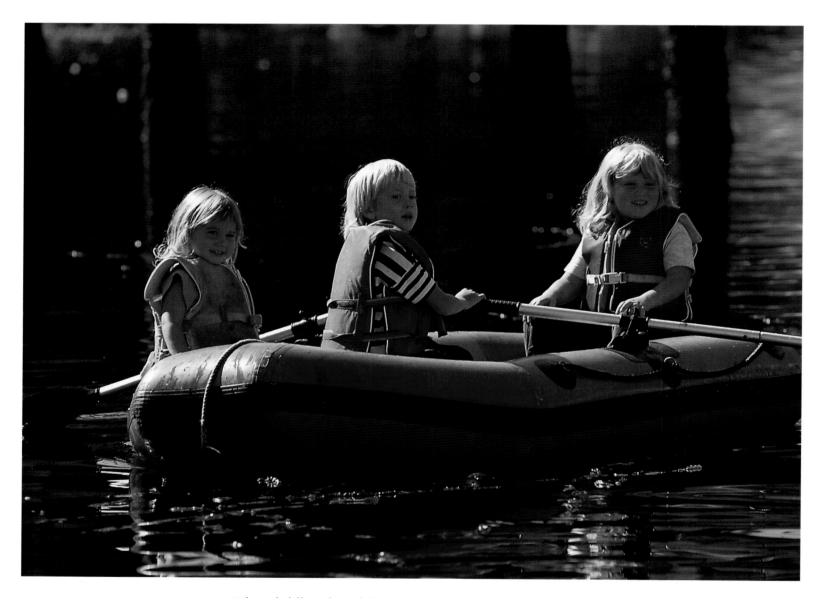

△ What childhood could be misspent in a place where the air, water, and land are free of pollution and crime? Such is life on the northwest shore of Chichagof Island, in the fishing hamlet of Elfin Cove, home to a handful of resourceful families. Timbermen have attempted to cut the forests near here, but Elfin Covers appreciate their trees standing, and have rebuffed them.
▷ Summer's flowers brighten crab pots stored along the shore of Wrangell Narrows, on Mitkof Island, near Petersburg.

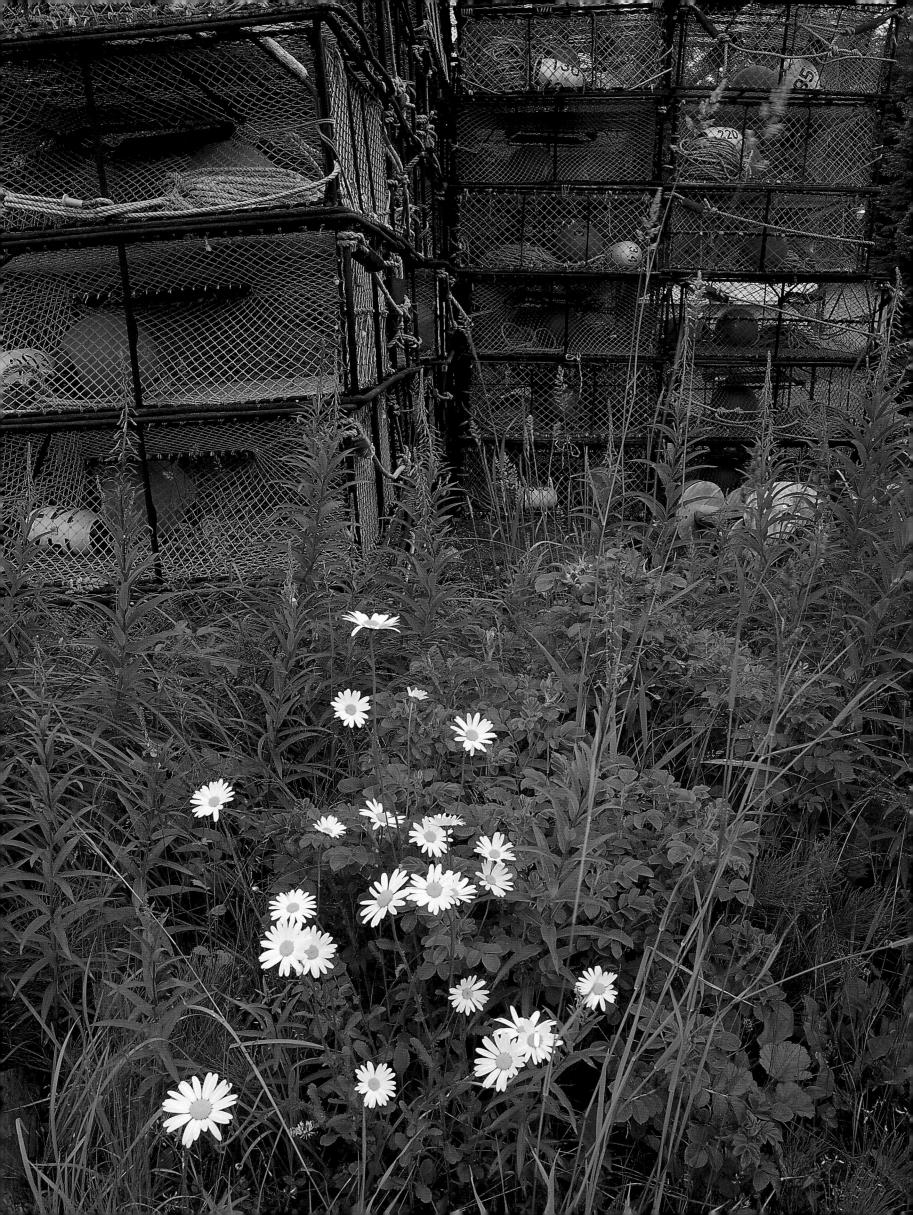

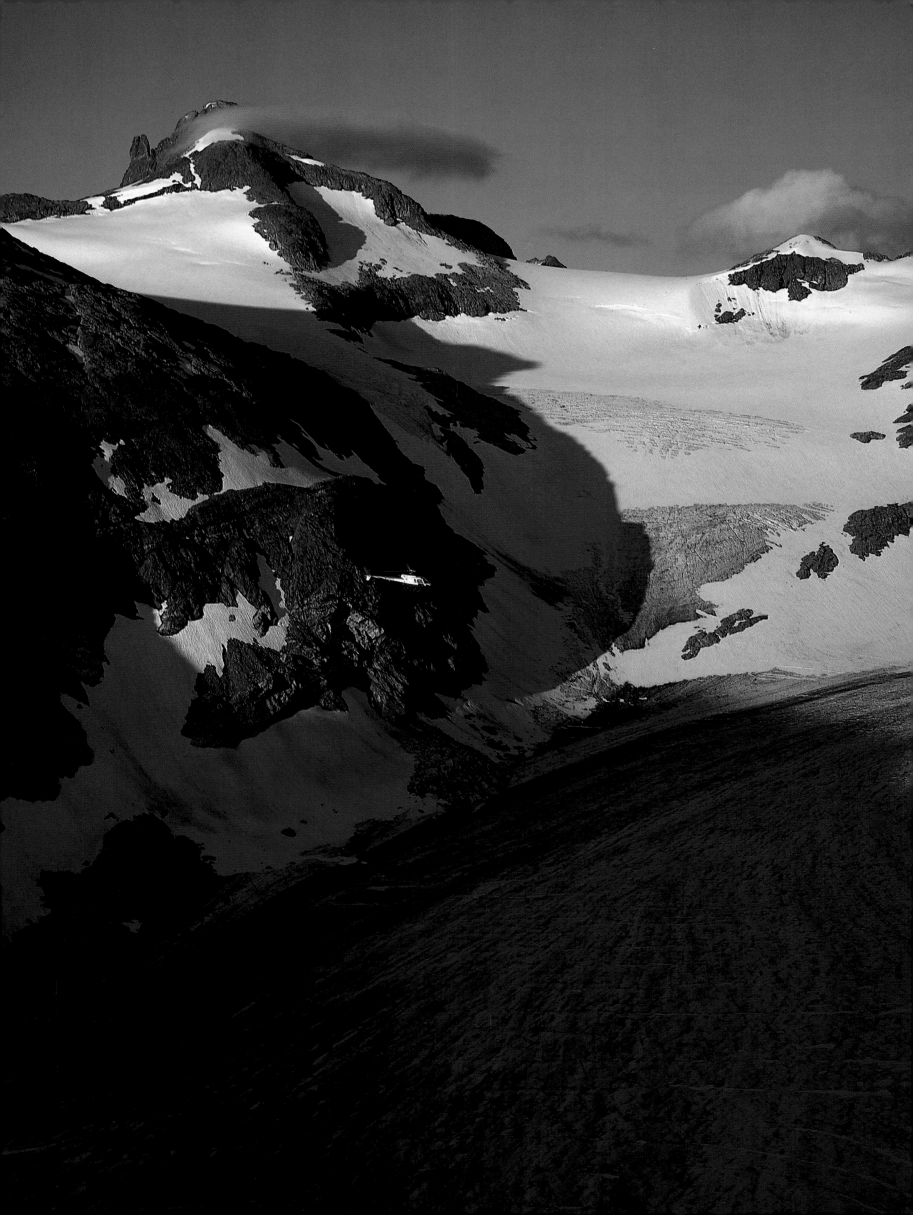

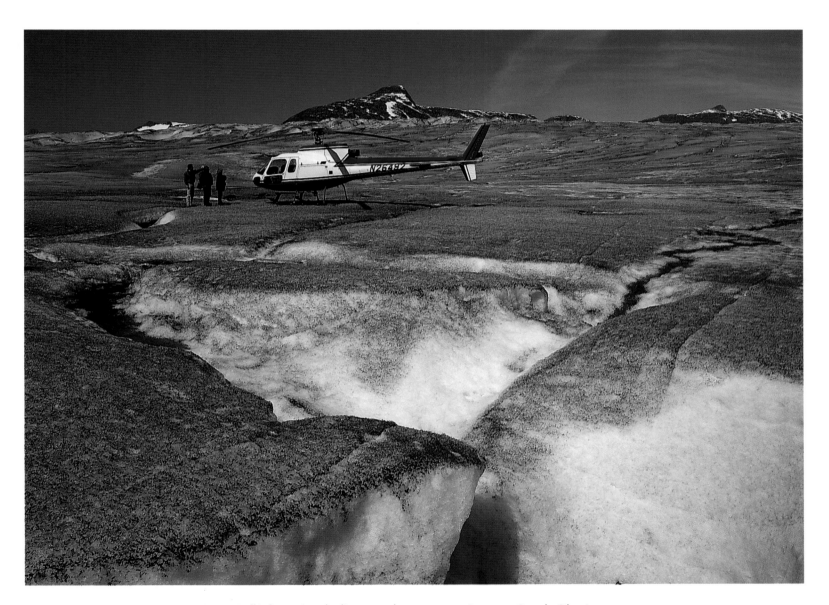

◁ A flightseeing helicopter hovers over Lemon Creek Glacier, near Juneau, Alaska's capital city. △ In recent years, helicopter excursions have skyrocketed in popularity, as tens of thousands of tourists fly over and land upon nearby glaciers each summer. While most helicopter rides follow a prescribed route, a few are "pilot's choice" and fly to remote destinations, such as here on the Taku Glacier. The flipside is that helicopters now invade wilderness areas that were once peaceful and quiet.

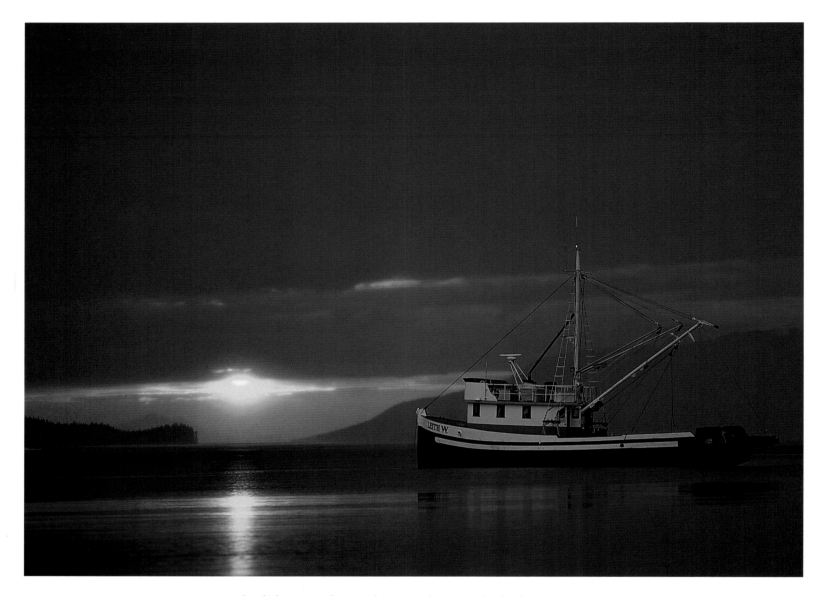

△ The fishing tender *Leith W*, working in Alaska from its home port in Washington State, anchors in Endicott Arm's Sanford Cove, as rain clouds advance over a colorful sunset in early June. ▷ A female great-horned owl stares with predatory eyes from its forest home on Baranof Island. ▷ ▷ The hamlet of Haines stands proudly beneath the Chilkat Range. Many of these buildings are part of old Fort William H. Seward, constructed by the U.S. Army in 1903, renamed Chilkoot Barracks in 1922, and designated a national historic site in 1972.

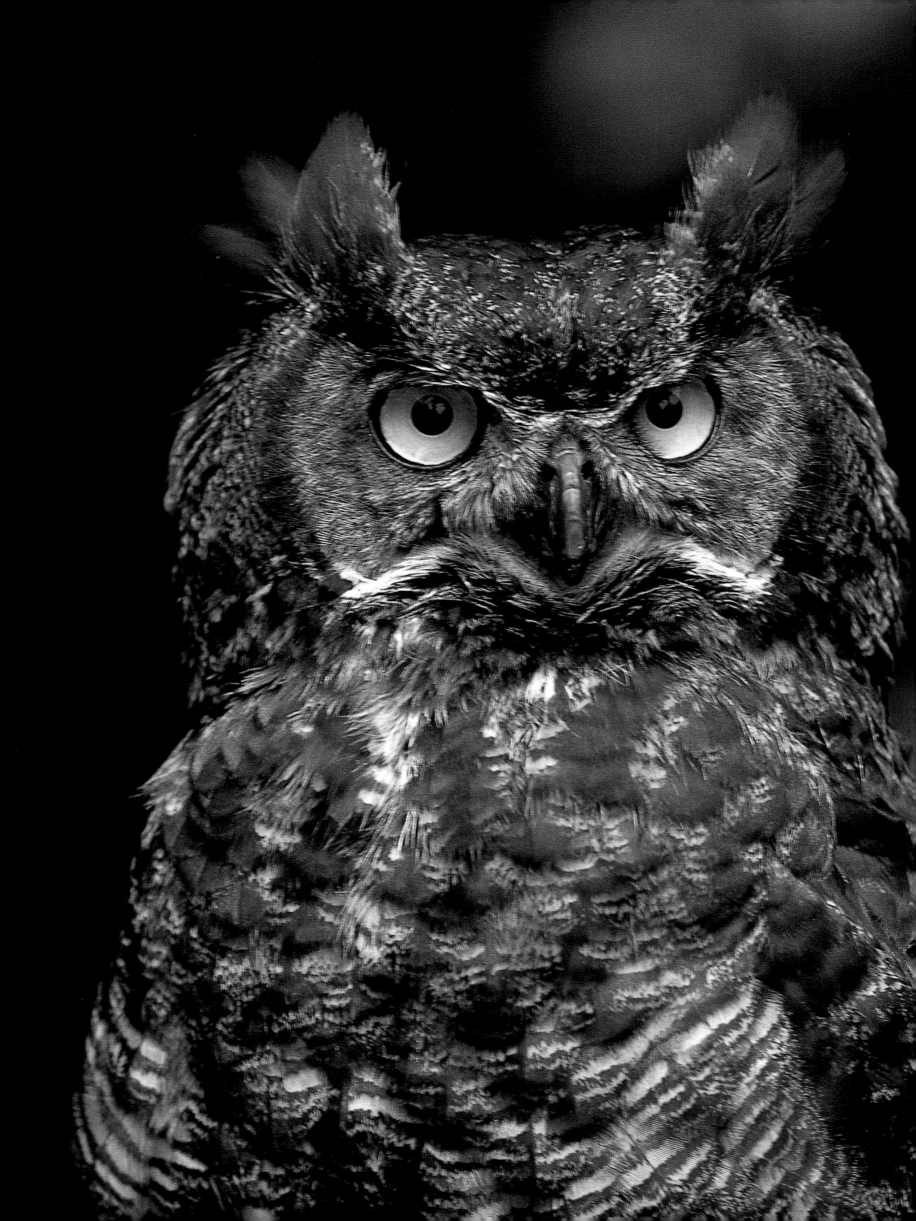

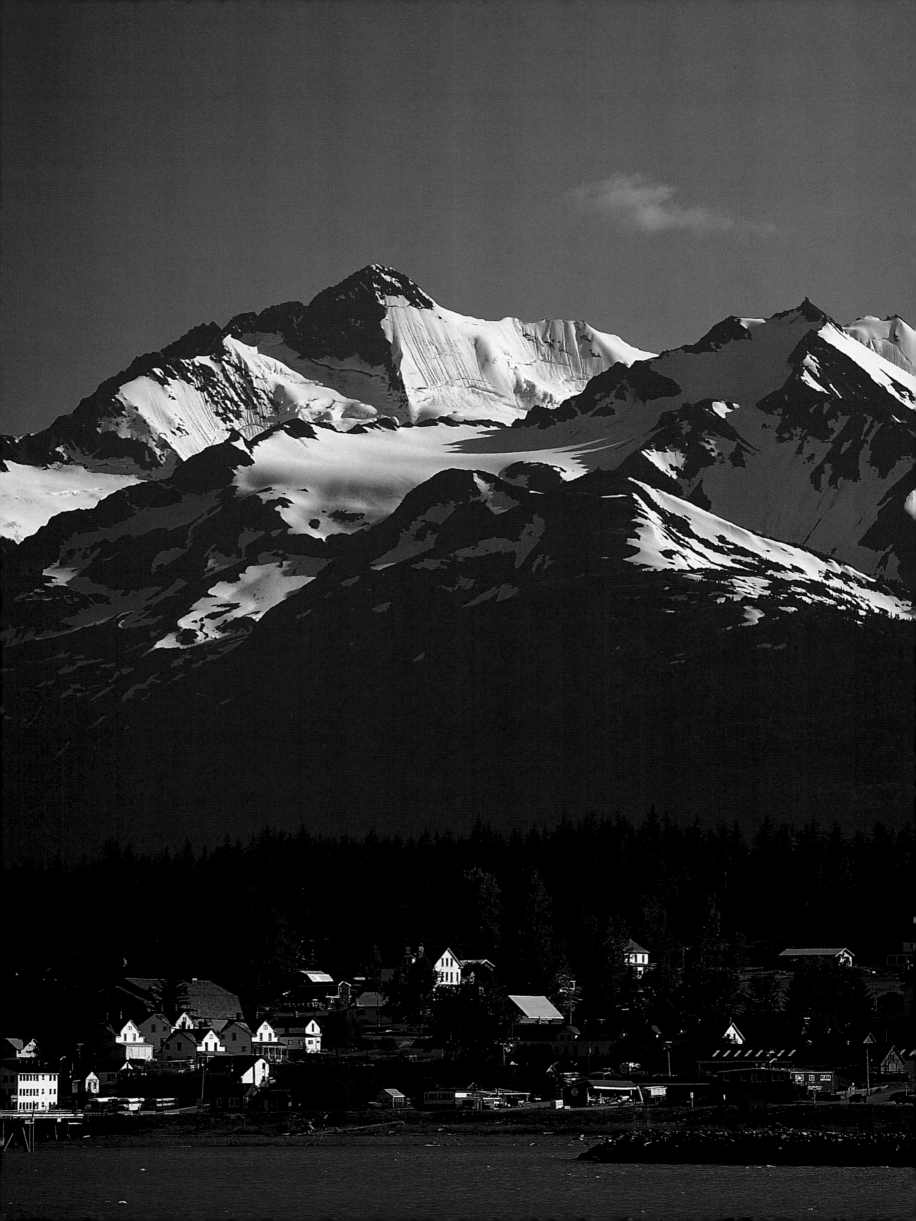

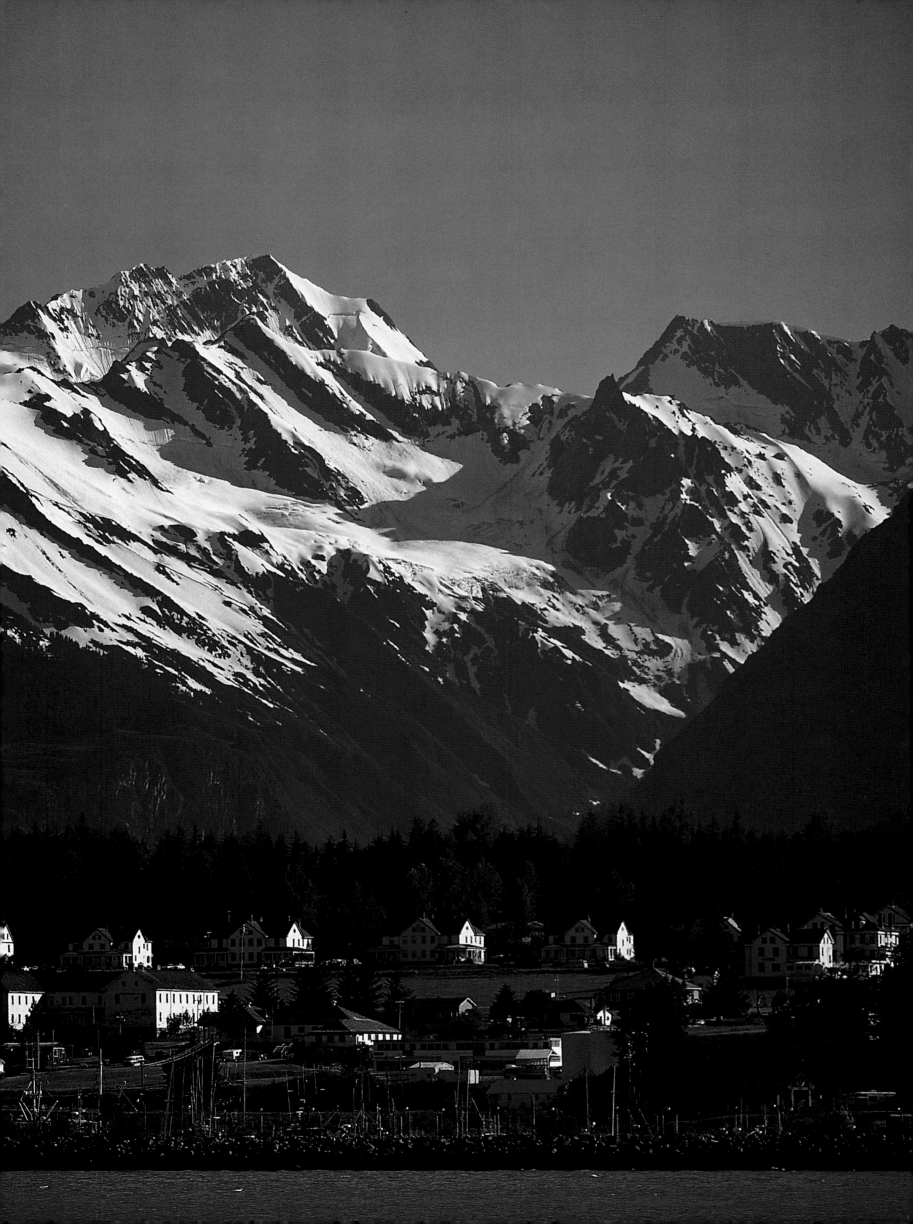

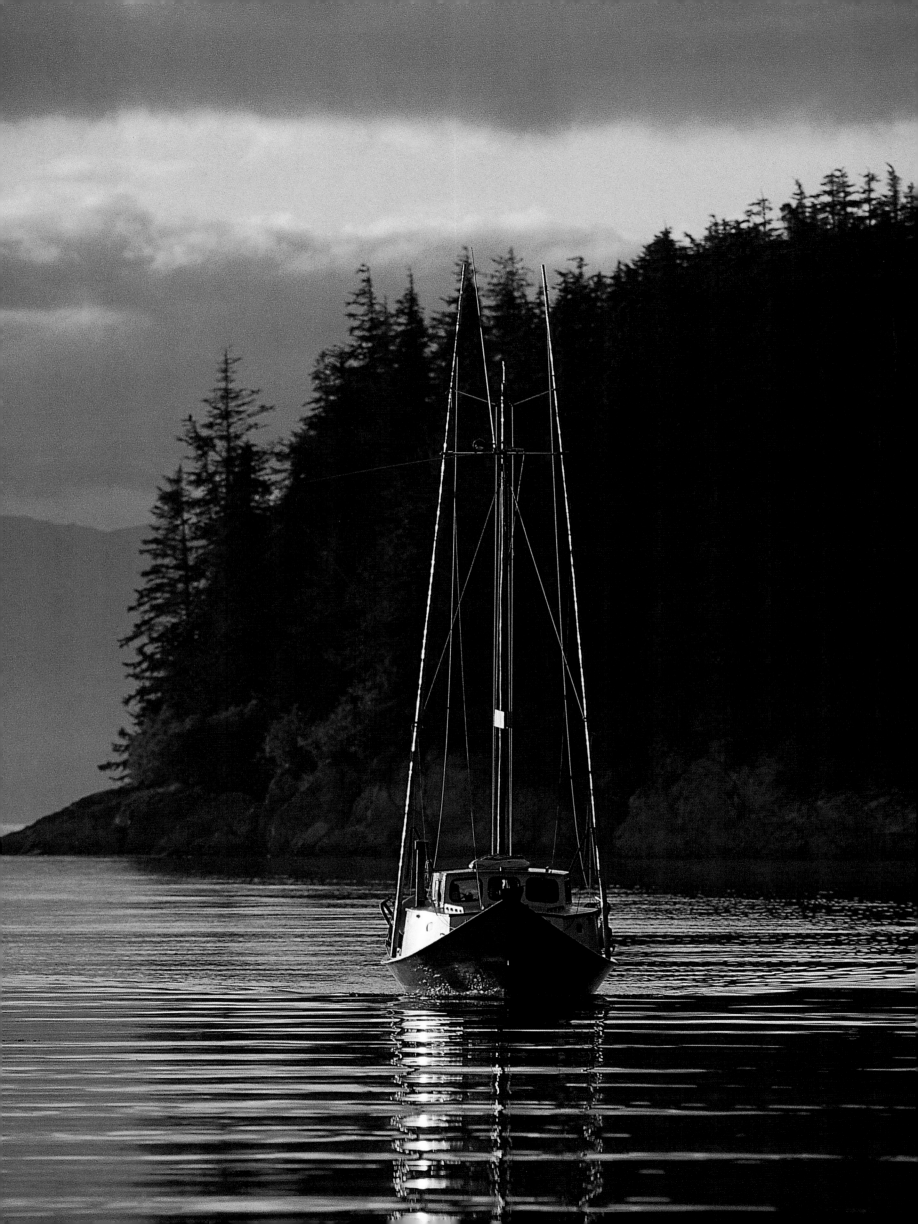

◁ A commercial troller enters the quiet sunset waters of Elfin Cove after a day of fishing in Icy Strait. Approximately six billion pounds of fish and shellfish are caught commercially in Alaskan waters each year. △ Building your own home, growing your own garden, and cutting your own firewood are essential to free spirits who make their homes along the Inside Passage. These people live simple, unincorporated lives, and make no more demands on others than they do on themselves.

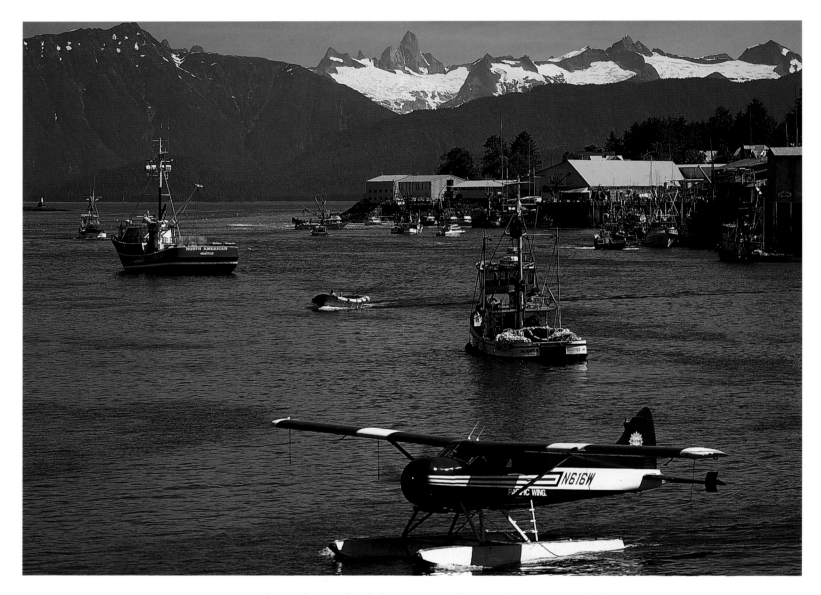

△ It's a busy day in the fishing town of Petersburg, on Mitkof Island at the north end of Wrangell Narrows, where traffic consists of boats and planes more than trucks and cars. In the distance stand the ragged summits of the Coast Mountains, most distinctly the 9,077-foot spire, Devil's Thumb, on the Alaska-British Columbia International Boundary. ▷ The Whiting River flows through the Tongass National Forest into Port Snettisham.

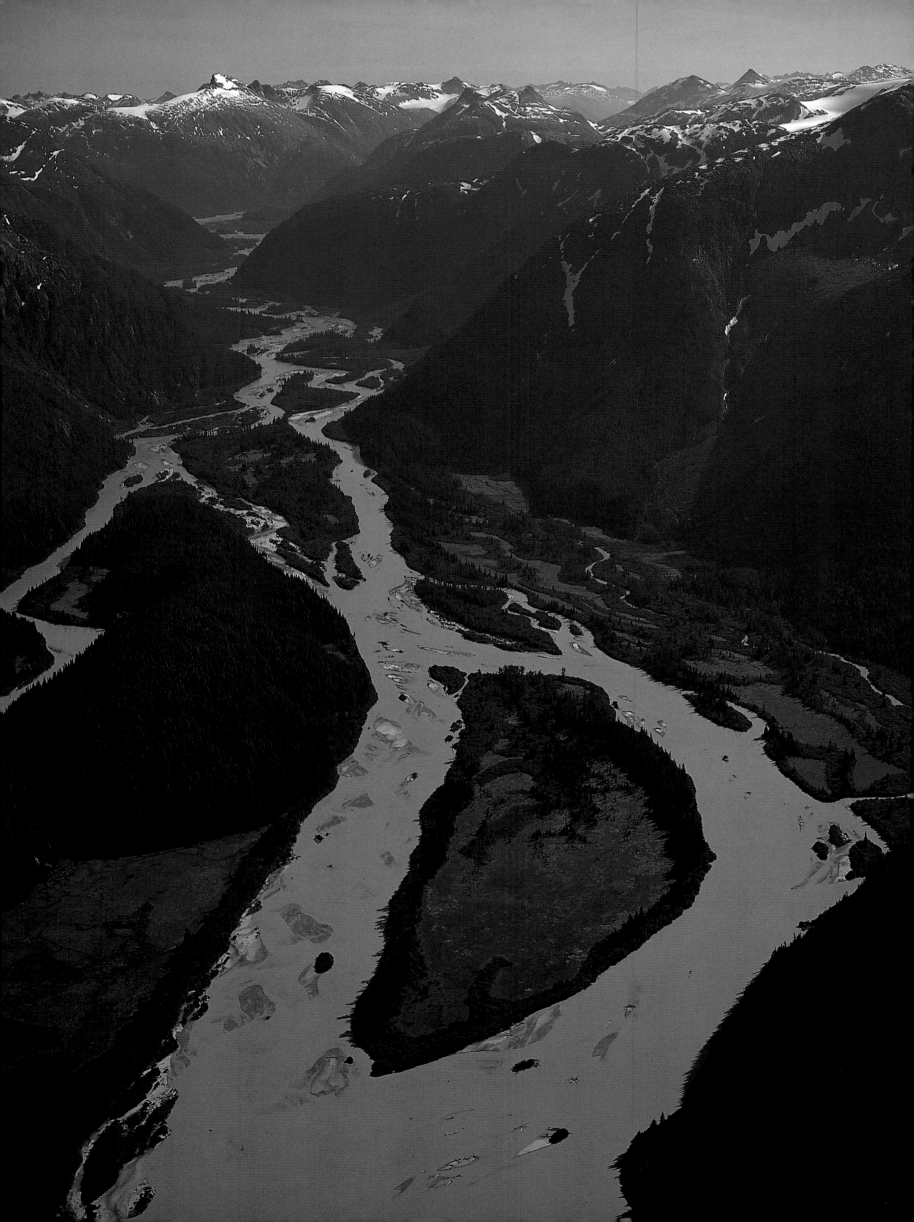

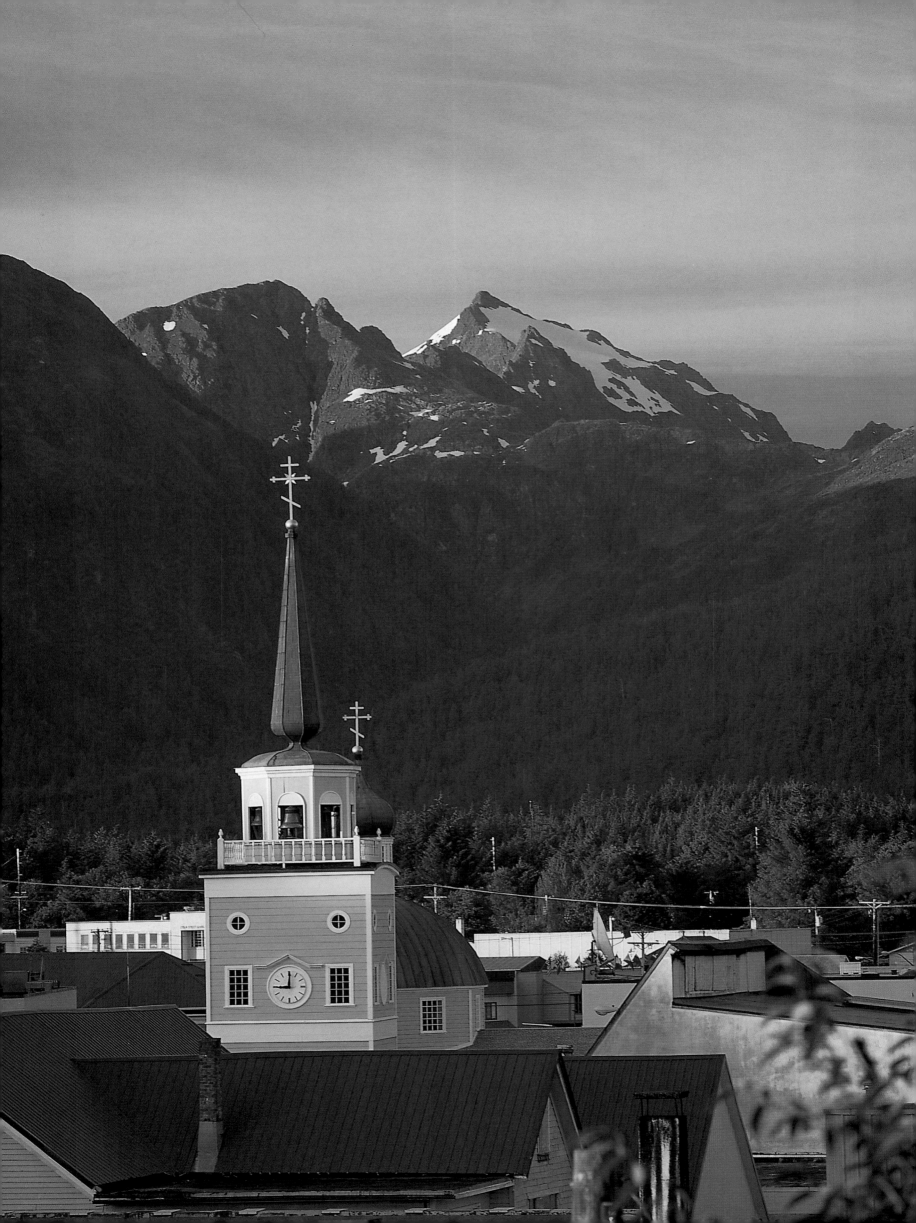

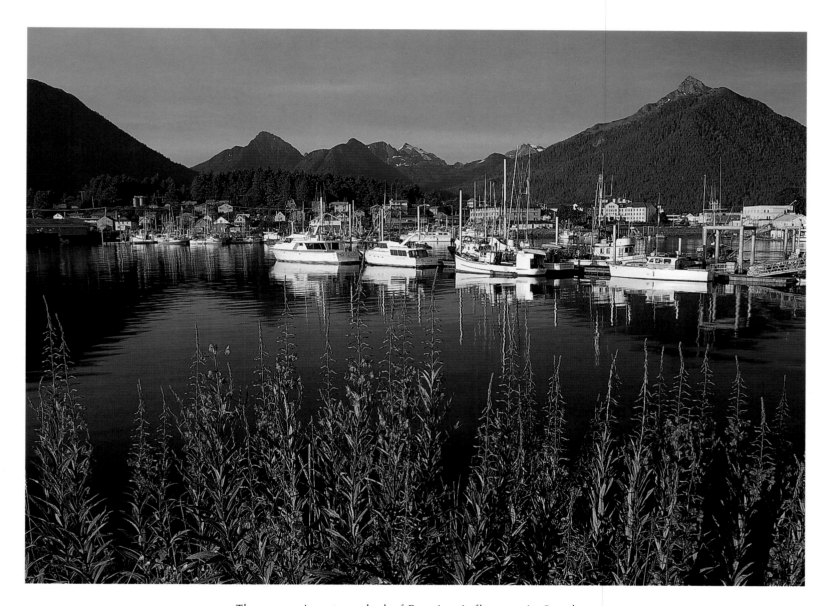

◁ The preeminent symbol of Russian influence in Southeast Alaska, Saint Michael's Russian Orthodox Cathedral rises above other less memorable rooftops in Sitka. Built in 1844-48, the original cathedral burned down in 1966. Townspeople braved the flames to save many priceless Russian icons, and in 1976 Saint Michael's was reconstructed using the original blueprints.
△ Tall fireweed brightens Sitka's boat harbor, with the mountains of Baranof Island cutting a jagged skyline behind.

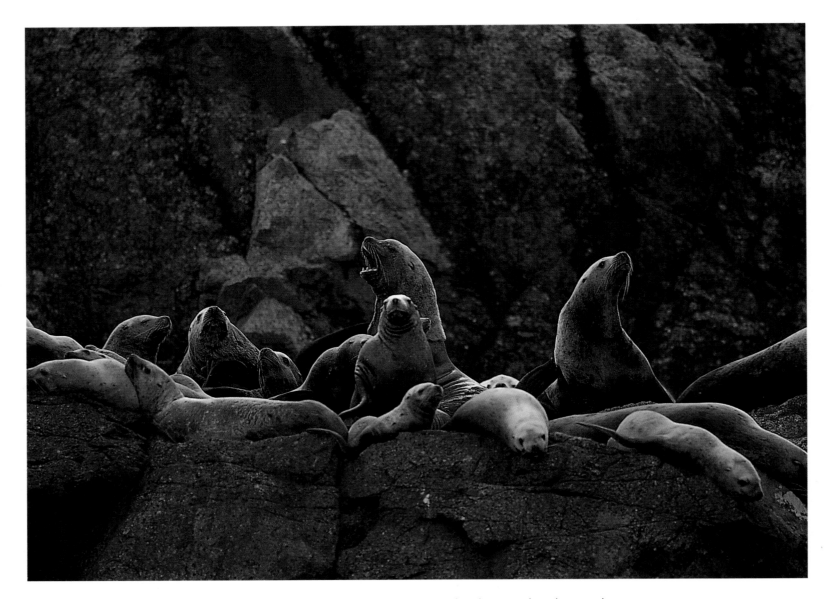

△ Steller's sea lions gather on Yasha Island, in Frederick Sound. While their numbers have remained stable in Southeast Alaska, they have collapsed in the Gulf of Alaska and Bering Sea, likely due to human overfishing of walleye pollock, an important feed fish for sea lions. ▷ Seabeach sandwort (also known as beach greens) forms mats along the high tide line in Glacier Bay's West Arm, a living laboratory for the study of glacial recession, plant succession, and wildlife immigration.

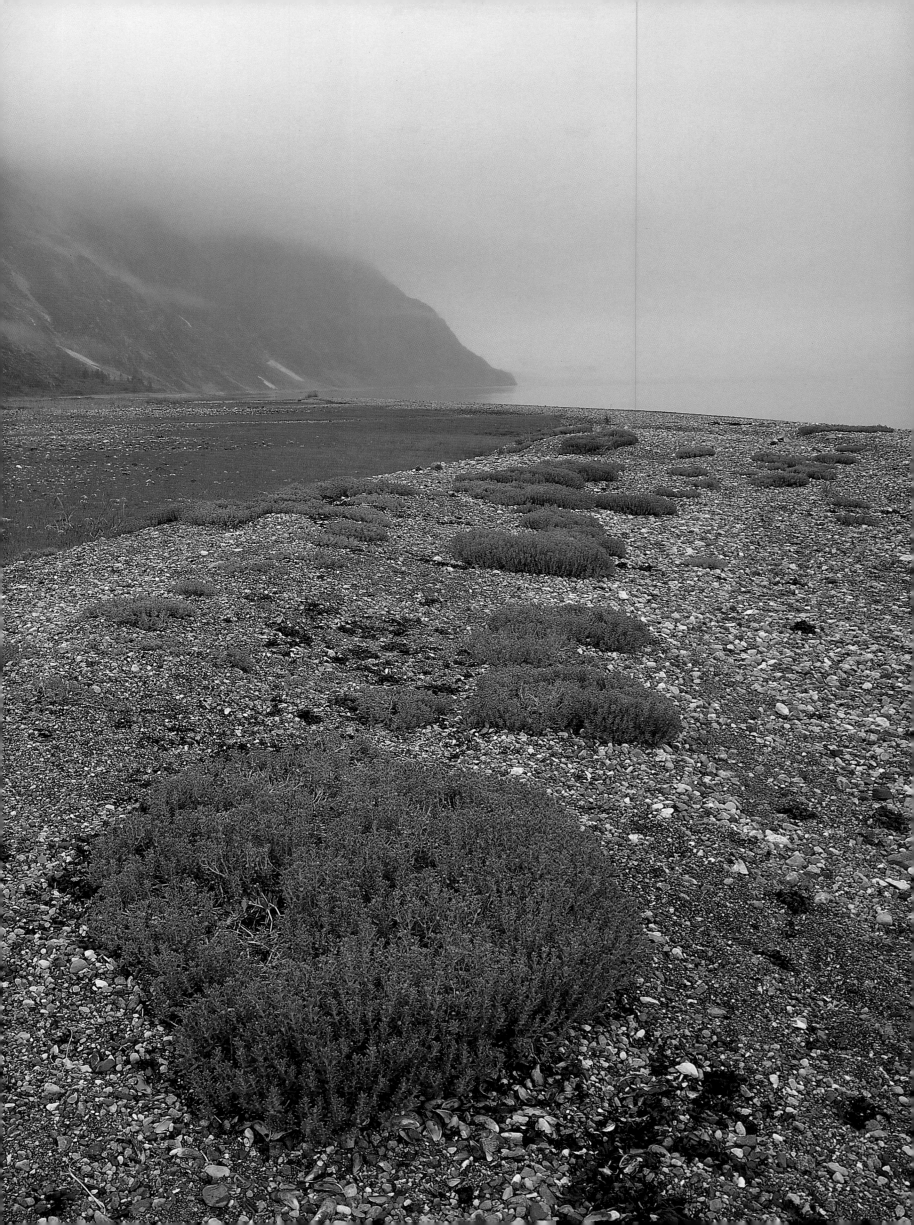

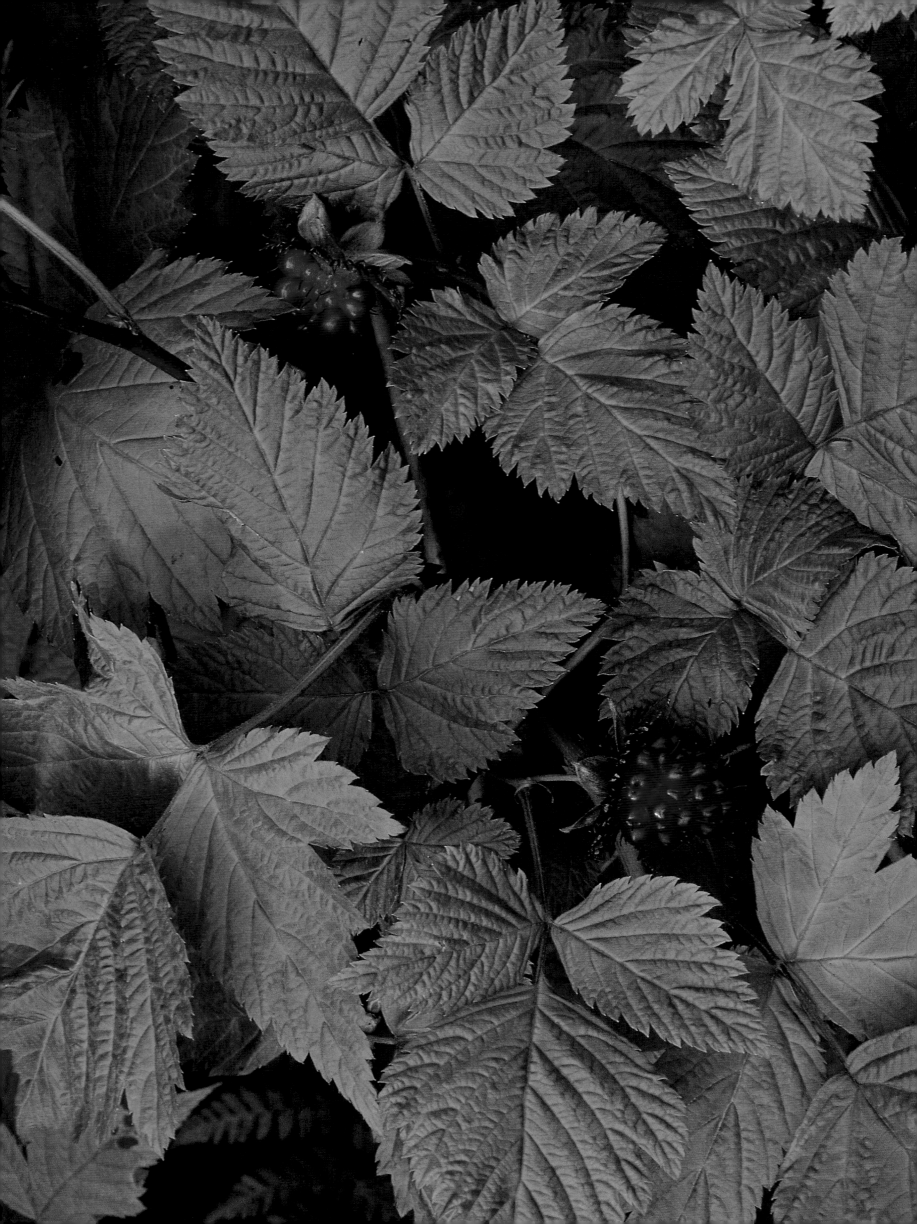

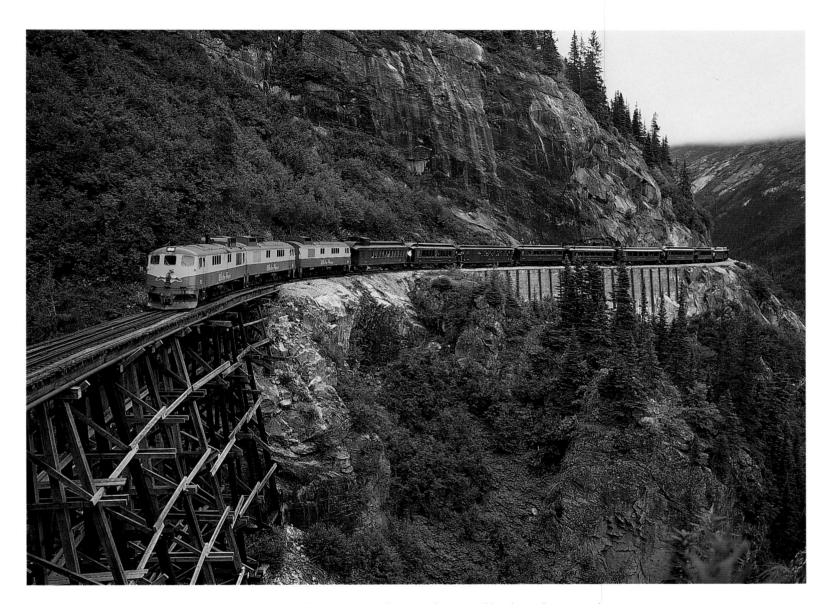

◁ Red salmonberries are a favorite forage of birds and mammals in Southeast Alaska. Unlike other organisms that prefer camouflage over conspicuousness, the beaconlike berries are designed to be eaten and thereby dispersed in the droppings of their consumers. △ The narrow-gauge White Pass and Yukon Route Railroad, a favorite of summer tourists, crosses Tunnel Mountain Trestle en route from Skagway to White Pass, following a route popular with Klondike gold stampeders of the late 1890s.

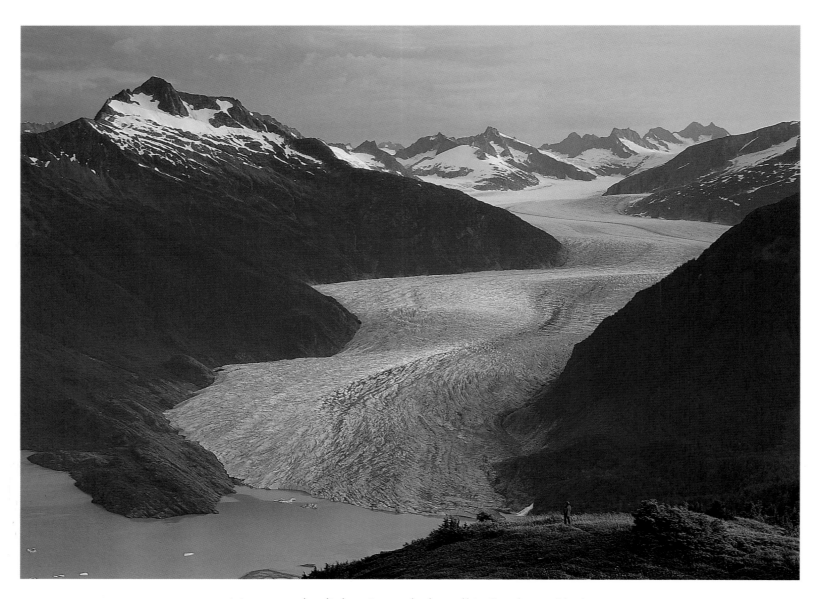

△ It's easy and enlightening to feel small in Southeast Alaska, such as during sunrise on Thunder Mountain, above Mendenhall Glacier. ▷ One of the more than three hundred species of birds that have been documented in Southeast Alaska is the lesser scaup. Like the canvasback and ring-necked duck, the scaup is a heavy-bodied diving duck that requires a running start to enable it to lift off the water. Mallards and teals, by contrast, are dabbling ducks that burst off the water into instant flight.

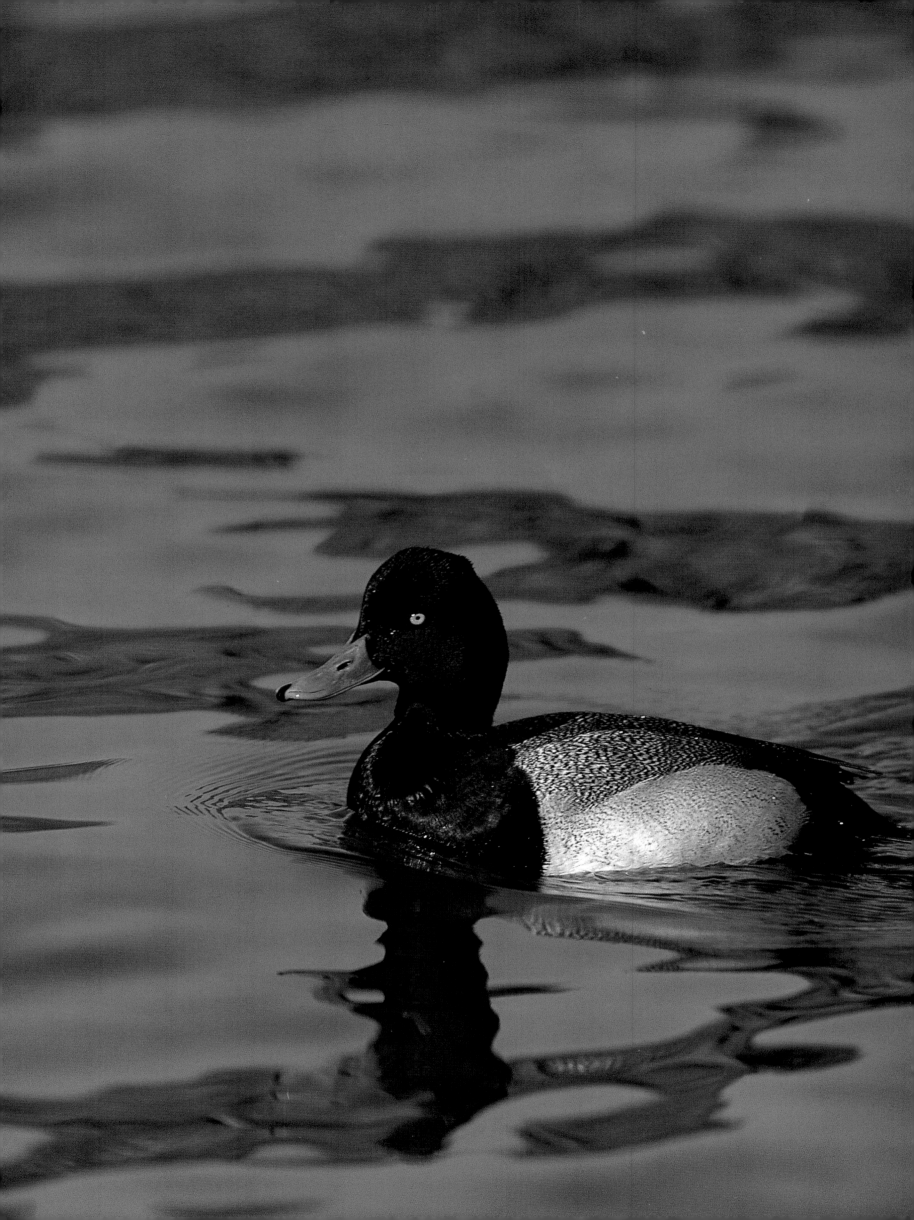

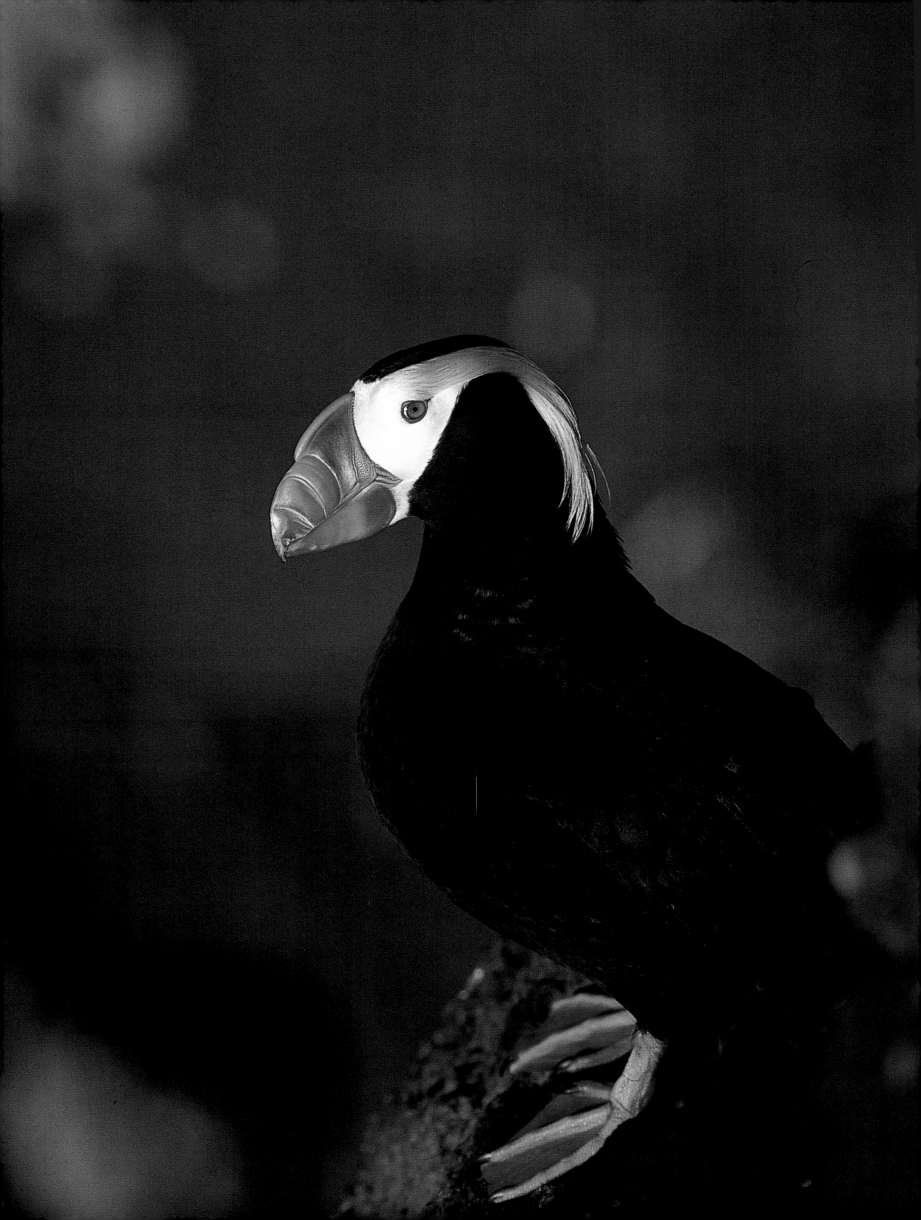

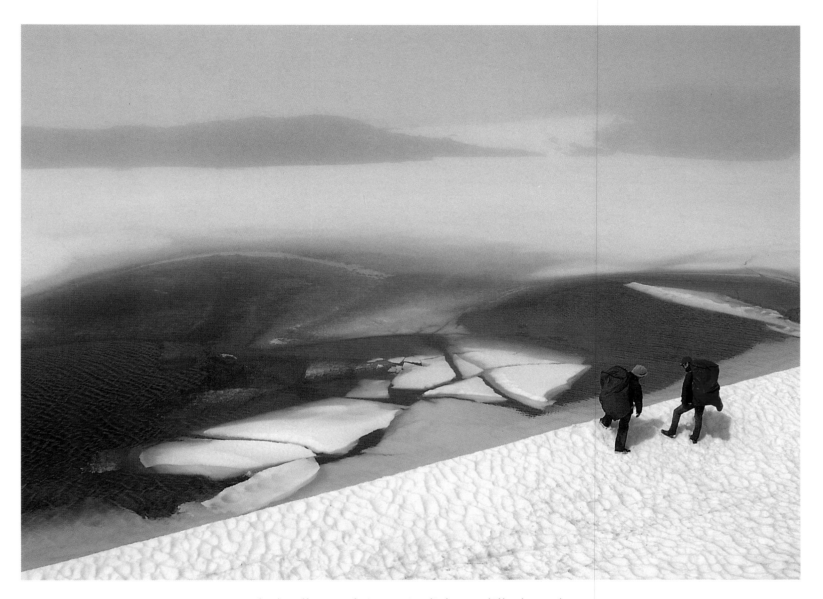

◁ A tufted puffin stands in sunrise light on cliffs above the sea. The puffin's white face and long tufts occur only in summer, when breeding. △ Hikers Larry Bright and Richard Steele pause in the snow and fog near the summit of Chilkoot Pass, on the famous Chilkoot Trail, traversed amid cold adversity by thousands of dreamers bound for the Klondike gold fields in the winter of 1897-98. ▷ A summer sunset over Gastineau Channel welcomes boaters home to Juneau after a day of sport fishing.

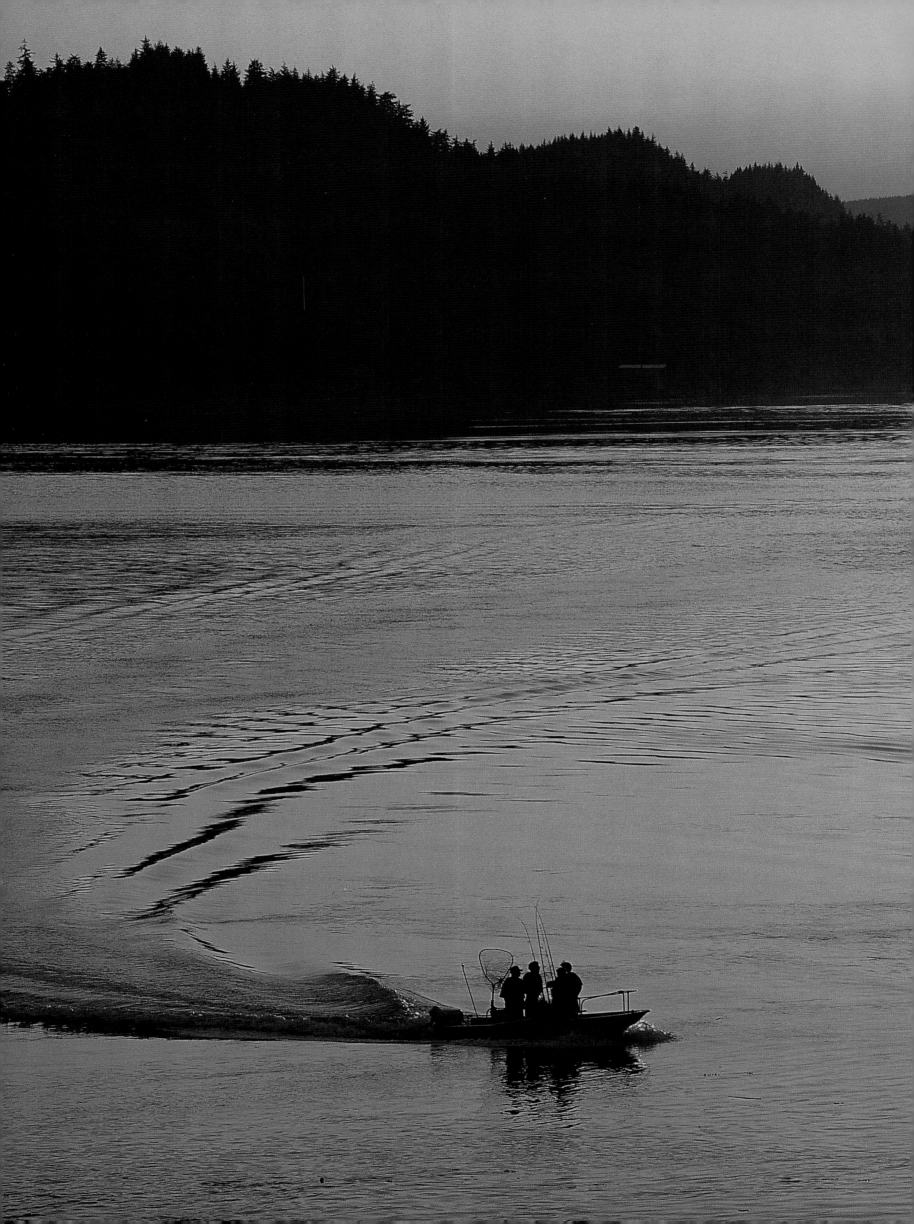

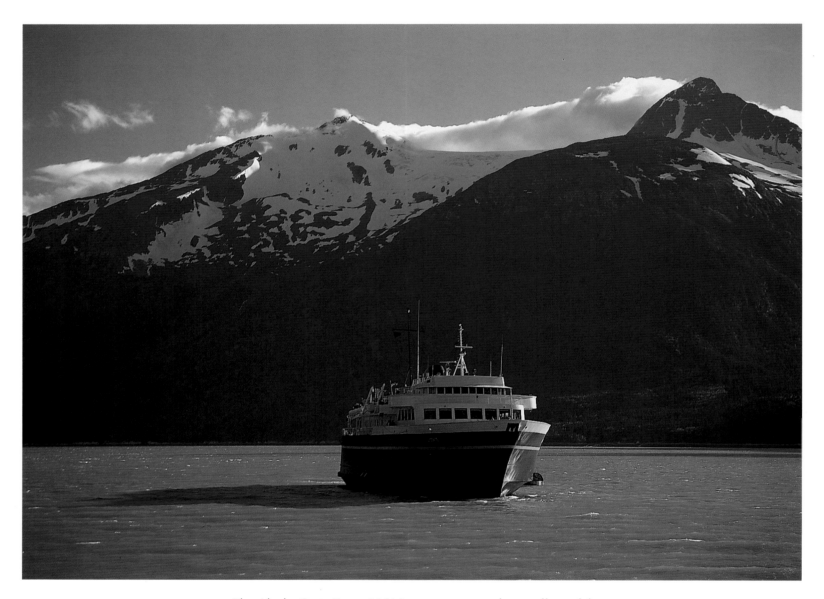

△ The Alaska State Ferry, M/V *Leconte,* among the smallest of the fleet of "Blue Canoes," travels up Chilkoot Inlet from Haines to Skagway. Also known as the Alaska Marine Highway System, the ferries have operated in Southeast Alaska since 1963. ▷ Harbor seals rest on icebergs near South Sawyer Glacier, in Tracy Arm. ▷▷ Boats anchor at the entrance of Mitchell Bay, in Angoon, Admiralty Island's only permanent settlement. Most of the island is a national monument and off-limits to logging.

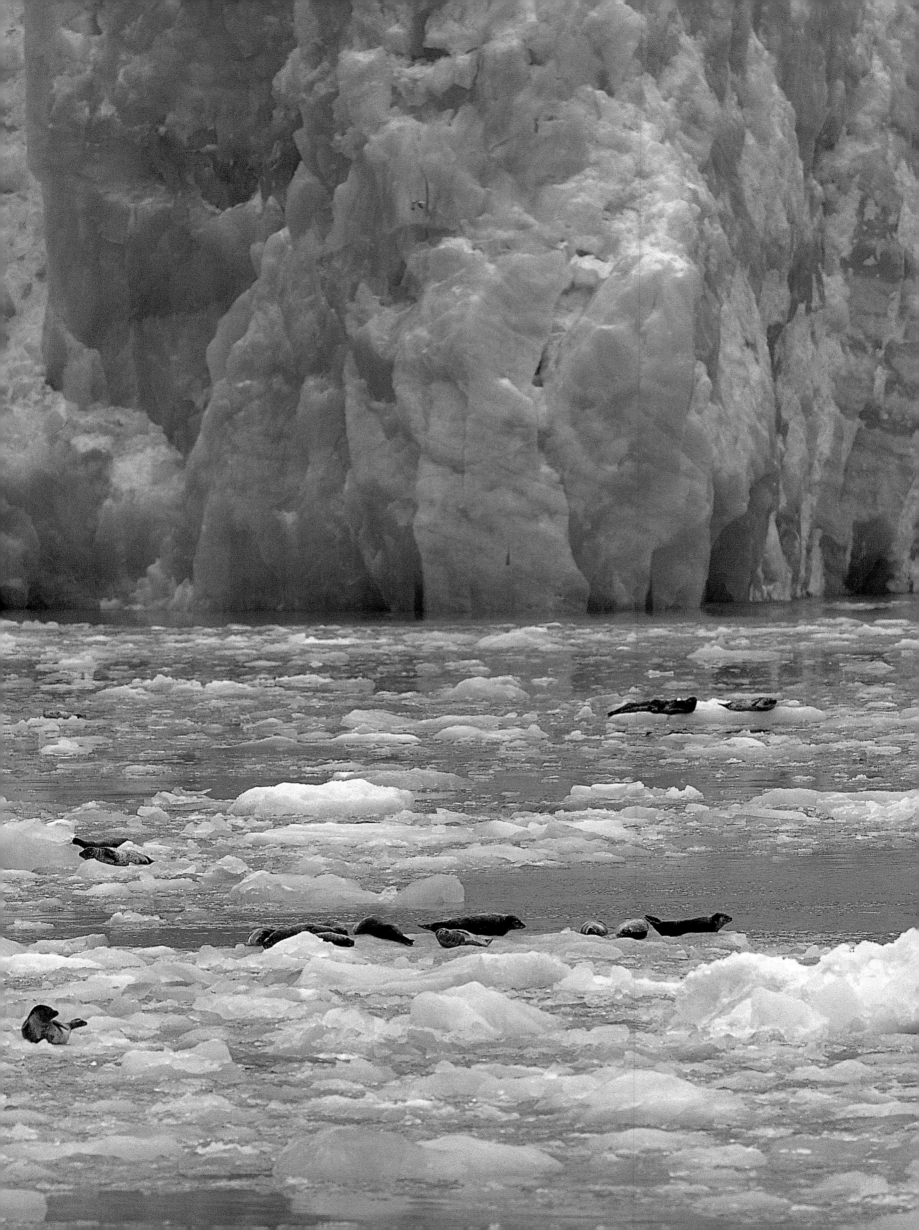

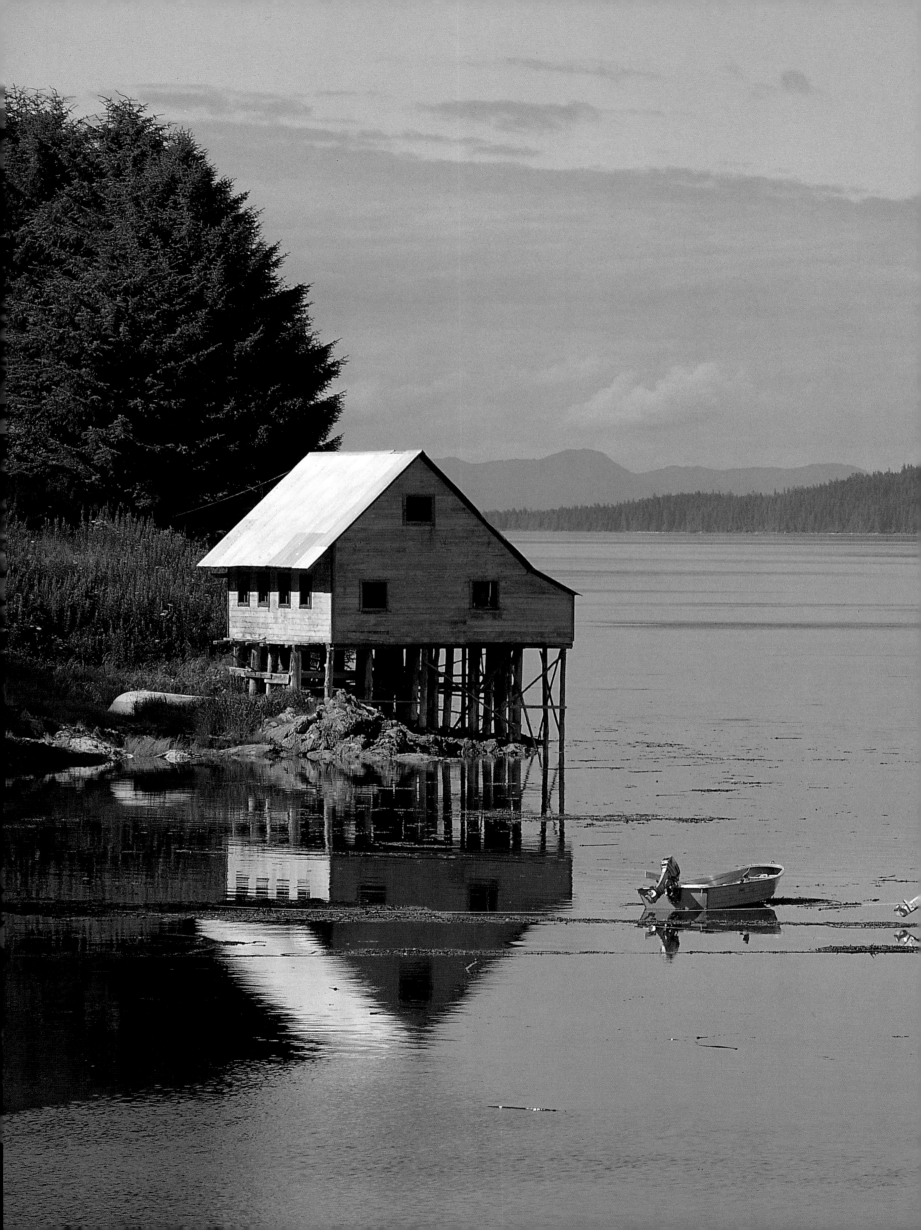

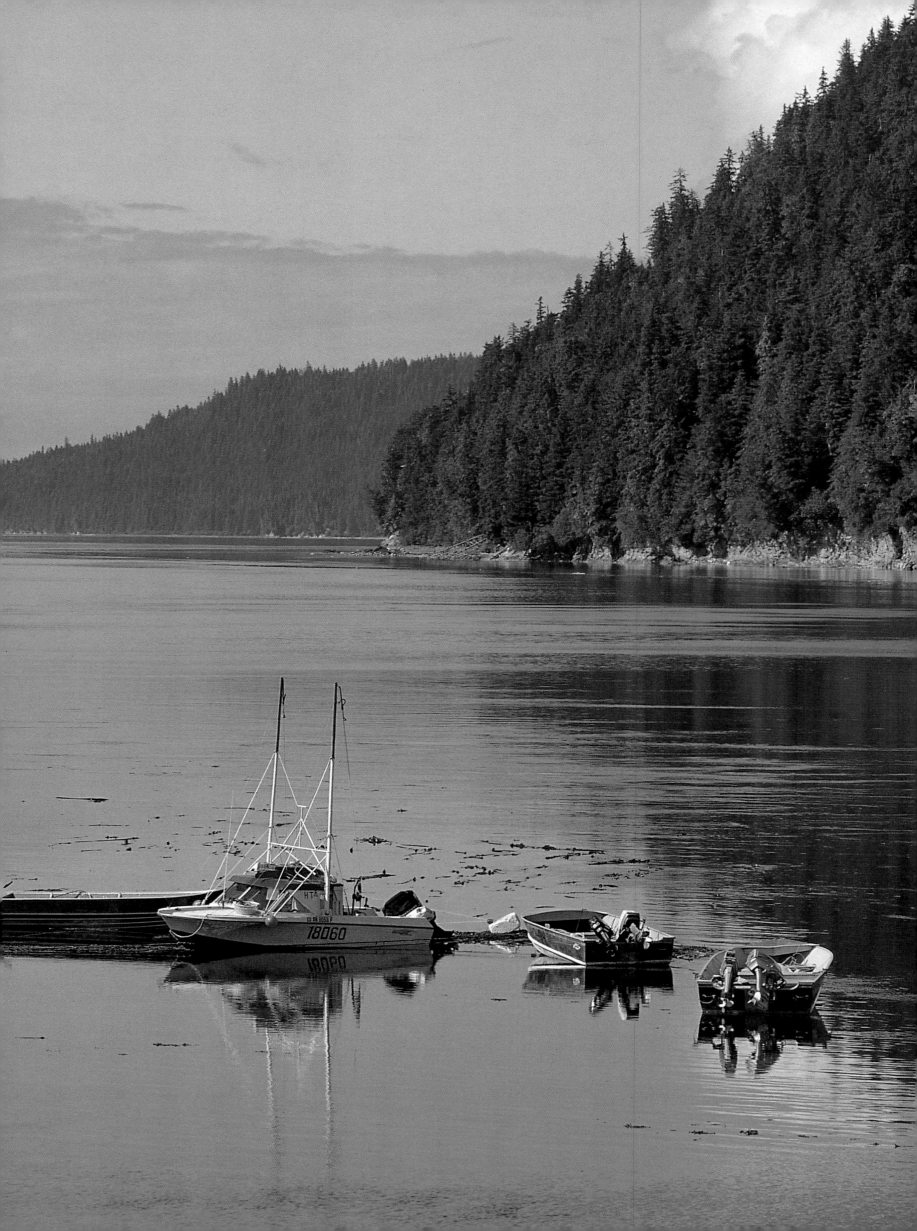

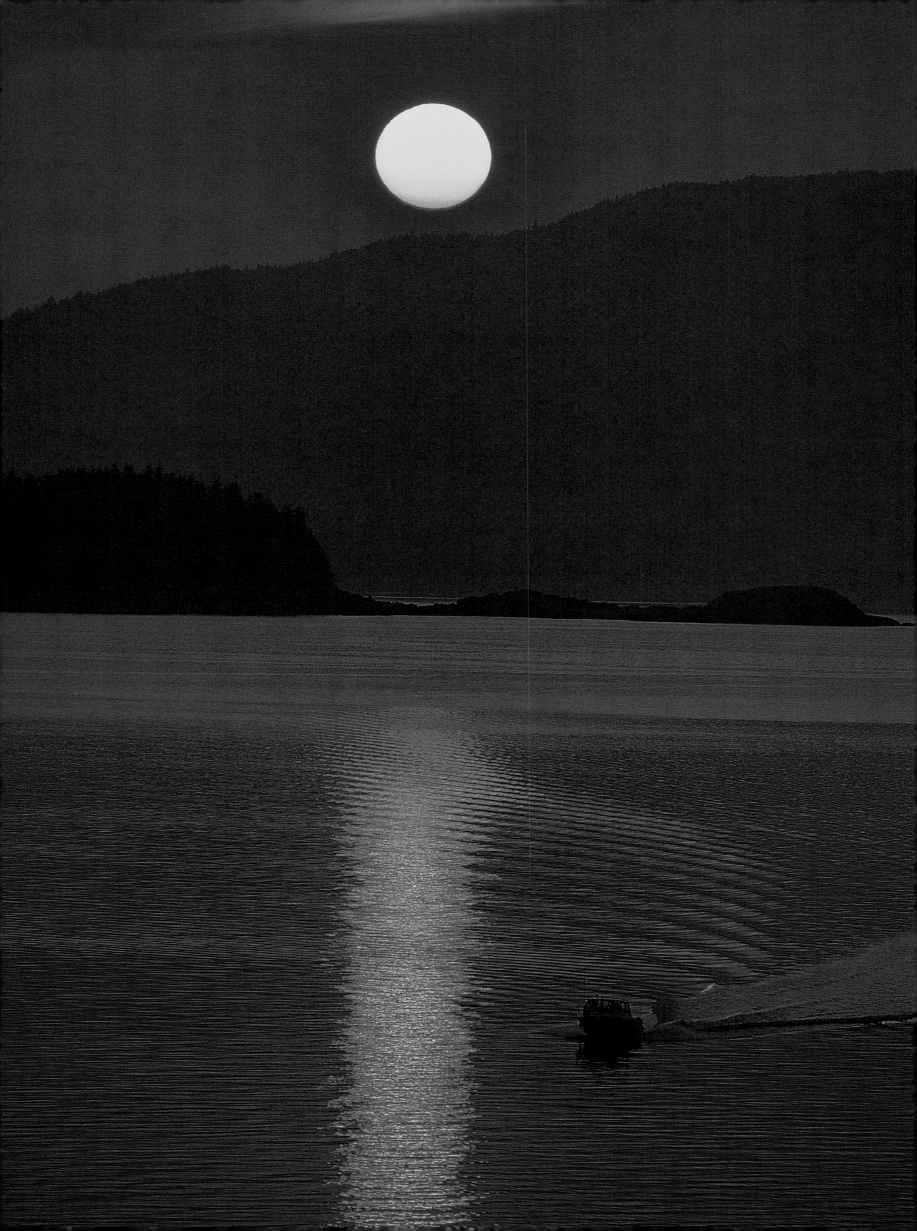

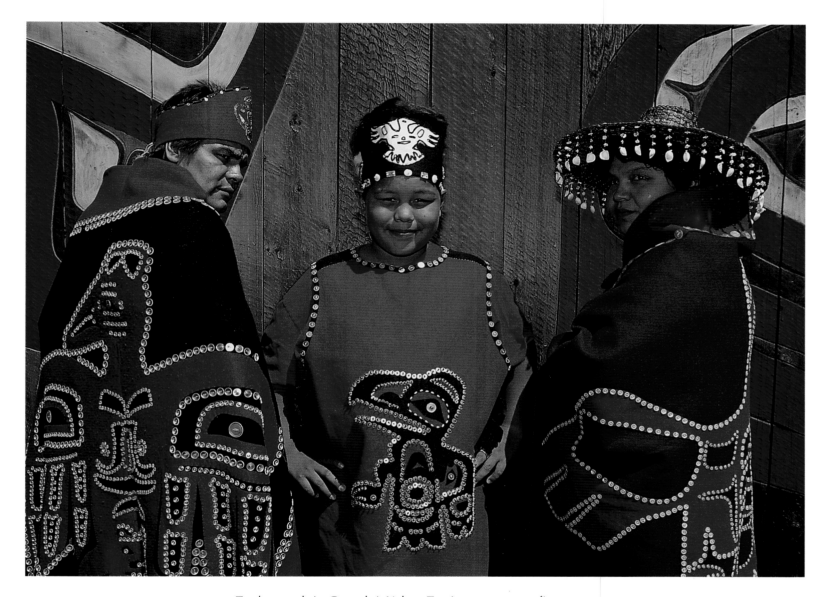

◁ To the north in Canada's Yukon Territory, summer fires create smoky skies and a cinnabar sunset over Lynn Canal. △ Tlingit dancers Albert Jackson, Timothy Williams, and Lorraine Williams pause outside a clan house after a performance in Saxman, near Ketchikan. Through legends and dance and the creation of blankets, baskets, totem poles, and other crafts, Alaska Natives strive to keep alive traditional values, which can suffer amid corporate mindsets and modern temptations.

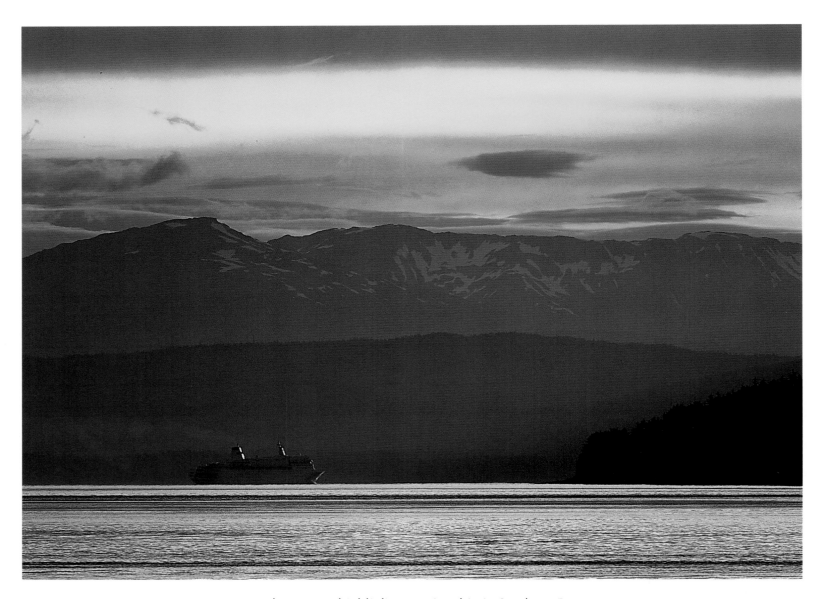

△ An amber sunset highlights a cruise ship in Stephens Passage off the south end of Douglas Island. Cruising Alaska's Inside Passage has grown in popularity since the 1880s, when steamships first arrived and intrepid women in Victorian dresses climbed ladders onto the glaciers. Modern ships today offer more luxury than daring, yet a cruise to Alaska can still be an adventure, a dream come true. ▷ In late summer, a cow moose raises her head from feeding on aquatic vegetation in a pond.

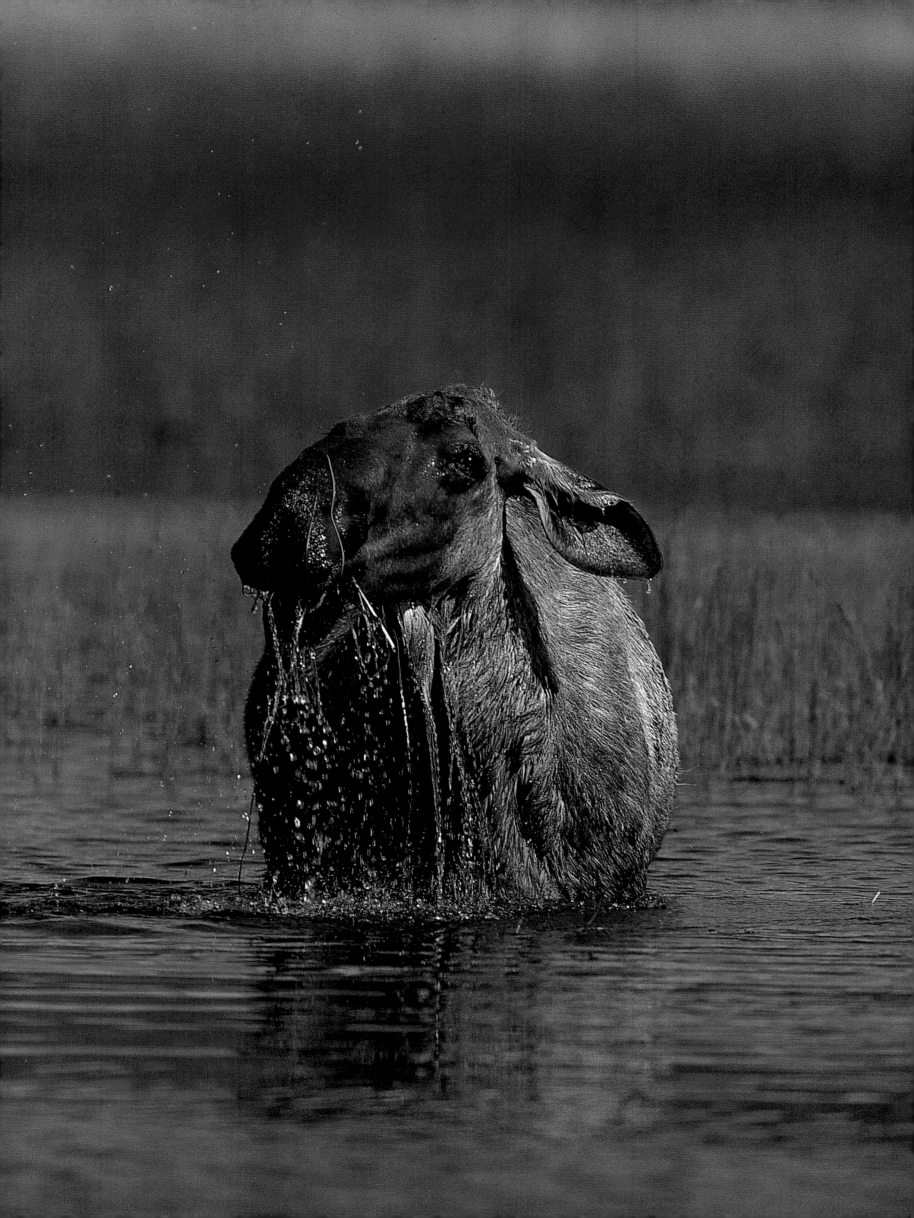

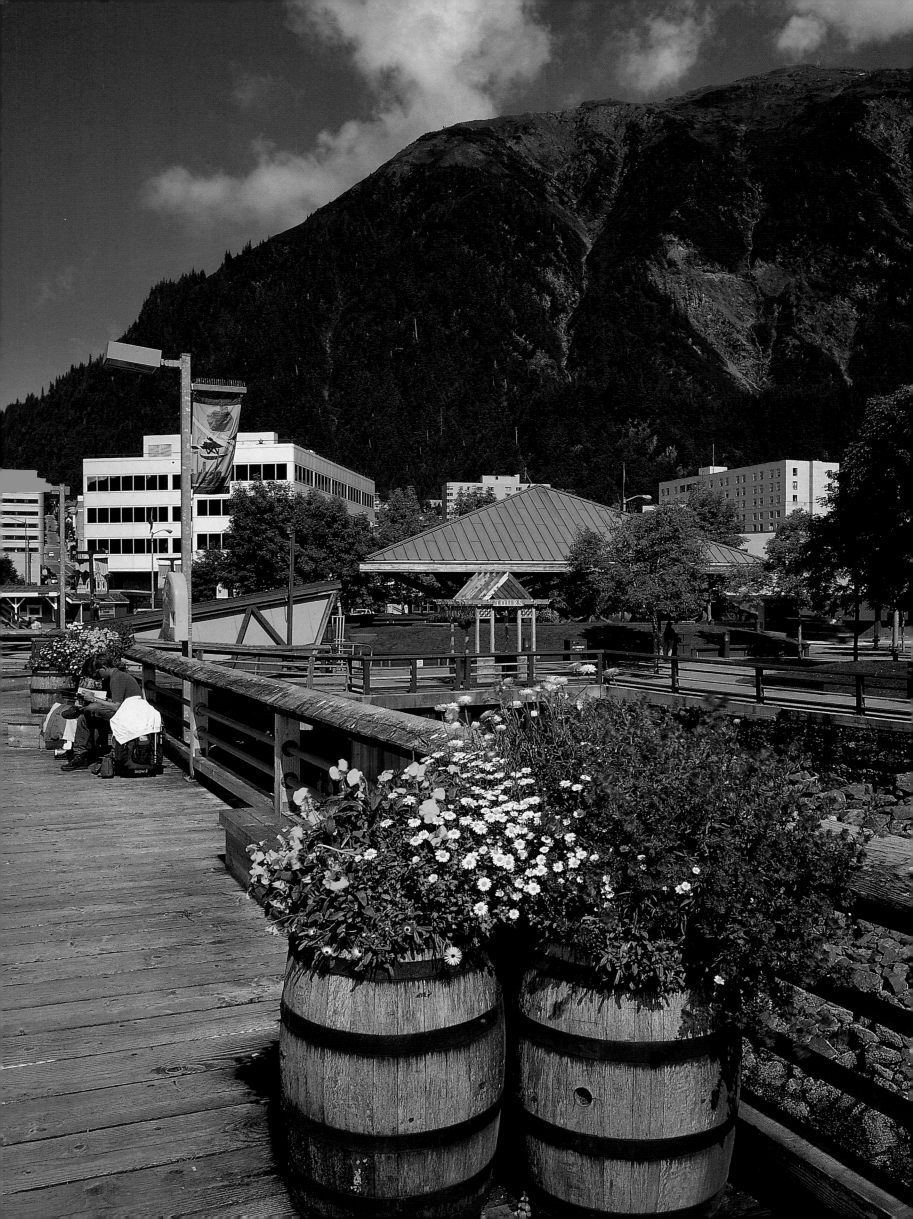

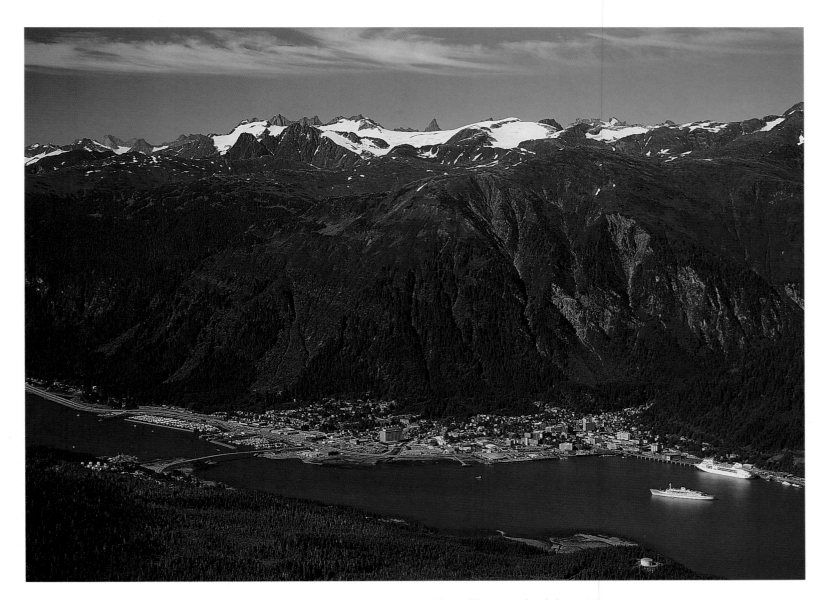

◁ Juneau's waterfront on a sunny day offers a colorful respite from the rain common in Southeast Alaska. Though born from mining, the capital city now survives primarily on government and summer tourism. △ Seen from atop Douglas Island, Juneau lies comfortably along Gastineau Channel. Beyond rise the Coast Mountains that cradle the Juneau Icefield, birthplace of glaciers. Ten thousand years ago, during the Ice Age, nearly every contour in this photo was beneath glacial ice.

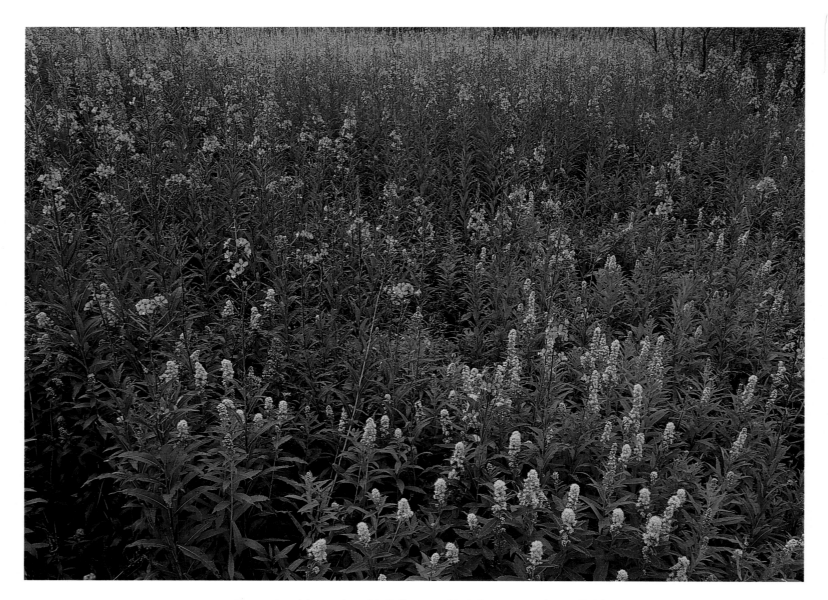

△ Elegant goldenrod and tall fireweed brighten a predawn field in Gustavus. Because stalks of fireweed bloom from the bottom up, summer is said to be over when the last, topmost blossom fades and falls, and the fireweed goes to seed. ▷ A 4:00 A.M. sunrise paints the sky crimson above Point Gustavus, looking north toward Beartrack Mountain. At 58° north latitude, the sun is up for eighteen hours in summer, but only six in winter.

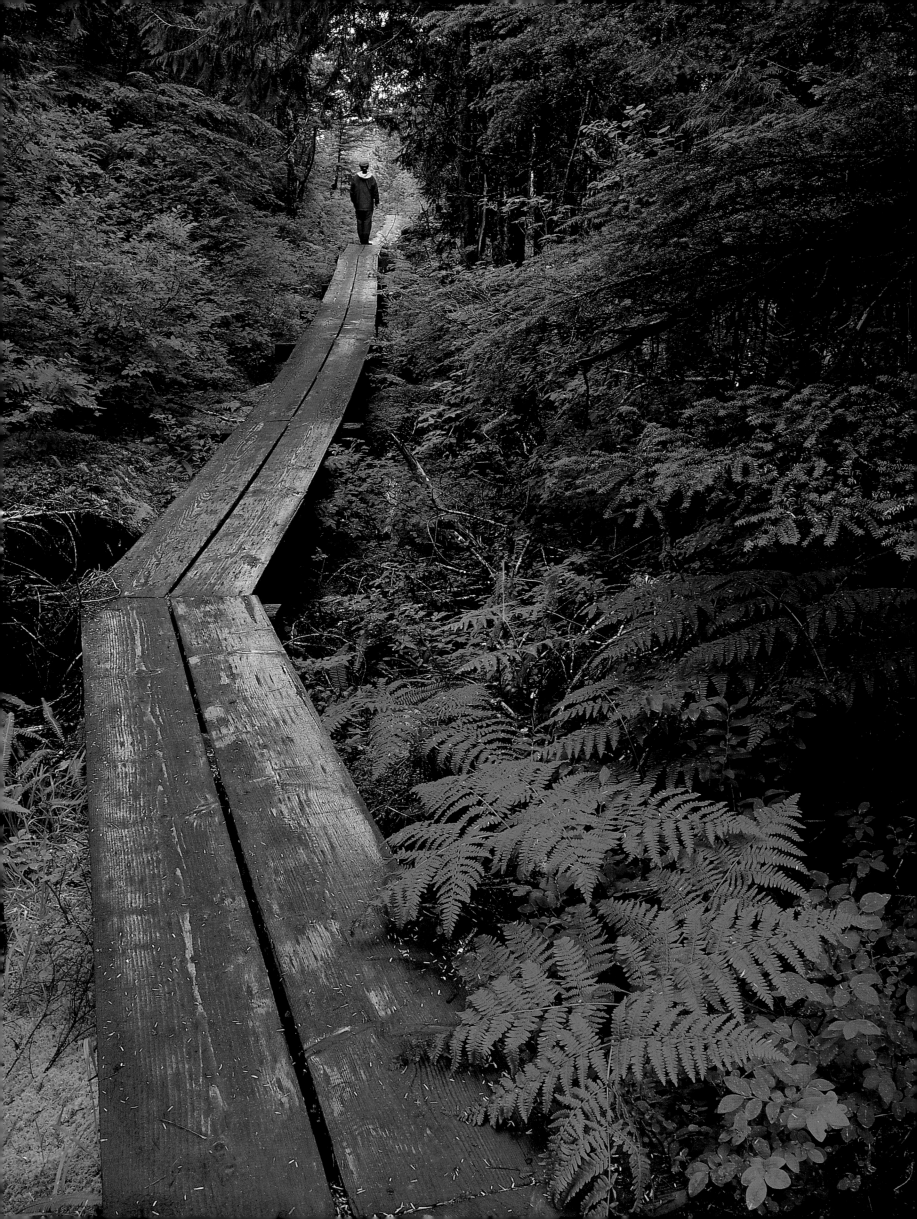

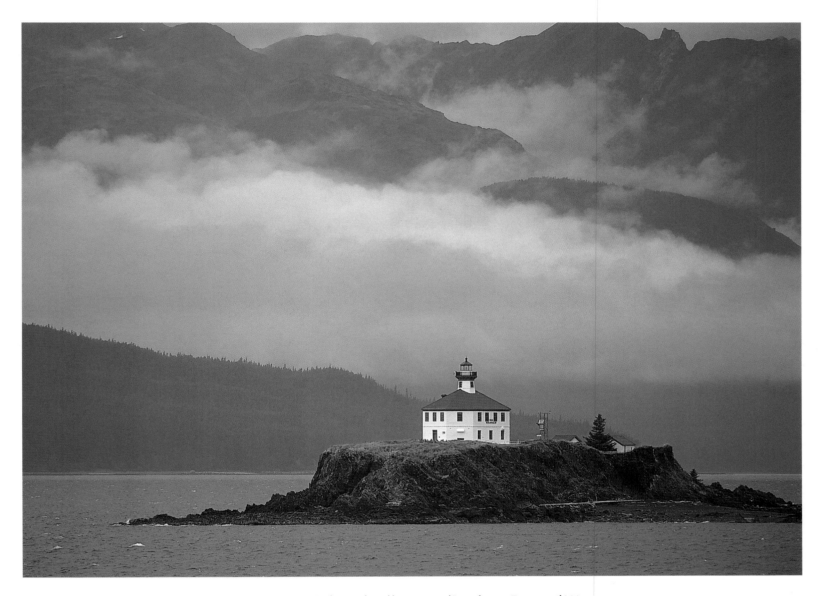

◁ A quiet, rustic boardwalk, extending from Baranof Warm
Springs to Baranof Lake, invites people into the forest. △ The
Eldred Rock Lighthouse, first lighted in 1906, stands a lonely
watch in the middle of Lynn Canal, between Juneau and Haines,
backdropped by the rugged Chilkat Range. ▷ Icebergs calved
from South Sawyer Glacier drift in Tracy Arm. Like many tide-
water glaciers in Southeast Alaska today, South Sawyer retreats
as its terminus calves ice faster than the glacier flows forward.

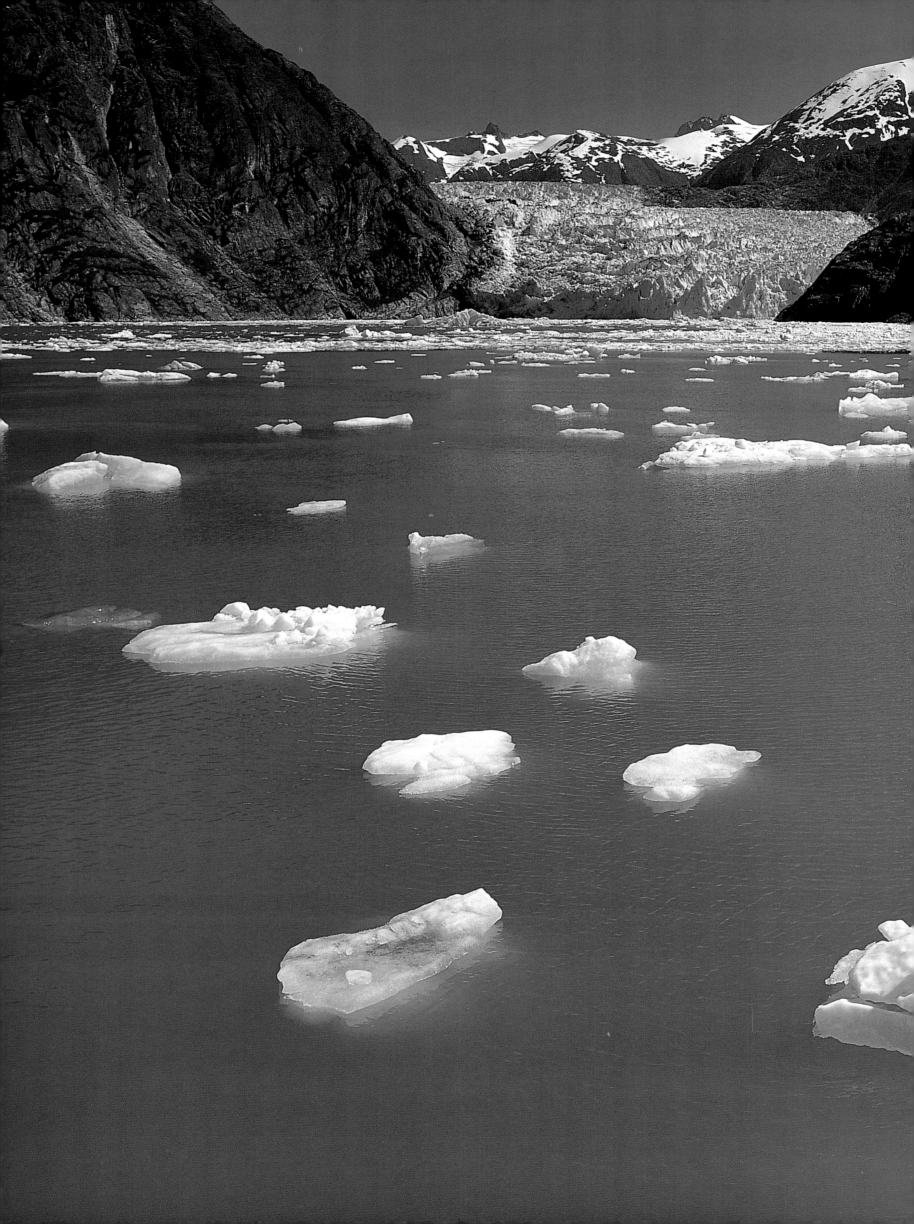

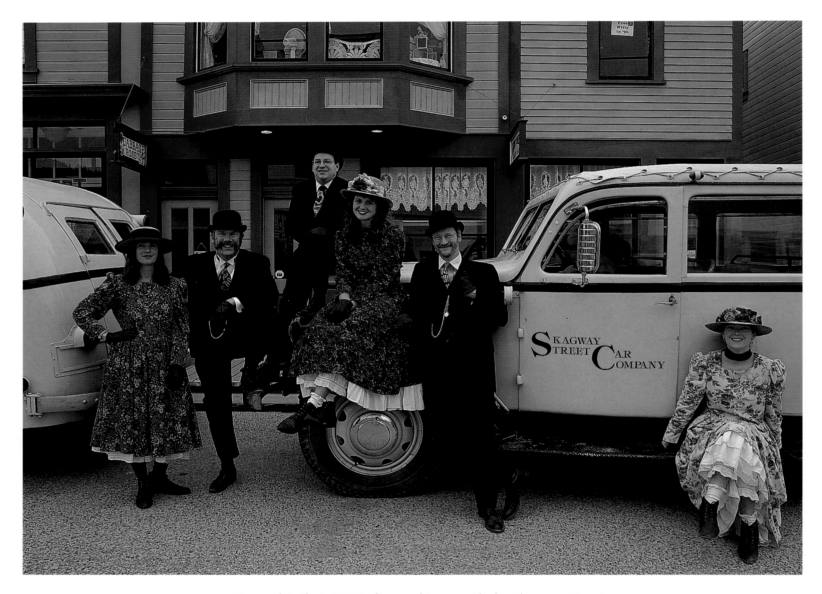

△ Dressed in their 1890s finery, drivers with the Skagway Street Car Company pose on downtown Skagway's Broadway Street, part of Klondike Goldrush National Historical Park. ▷ Give a glacier enough time and it will move mountains, as evidenced on the surface of Grand Canyon Glacier, near Skagway, where sediment and boulders of all sizes are excavated and carried downslope. ▷▷ Starfish cluster on shore near Sitka, where twice each day tides rise and fall as much as twelve feet.

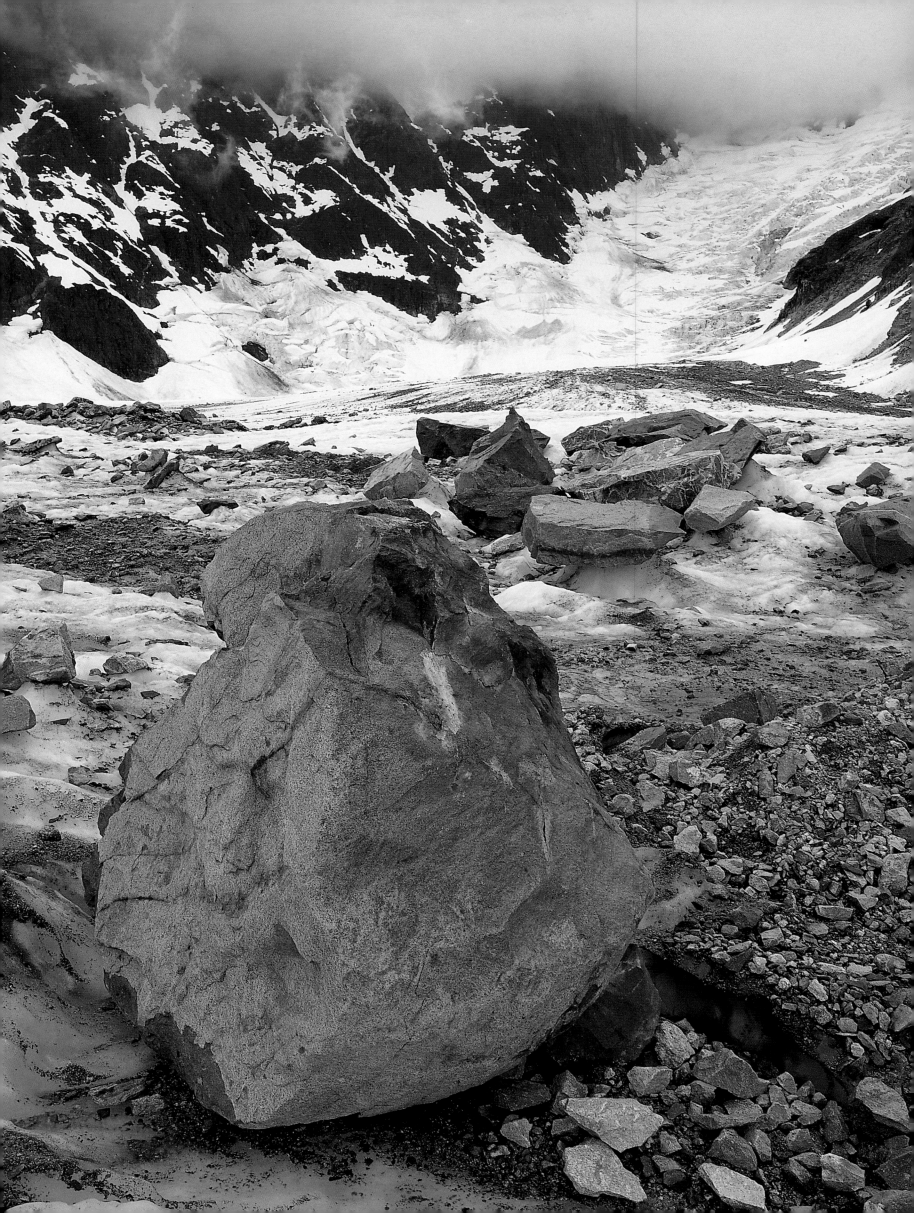

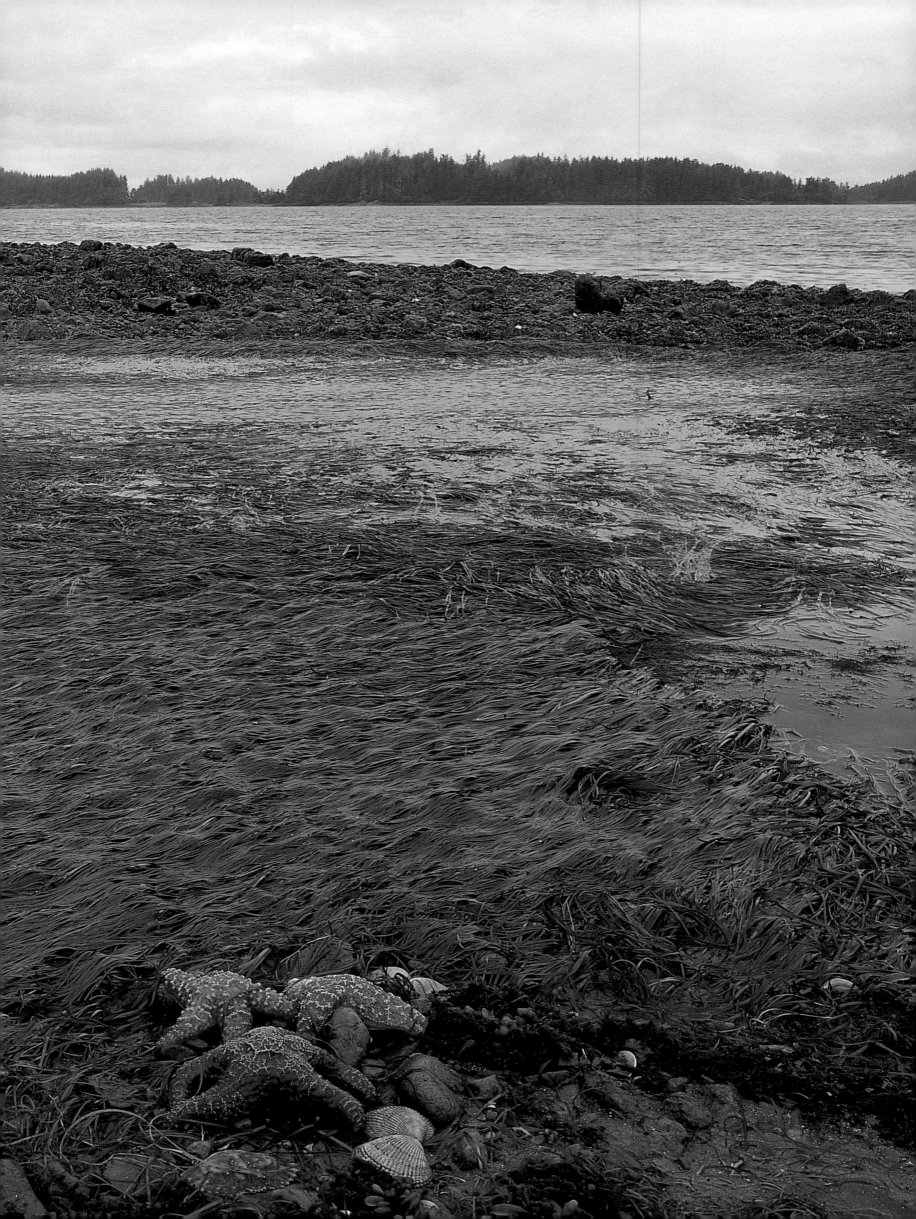

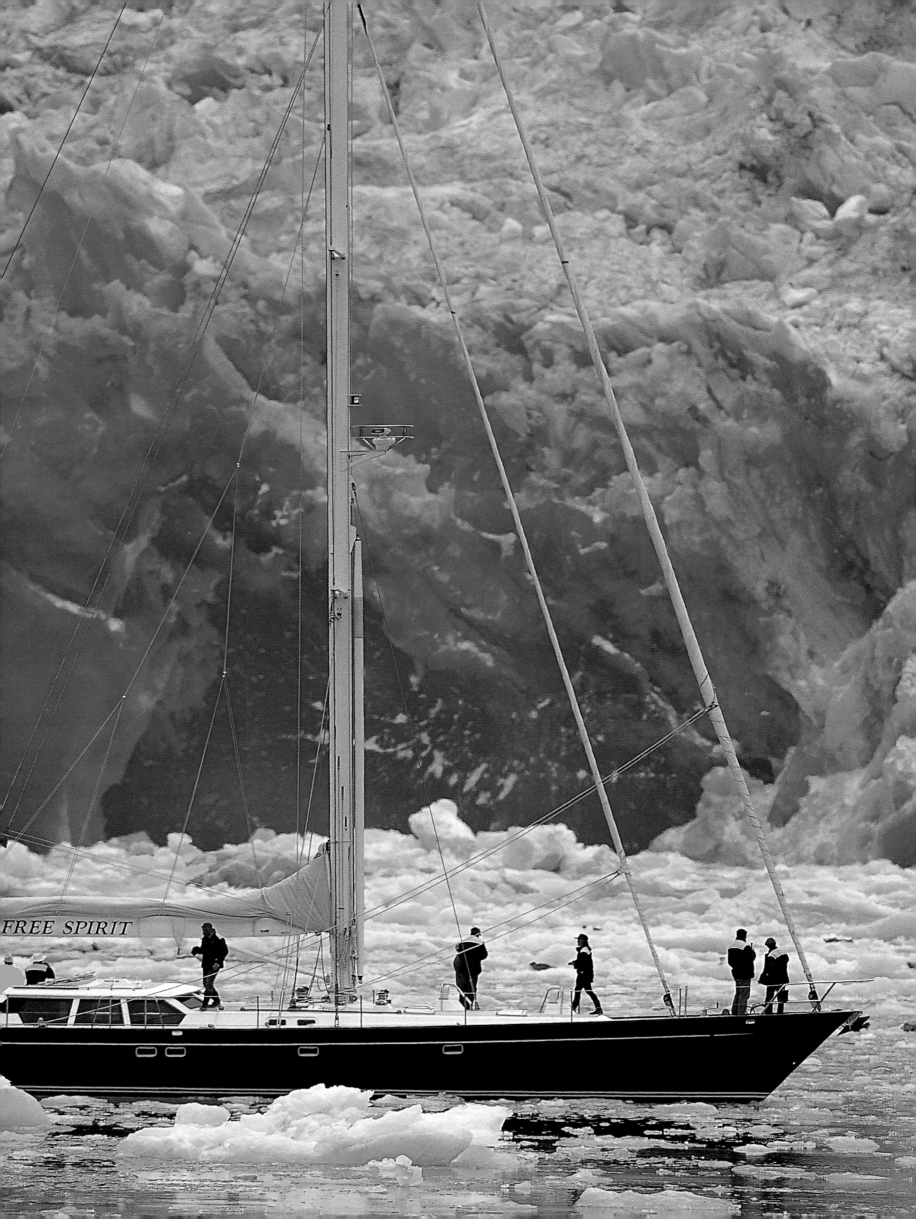

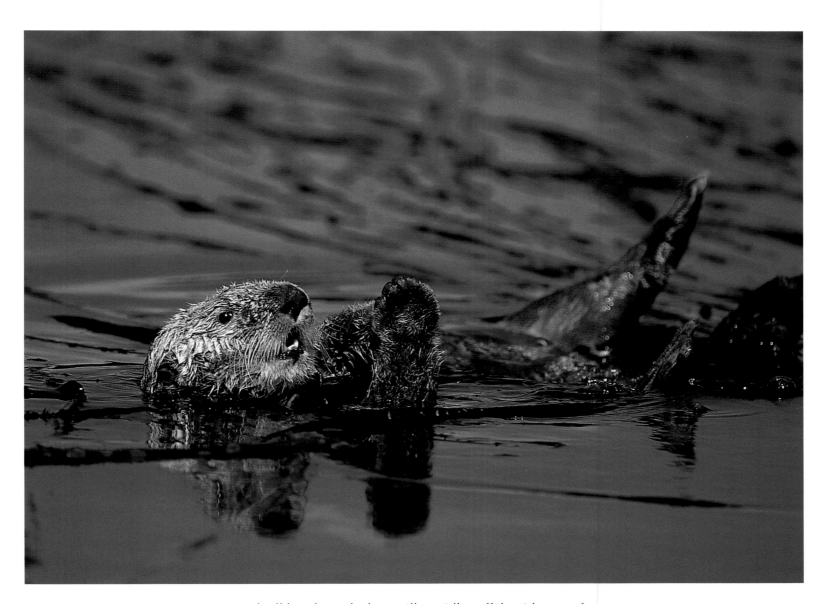

◁ With all hands on deck, a sailboat idles off the tidewater face of Tracy Arm's South Sawyer Glacier. As light hits dense glacial ice such as this, all colors of the visible spectrum are absorbed except blue, which is scattered and refracted. △ Back from the brink of extinction, a sea otter floats amid a bed of kelp. Once overhunted for their furs, sea otters today have made a comeback—with the assistance of wildlife biologists—and occupy a large percentage of their former coastal habitat. With knowledge and compassion, mankind is learning that places like Alaska's Inside Passage can remain wild and pristine.

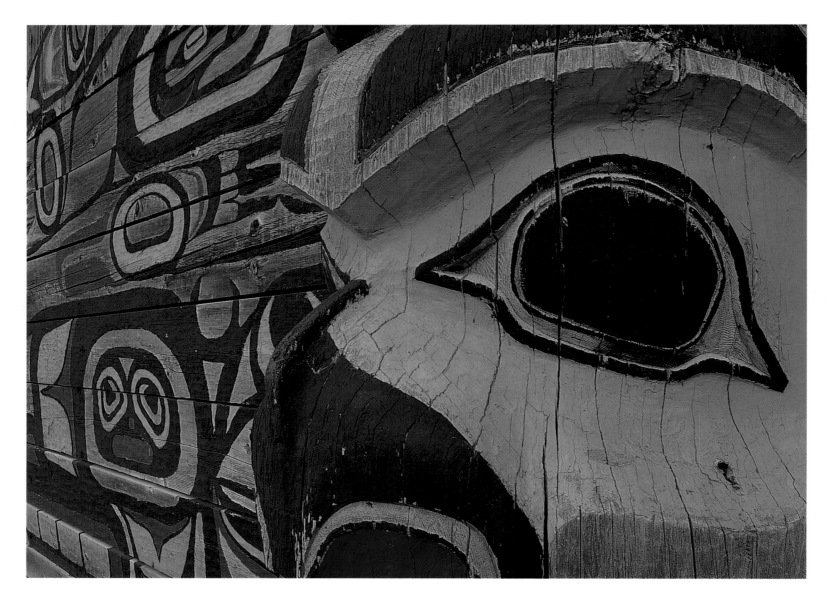

△ The bold obliques of Tlingit art can be seen at many places in Southeast Alaska, such as Raven's Fort in Haines. ▷ A feather lies in gentle repose amid red paintbrush. Other feathers and bones in the area testified that a bird met a violent end here, underscoring nature's laws of predator and prey, that life and death beget one another and form a circle unbroken.

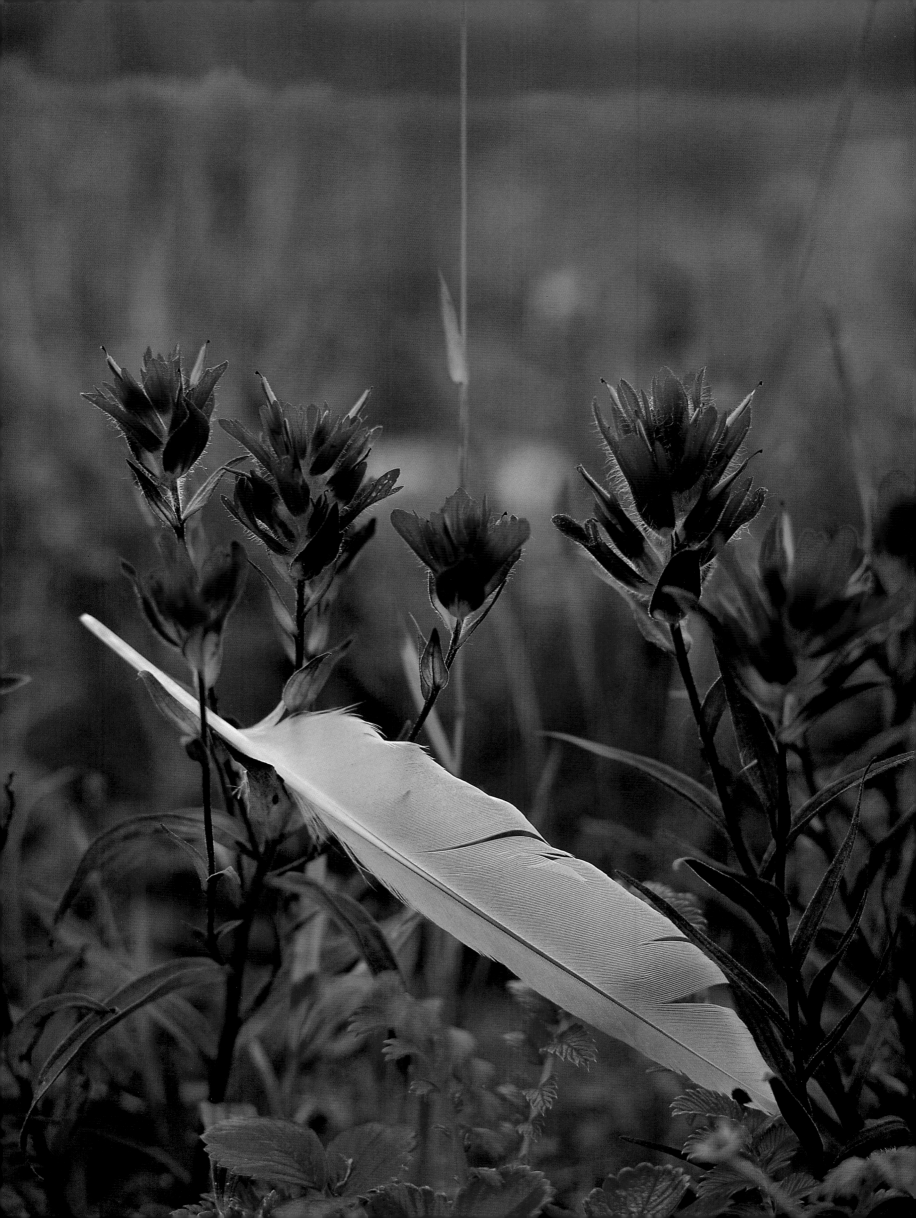

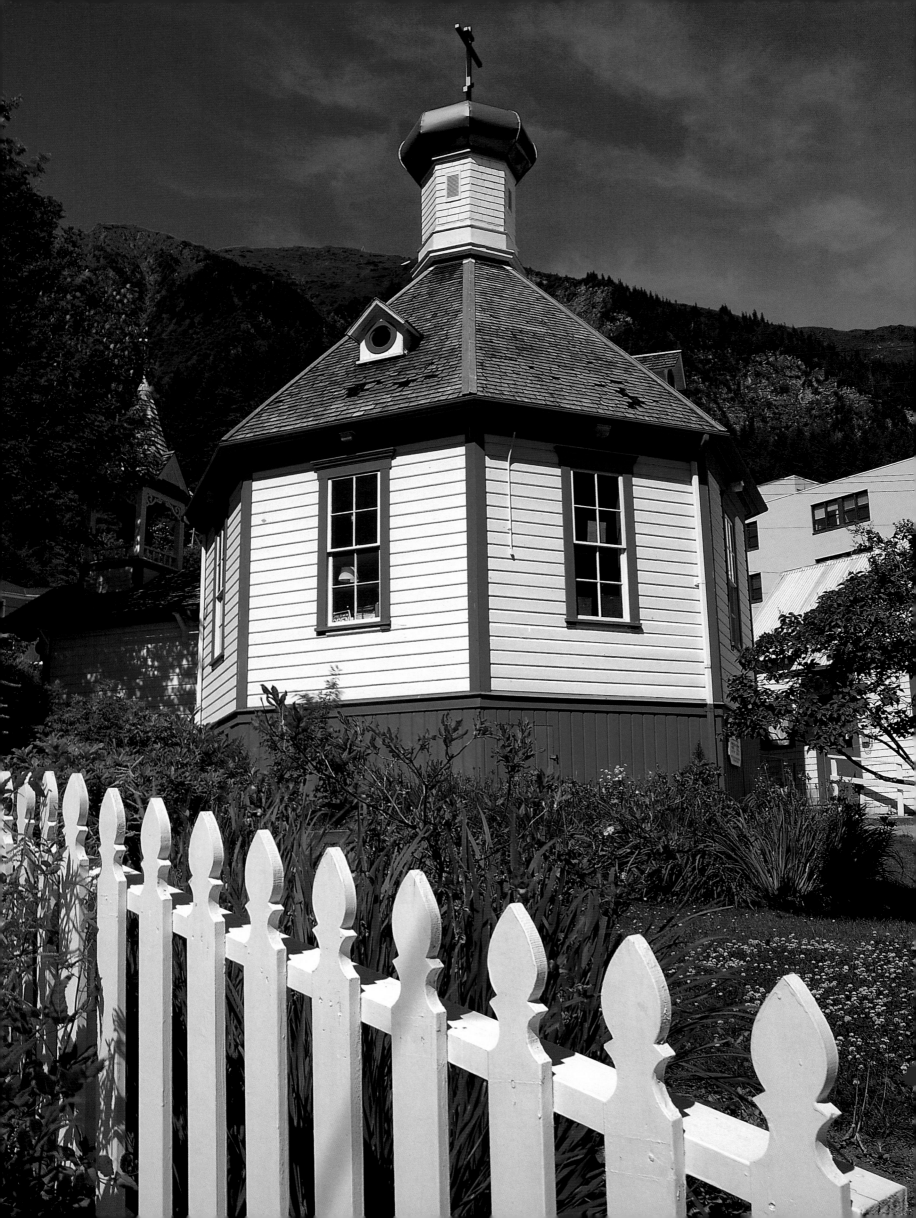

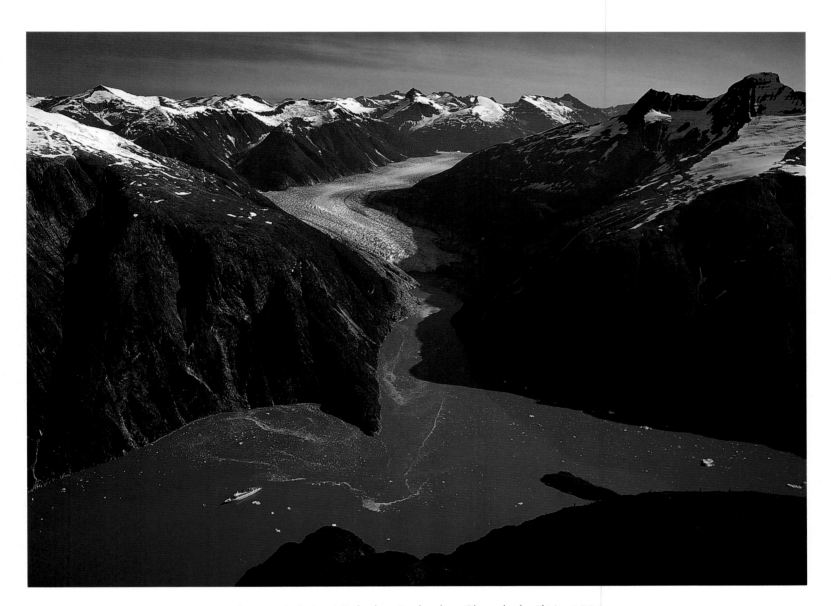

◁ Juneau's Saint Nicholas Orthodox Church, built in 1894, is the oldest original Russian church in Southeast Alaska. △ A cruise ship is dwarfed by the topography of Tracy Arm, a rock-ribbed fiord rising thousands of feet into alpine slopes, and fronted by North Sawyer Glacier. ▷▷ A meltwater stream courses over Taku Glacier, near Juneau. Glaciers in Alaska constantly thaw and refreeze as they flex and grind downslope.

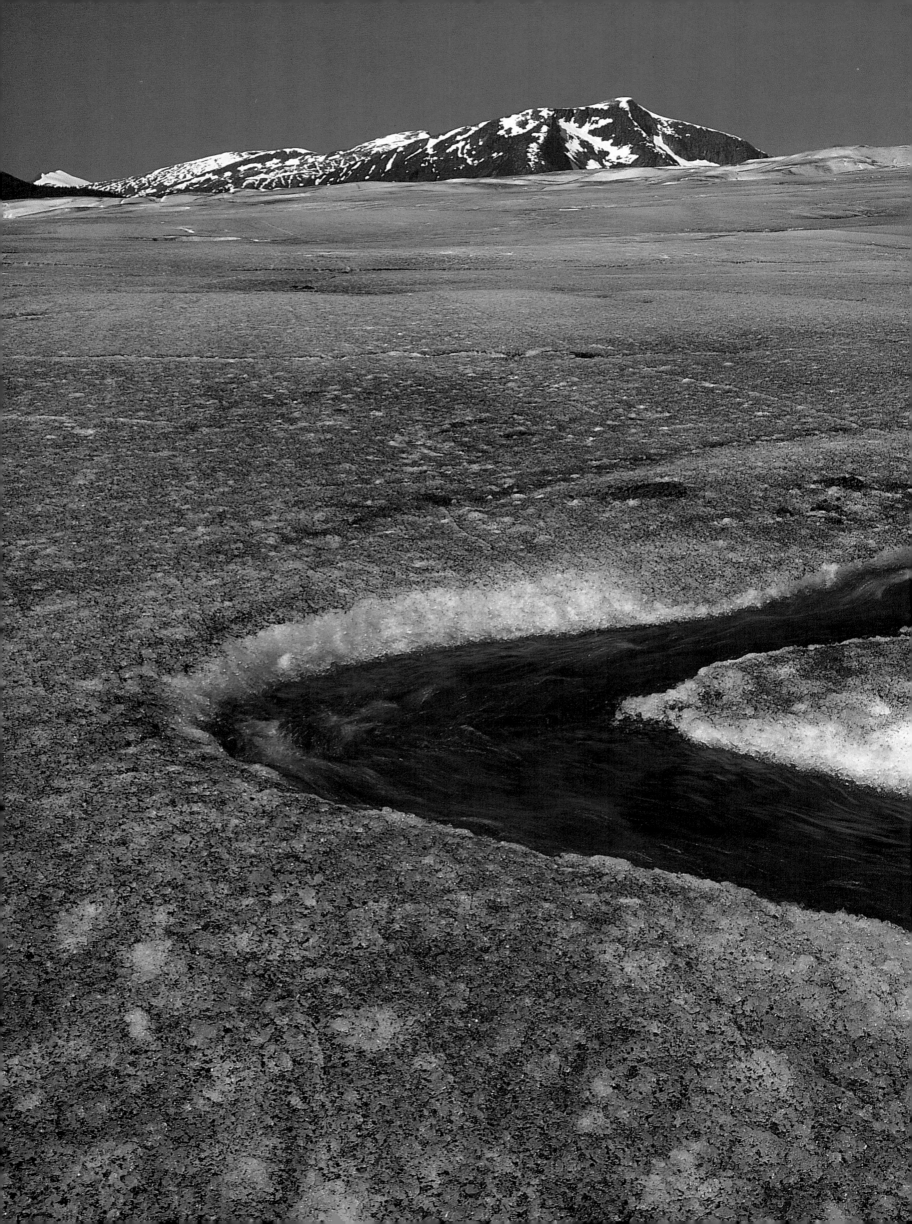

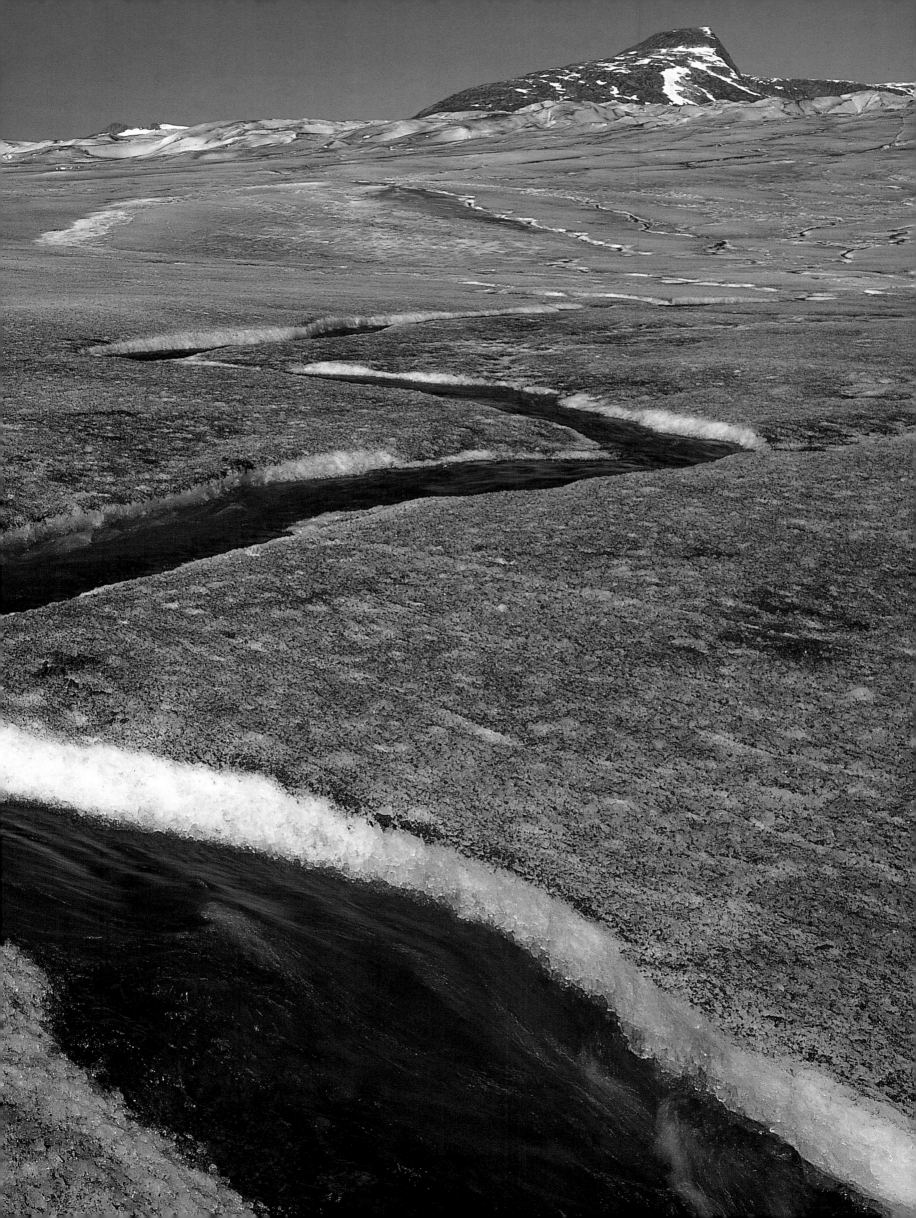

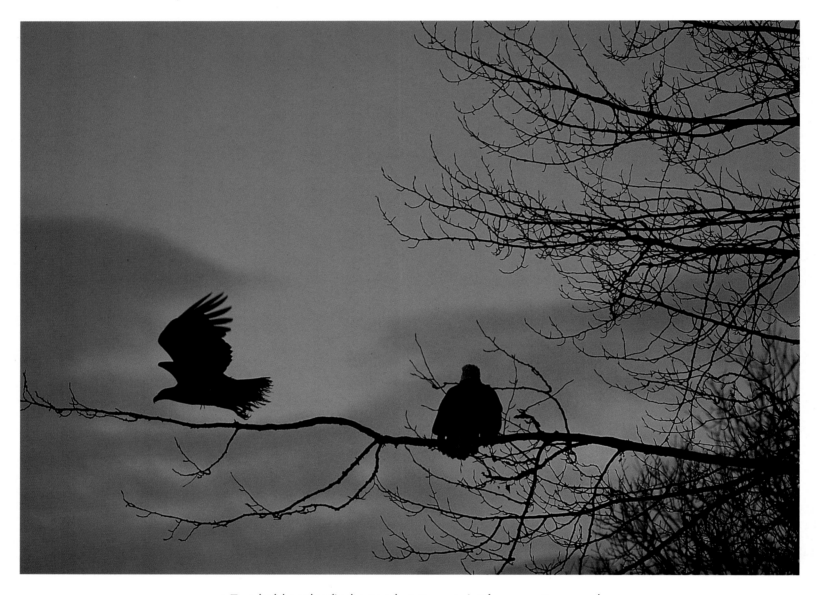

△ Two bald eagles find a good vantage point from a cottonwood limb above the Chilkat River, where numerous eagles have gathered to feast on a late autumn run of chum salmon. While some eagles spend the entire year in Alaska, others migrate in winter to the Pacific Northwest and Montana. ▷ In an ice cave beneath a remnant glacier, the author negotiates slippery terrain with an ice axe. Most tidewater glaciers in Southeast Alaska have retreated dramatically over the past couple hundred years.

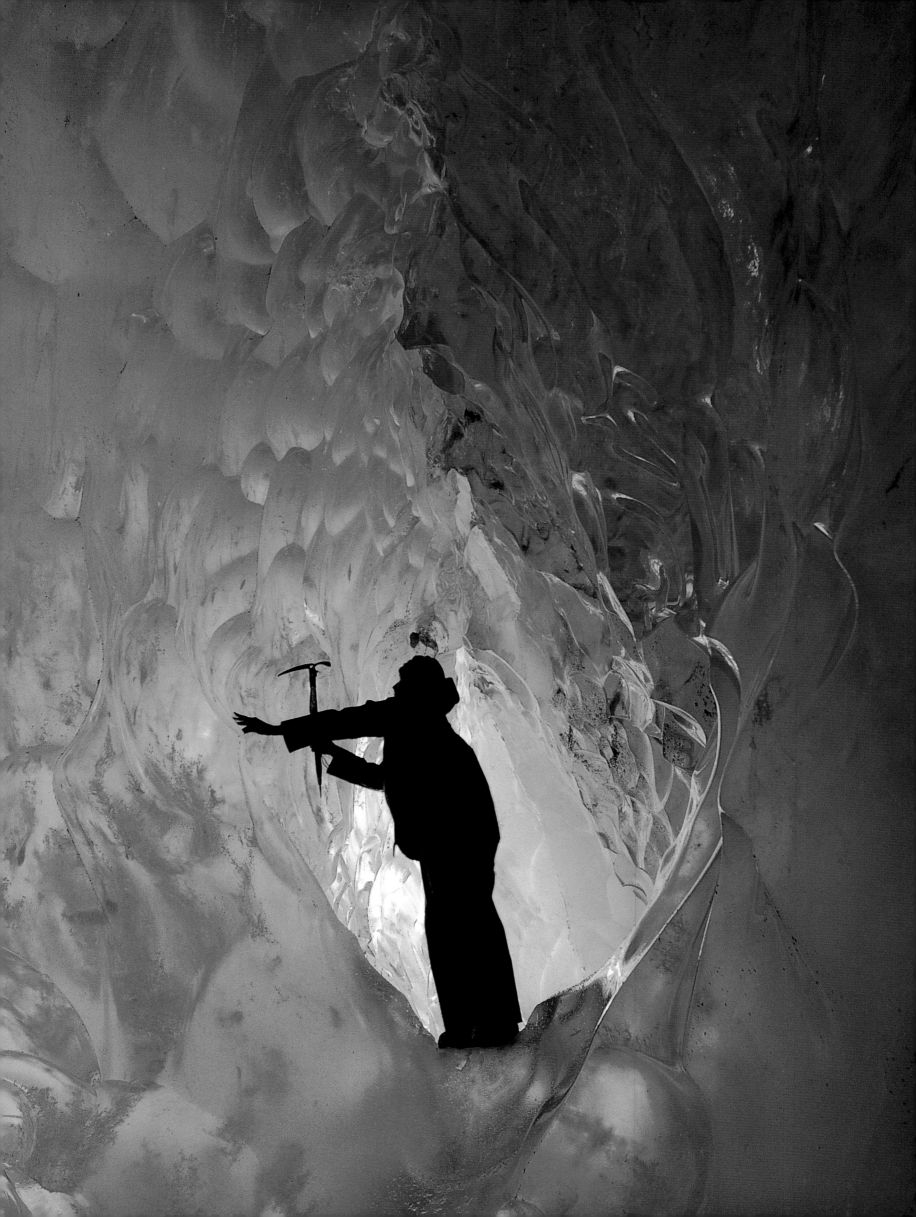

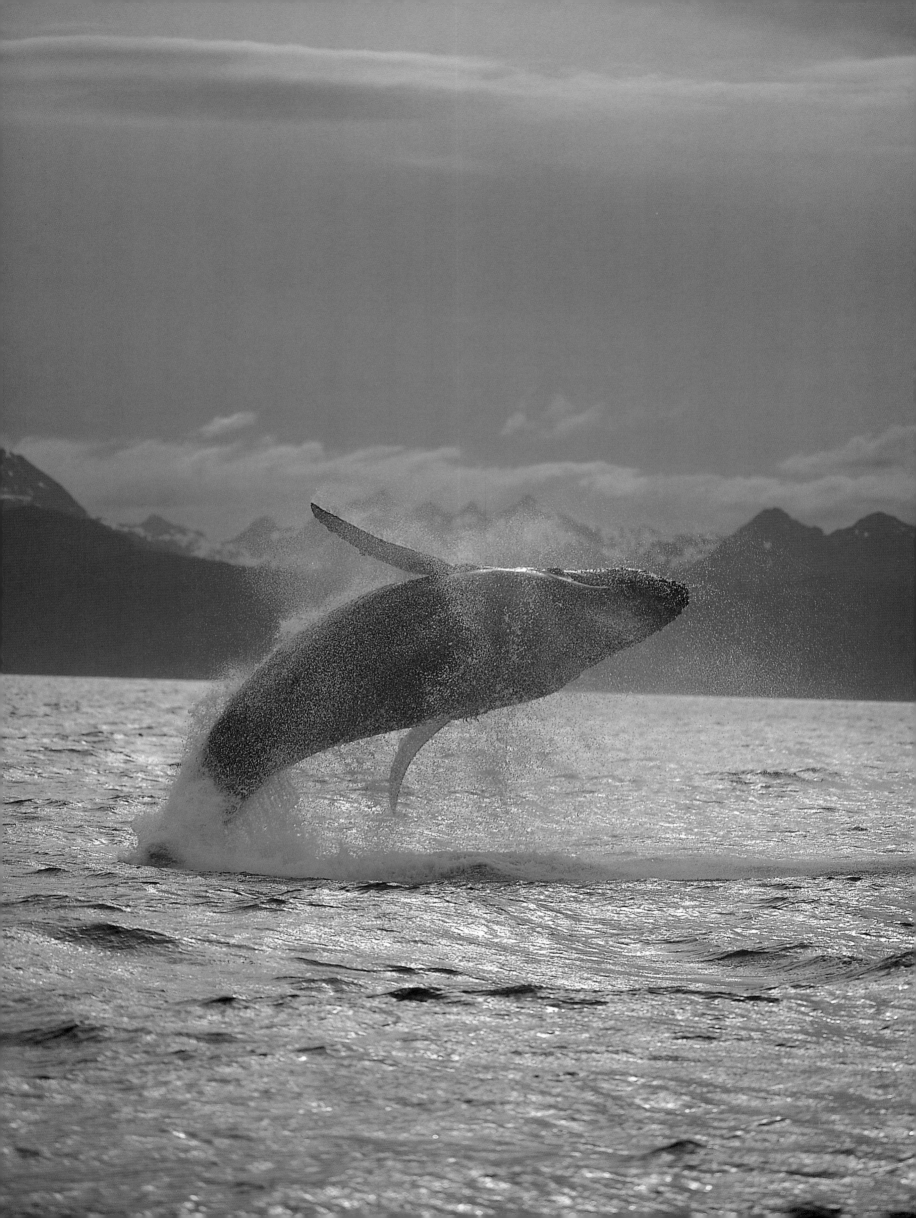

In the Company of Whales

This humpback whale is roughly forty feet long, weighs forty tons and is about forty years old. And right now is somewhere below our boat.

We wait.

She comes from Hawaii, where she was born, and where she typically spends her winters in Kalohi and 'Au'au channels, among the islands of Moloka'i, Lanai, and Maui. Every summer, however, she returns to the cold, nutrient-rich, fish-filled waters of Alaska's Inside Passage where, after fasting in Hawaii and traveling thousands of miles, she gorges herself on schooling fish—herring, sandlance, capelin—and on shrimplike krill.

Bubbles rise to the surface just off starboard. I look expectantly at my boatmates, Lynn Schooler and Michio Hoshino. "What's she doing down there?" I ask. Lynn shrugs and fingers the throttle, engine idling. Michio loads his camera.

We know she is a female and a mother, because she has a calf with her. We suspect she mated and gave birth in Hawaii, as do most North Pacific humpbacks. After an eleven-month pregnancy, she produced this single calf, which she will nurse another eleven months before weaning it and mating again. A successfully fertile female can give birth fifteen times, which is important since humpbacks, like most other whales worldwide, were devastated by eighteenth- and nineteenth-century commercial whalers. The North Pacific humpback population is roughly 2,000 animals: 10 percent of the pre-whaling numbers. The Southeast Alaska population is 300 to 350. Most head south for the winter, yet a few have been seen here year-round.

No bubbles now. The water is disquietly calm.

We call her *Megaptera novaeangliae,* Latin meaning "long-winged New Englander," for like any adult humpback she has fifteen-foot-long pectoral flippers that enable her to move agilely in shallow waters and feed near shore. She might have a common name as well—*Garfunkel, Tic-tac-toe, MacDuff*—given by cetalogists (scientists who study whales) because each humpback has a tail of distinctive shape and marking. Dated photographs of the tails (or "flukes") can be matched to other photographs of the same whale in other locations. In this way, we begin to map and understand the humpback whale ecology and life history.

The bubbles reappear in a ring directly off our bow. "She's bubble-netting," Lynn yells. "Get ready."

Michio stands with one camera in hand, another around his neck; one with a medium focal-length lens, the other a wide angle. I regard Michio as the finest nature photographer in Alaska, and so watch him and hope to learn from him. He grins at me and says, "This is a good whale."

"Really, Michio, how so?"

"All whales are good whales," he says.

Thirty feet below, the great leviathan rises, swimming in an upward spiral, pirouetting in her three-dimensional world. As she rises, she exhales bubbles that act as a net to entrap small fish overhead. The confused fish swim back and forth, concentrating as the net tightens around them.

We wait breathlessly.

Suddenly the whale explodes to the surface, mouth agape, barnacles visible on her jaw. The sea boils with small, jumping fish. I hear the motor drive on Michio's camera; he is shooting three frames per second. I, on the other hand, am too stunned to take a single photo; I stand on deck, frozen by the moment—witnessing a huge mammal swallow hundreds of small fish at once. She belongs to the rorqual family of baleen whales, meaning she has no teeth—unlike Melville's legendary sperm whale Moby Dick—but rather has pleats along her throat

◁ *A humpback whale breaches in lower Chatham strait. Roughly three hundred humpback whales spend at least part of their year, typically summer, in Alaska's Inside Passage.*

and belly that expand as she opens her mouth to intake large volumes of water. She then expels the water through her comb-like baleen (made of keratin, like human fingernails) and swallows the fish. Simple and efficient. She will eat a ton of fish a day.

Again and again the mother surfaces, lunge-feeding through her seafood buffet, her calf next to her, also feeding and, more important, learning. Lynn throttles back as he dances on deck with excitement, saying, "This is amazing. This is amazing." Michio reloads film with Olympian speed and dexterity. The whales spout with a percussive "WHOOSH," exhaling and inhaling through their blowholes at one hundred miles an hour. Mist hangs in the air. We smell their breath—not exactly parsley scented. They show their flukes and dive deep—we think.

But no sooner do we catch our breath than mother whale rockets from the sea in a full body breach, as magnificent as a Jules Verne invention, fifty meters to port. She slams down in a great splash as her calf mimics her. Again they breach, side by side. And again. Over the next couple of hours they repeat the spectacle dozens of times, mother and calf breaching, slapping their pectoral flippers on the surface, lobbing their tails. Sometimes together, sometimes alone. We wonder: what's going on here?

Are the whales communicating? Playing? Trying to dislodge barnacles off their skin? Trying to stun nearby fish? Are we disturbing them?

These are questions that have been asked countless times before; the answers are still inconclusive. Nobody knows.

Lynn kills the engine.

Whales are no doubt sensitive to underwater noise; it is their world, after all, where they find each other, and their prey, by sonar and echolocation. It has been postulated that by bouncing sonar off other whales' vital organs, the densities and physiologies of which vary with temperament (and probably health), whales can determine the moods of their kin, much as we do with facial expressions.

Humpbacks in Glacier Bay have been observed breaching at the precise moment a tour boat, many miles away, starts its diesel engines. Yet whales have also been observed feeding in Bartlett Cove, at park headquarters, where the greatest number of vessels concentrate. Prevailing wisdom—if there is such a thing—says if food is abundant, whales will stay and feed regardless of human vessel traffic.

Lynn agrees but adds, "It's not our right to test their tolerance. After what we've done to whales around the world, they deserve the benefit of the doubt."

So we drift, leaving mother and calf in silence. They continue their antics for another half hour, then swim north up Chatham Strait, between Admiralty and Baranof Islands.

All these years later I can still see them, hear them, smell them, feel the freedom of the sea between them, and beneath us.

We laughed a lot on that trip—Lynn, Michio, and I—set free by ten days of wildness, friendship, and discovery. I never imagined Michio would die too soon, four years later at only forty-three, killed by a rogue brown bear in Russia's Kamchatka Peninsula. Lynn did not imagine it either. Had we known it would happen, we might never have let Michio go. But that would have killed him too. He loved bears as much as he did whales: all bears were good bears. The fact that one killed Michio Hoshino, wrote Fairbanks writer Sherry Simpson, "seems both a betrayal and a benediction."

I was lucky. I knew him—not well, but well enough. Our friendship grew in the best of circumstances: in the company of whales.

▷ A troller glides
through Olga Strait
during a salmon open-
ing on the west side of
Baranof Island. Alaska
accounts for 95 percent
of U.S. commercially
caught salmon.

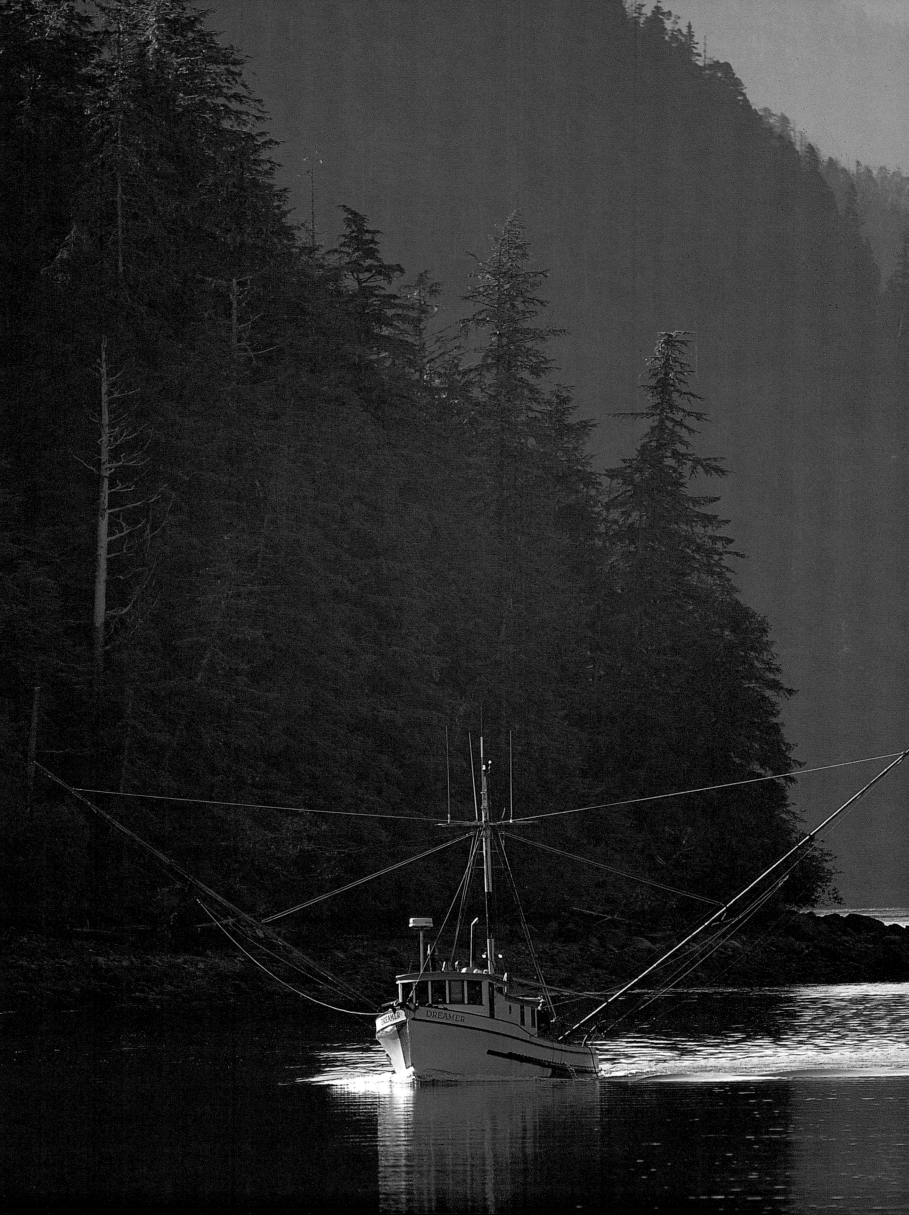

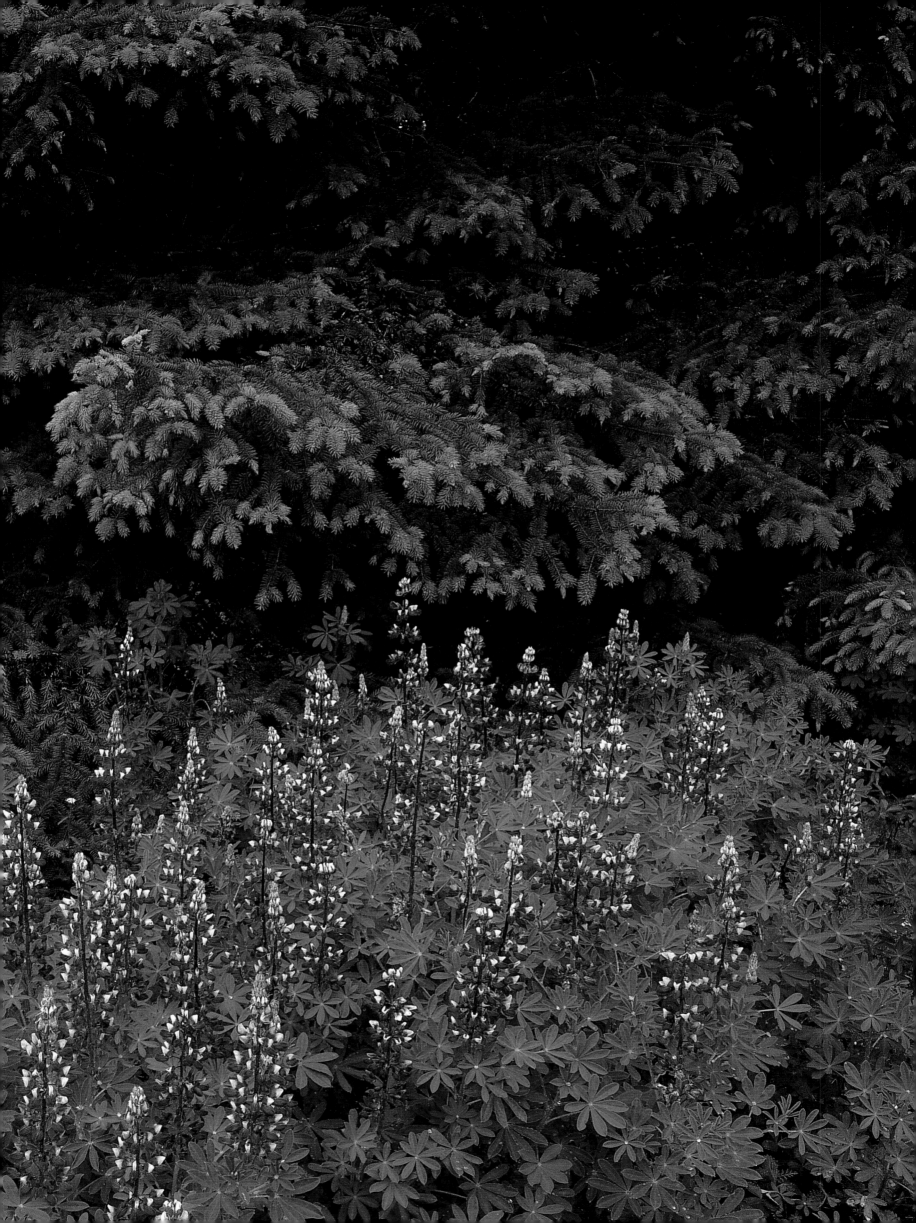

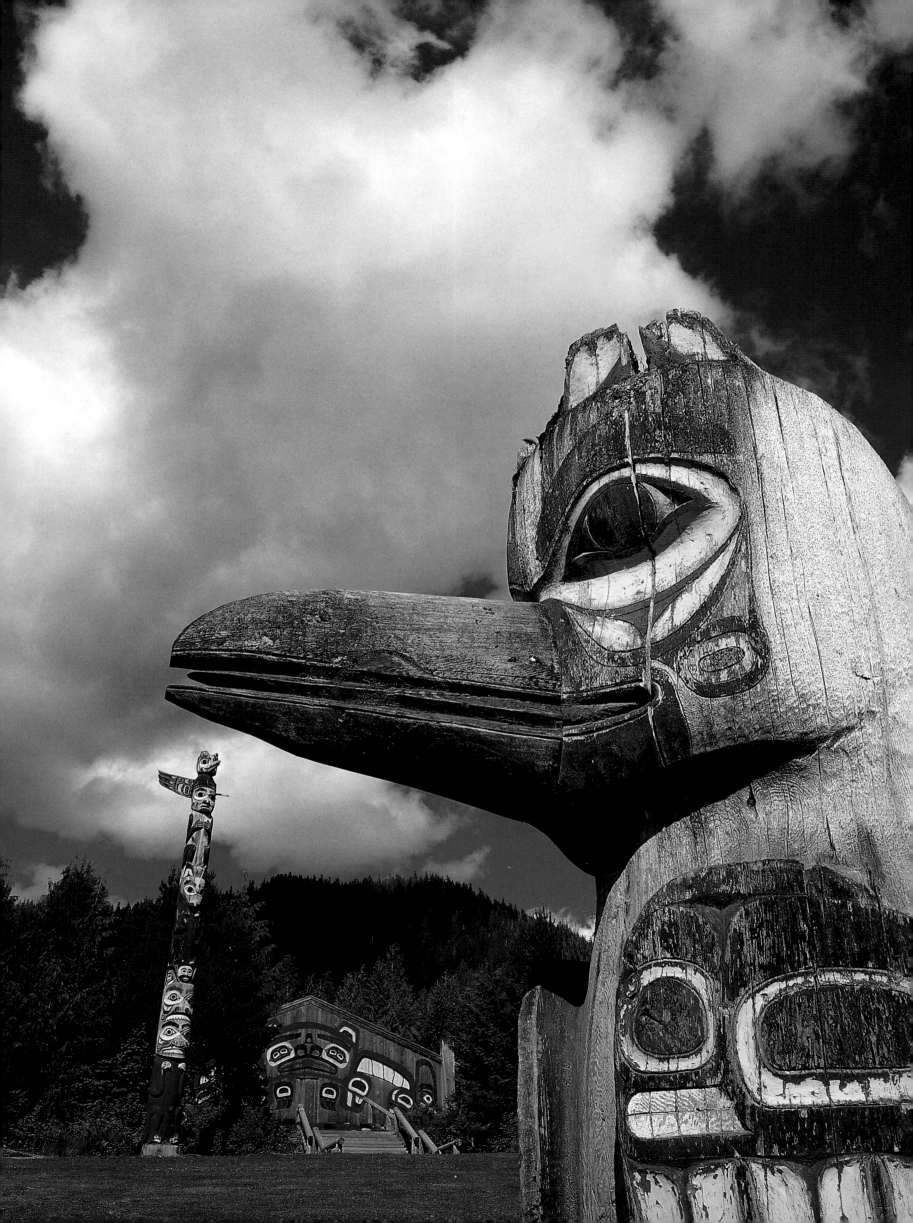

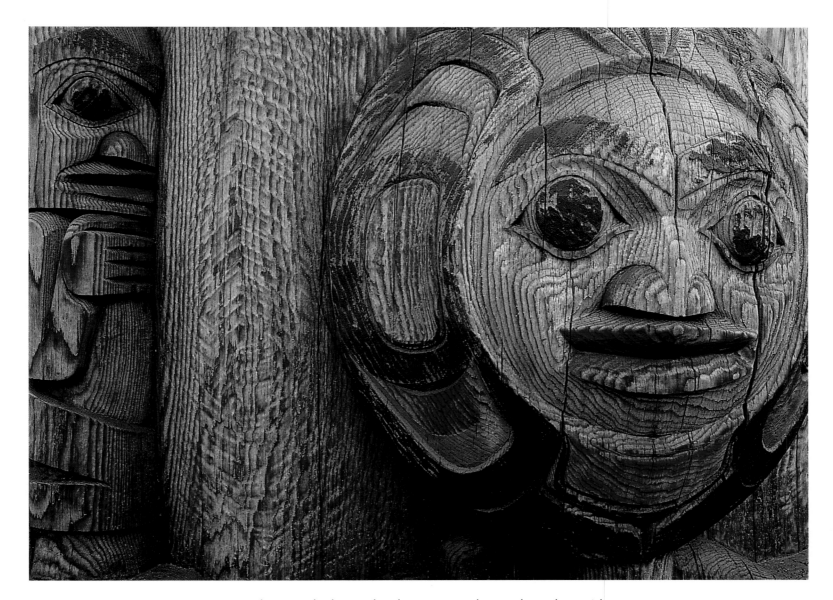

◁ ◁ Blue Nootka lupine brightens many shores along the Inside Passage. An important pioneering species, lupine adds nitrogen to the soil, making it inviting for colonization by willow, alder, spruce, and hemlock. ◁ △ Totem poles capture a rich Native heritage in Alaska. While many were (and still are) fashioned as "story poles" to aid the memories of storytellers, none were the religious objects early white explorers thought them to be.

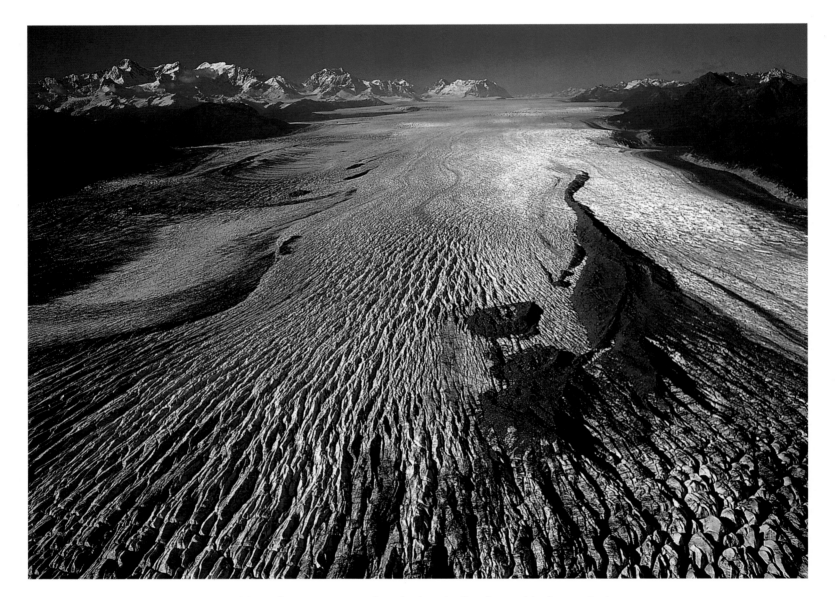

△ More than seventy major glaciers in Southeast Alaska remind us that this entire region lay entombed beneath great sheets of ice for many thousands of years. ▷ Winter offers cold mornings and frosty wild strawberry leaves. In Southeast Alaska, autumn, like any season, can be brutally wet and windy, yet winter can be cold and clear, with crisp, short days when bird calls carry with remarkable clarity over still water.

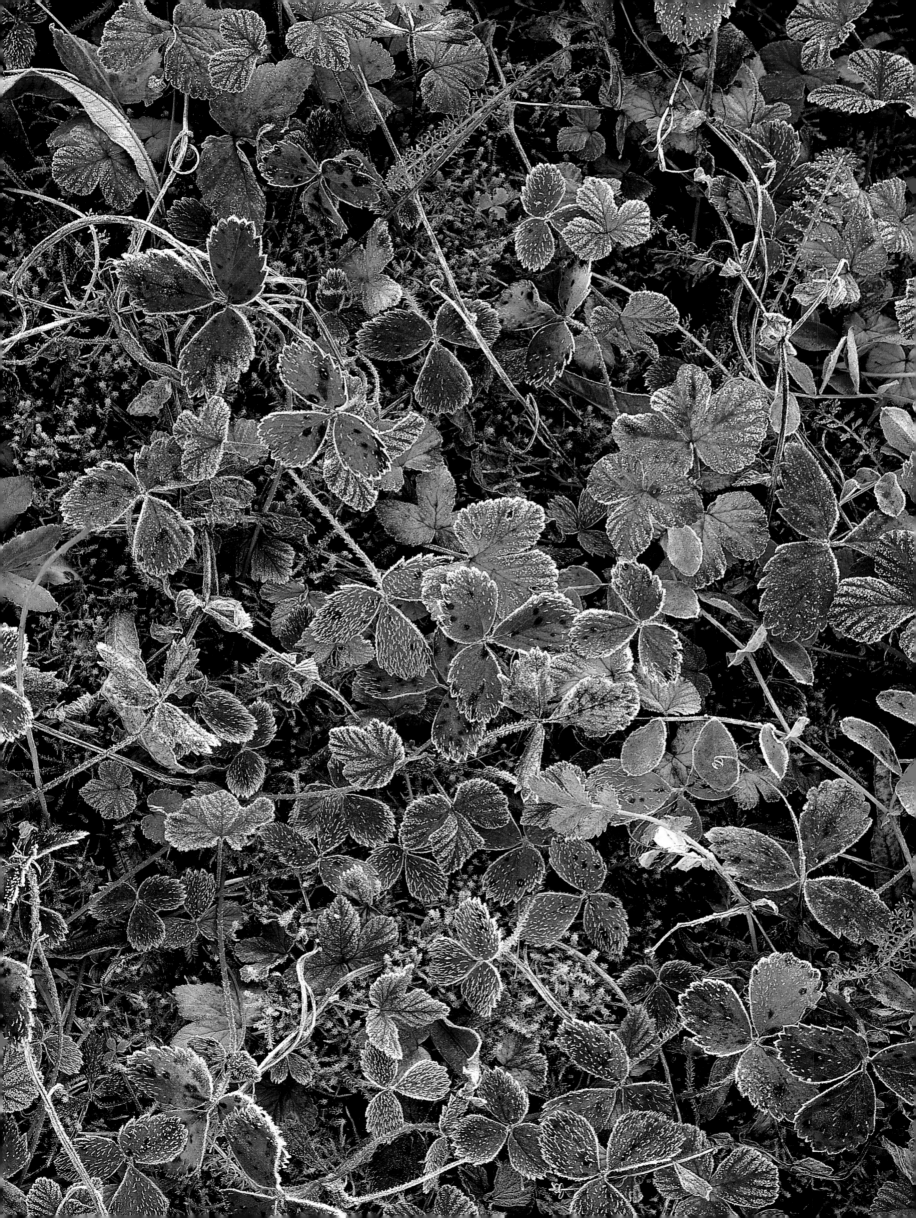

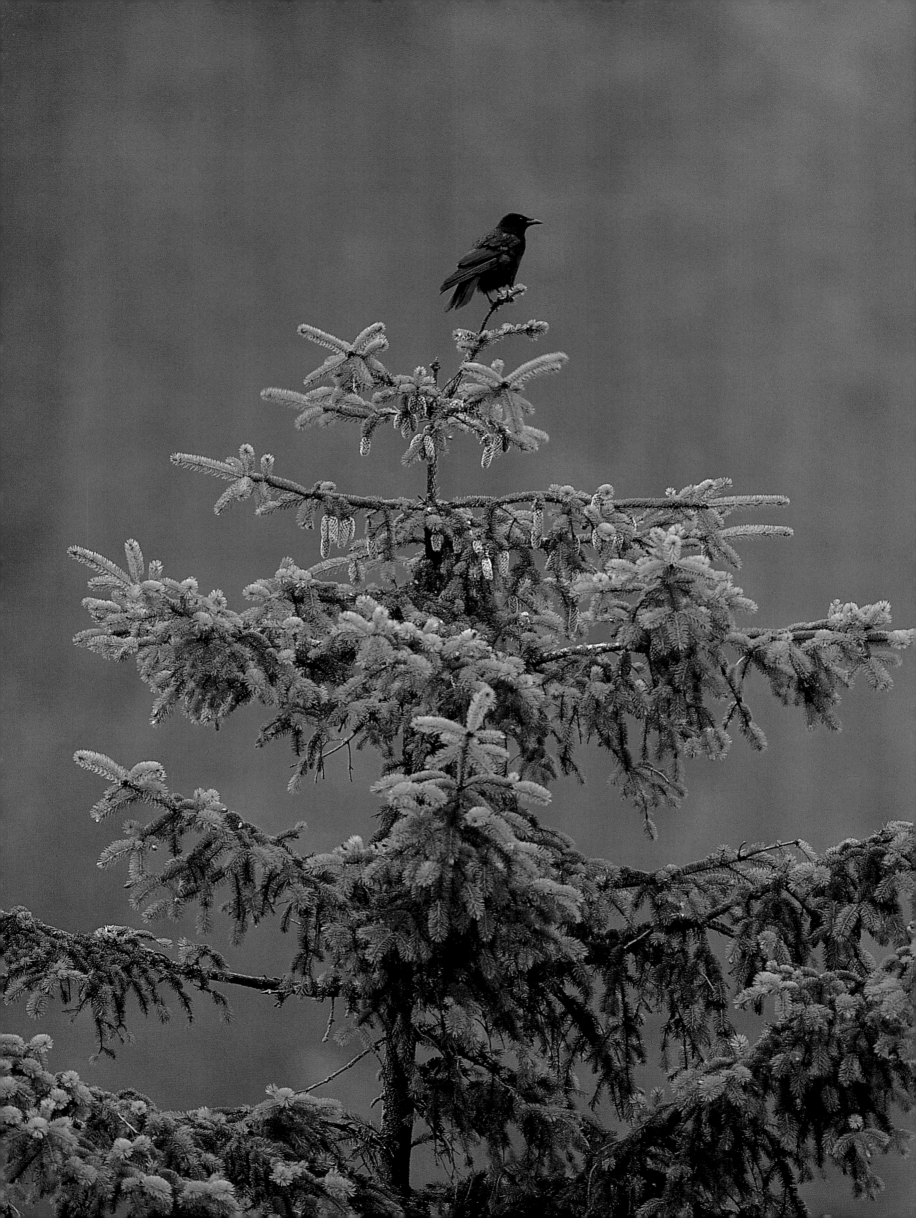

Eagle and Raven

They mate for life, and in courtship lock talons in midair and fall through the sky, spiraling down, down, down, calling in dialects of mischief and love. They fly on thundering wings and acknowledge the world with inscrutable eyes. One dresses in noble white, the other in trickster black. One has a spiral dagger beak, the other a lethal broadsword. Both are highly intelligent. They are eagle and raven, two signatory birds, each a confirmation of wildness, freedom, and strength, for without either the land and sea of Southeast Alaska would be much less.

It has been this way for a long time.

Tlingits and Haidas—the Natives of Southeast Alaska—are each born into one of the two great moieties, or tribal subdivisions: Eagle or Raven. This social system is venerated and matrilineal, requiring that each newborn child assume the moiety of his or her mother, but marry into the opposite moiety. Each set of parents, therefore, contains one Eagle and one Raven.

Long ago these great moieties branched into kinship clans, house groups, and kwans, some defined by totems, others by geography. While these Tlingit and Haida social lines might be less distinct today, the moieties, like the wild eagles and ravens themselves, remain paramount. They more than endure, they prosper.

Southeast Alaska contains an estimated ten thousand adult bald eagles, plus perhaps five thousand immatures—the strongest population in the country. Along some shores, such as Admiralty Island, their nests occur about every 1.2 miles. They congregate on the Stikine River each spring to eat spawning eulachon, a small oily fish, but their greatest gathering is along the Chilkat River, near Haines, in November and December, when a late run of chum salmon attracts as many as thirty-five hundred. They gather on river bars and perch in cottonwoods, three to a limb, ten to a tree, as autumn snows whiten their shoulders. It is one of the greatest wildlife spectacles in North America, and the people of Haines welcome the eagles with an annual festival.

Times were not always so good, however. From 1917 to 1953 Alaska's territorial legislature placed a bounty on eagles: fifty cents per bird, later raised to two dollars—good money for an enterprising sharpshooter. "The purest of all rifle sports," gushed the National Rifle Association. Eagles were considered vermin that preyed on spawning salmon and on young foxes raised on fox farms, and so deserved culling. The final tally was an estimated 128,000 bald eagles shot and killed.

In truth, eagles primarily feed on herring and smelt, and scavenge dying salmon that have already spawned. When there is no fish, they prey on small birds and mammals. Only when desperately hungry might an eagle attack a fox. But wildlife biology and ecology were infant sciences back then. Nobody fully understood the life history of the American bald eagle, a bird Ben Franklin called of "questionable moral character." He wanted the wild turkey to be named the national symbol of the United States.

Today, under the Bald Eagle Protection Act, it is illegal to kill or possess any part of an eagle; repeat offenders can be fined up to $10,000 and jailed for two years. It is also illegal to tamper with nesting sites. Rather than build anew each year, a breeding pair of eagles will add sticks and moss to a previous nest until it reaches enormous proportions: up to eight feet across and seven feet deep. It takes a mighty tree to cradle such a castle: typically a four-hundred-year-old Sitka spruce or western hemlock, 3.5 feet in diameter, and within 220 meters of shore. Hence the importance of the old-growth forests to the American bald

◁ *A northwestern crow, smaller cousin to the raven—bird of myth, legend, humor, and intelligence—perches in a Sitka spruce, unperturbed by the rain.*

eagle, and the tragedy of clearcutting these forests, especially near shore where eagles fish.

The bald eagle is in fact not bald, but instead has a regal white head that comes from the Middle English *balde,* meaning "white." Young eagles have dark heads and tails (and are sometimes mistaken for golden eagles). As they mature, their heads and tails lighten until at three or four years they turn pure white, denoting sexual maturity. Eagles court in March and lay their eggs in April. The chicks hatch in June and fledge in August. Though two or three eggs might be laid, odds are only one chick—called an eaglet—will survive.

The U.S. Fish & Wildlife Service estimates there are as many bald eagles in Southeast Alaska today as before the arrival of white men—a great success story considering the bald eagle was on the endangered species list (and remains on the threatened list) in the Lower 48 states for many decades, due in large part to shootings, poisonings, and habitat loss. Eagles do not thrive amidst human development; they cannot nest or feed in a parking lot or a shopping mall.

But don't tell that to ravens. They perch on floodlights, shopping carts, and pickup trucks (preferring Fords). They hop over pavement and eat bakery scraps (donuts, old-fashioned). They squawk indignantly as if they own the place, wherever it might be: the local shopping market, the fishing dock, the baseball diamond, the town dump. Not to be mistaken for the ubiquitous northwestern crows which measure seventeen inches long and call with a raucous "caw, caw, caw, caw, caw," ravens are twenty-four inches and have a full repertoire of calls. From a throaty "kla-wock, kla-wock," to an abbreviated "klok, klok, klok," to a resonating "goink, goink, goink" (like water dripping into a cistern) ravens unabashedly exercise their alto, contralto, profundo vocals. Mimic

them, or try, and they cast an obsidian eye onto your foolish antics.

"The raven turns and flies along the shore," writes Richard Nelson in his acclaimed book, *The Island Within.* "As his silhouette grows larger, I notice an odd shape clamped in his beak: grapefruit-sized, slightly flattened, and bristling with spines—a purple sea urchin. He must have found it among the rocks or stolen it from an otter. Why would he try to carry such a load, rather than peck it open on the rocks? Where is he going?" Where indeed. And why? In the muskeg behind the forest is a pile of old urchin shells, some broken, some nearly whole. Did an otter or mink leave them there, or did raven?

No animal in Alaska is imbued with greater mystery and mythology than is the raven. Robert Armstrong writes in *The Nature of Southeast Alaska* that, "The Tlingit and other original peoples of the Northwest Coast recognize the deep intelligence and profound ecological importance of ravens and their smaller relatives the crows, magpies, and jays. The Native sense of humor and sophisticated mythology accord Raven a sort of hobo's dignity. He is a creature to be reckoned with—the world is Raven's playroom, and every other creature is Raven's toy. . . . He uproots mountaineers' snow caches on the ice field, drops from mossy hemlocks onto deer hunters' leavings, surveys for roadkills and big Macs from power lines, and strides confidently down the sidewalk."

It was Raven who stole the water from Petrel and created the salmon streams of Southeast Alaska, including the great rivers: Stikine, Taku, Chilkat, and Alsek. It was Scamp Raven, the trickster, who made the earth from mud, then stole the sun, moon, and stars to give it light. And together with Eagle, it is Raven who speaks of lineage, home, and spirit; who flies on thundering wings and gives dimension to the world.

▷ *Hikers descend the Mount Jumbo Trail on Douglas Island, above Gastineau Channel. Dozens of trails and backcountry cabins make outings inviting in Southeast Alaska.*

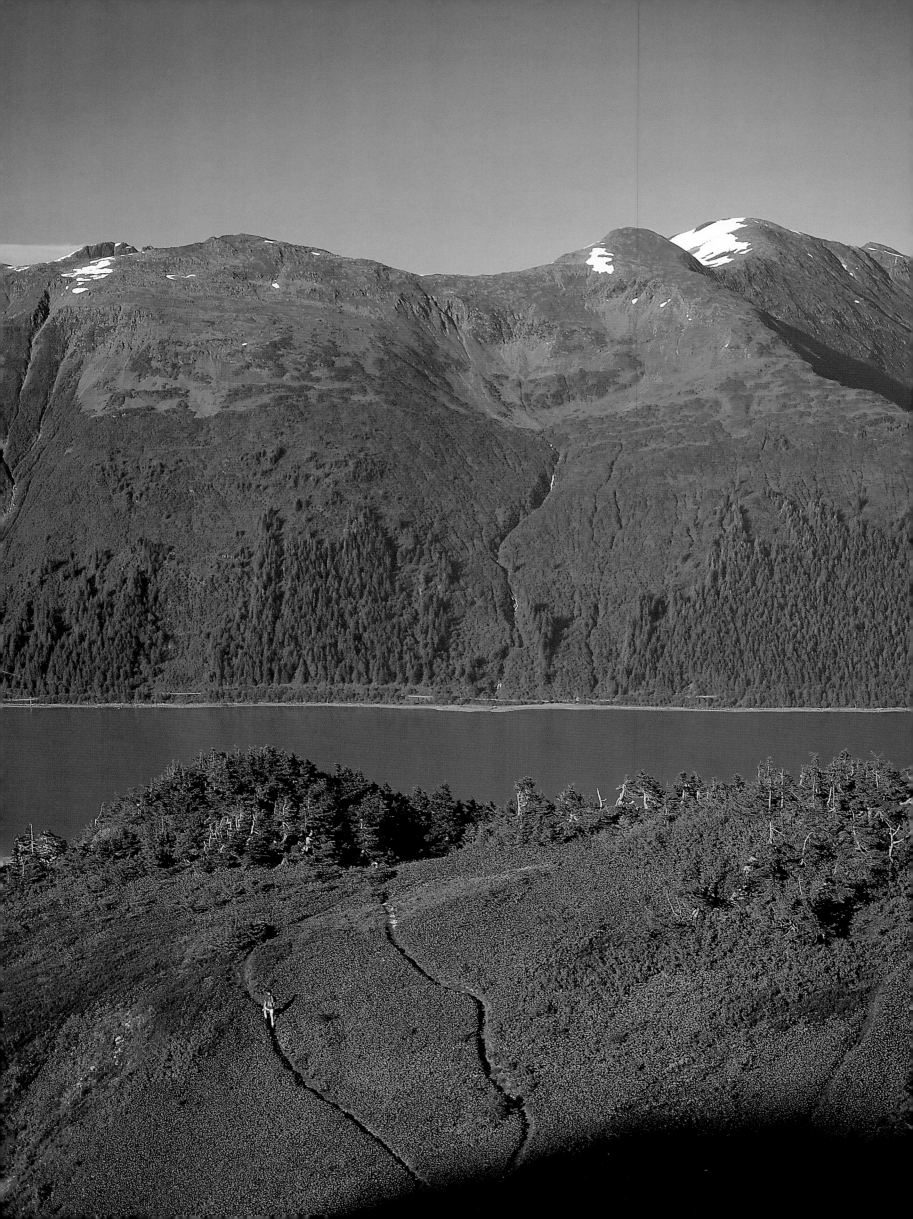

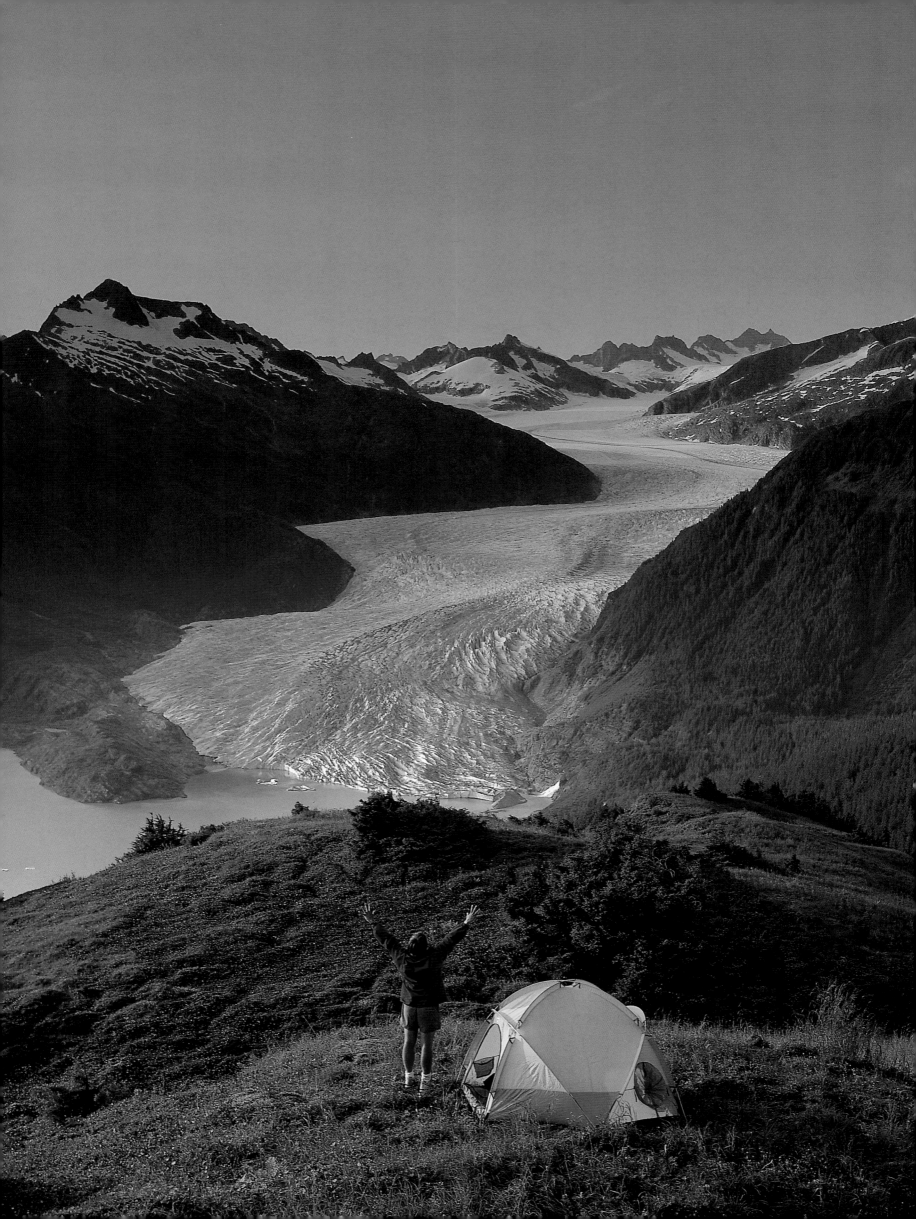

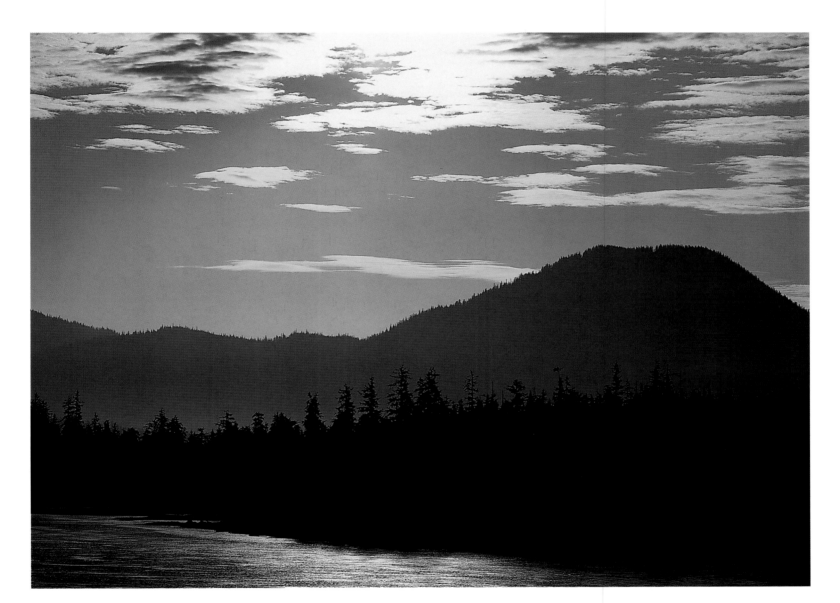

◁ Richard Steele, a Juneau school teacher and former park ranger, enjoys a Thoreauvian night of camping on Thunder Mountain, above Mendenhall Glacier. △ Sunrise warms the waters of Wrangell Narrows, an intimate waterway (sometimes less than one hundred yards wide) between Wrangell and Petersburg, which is frequented by pleasure boaters, small tour vessels, and the Alaska Marine Highway System (state ferries). Alaska has 33,904 miles of shoreline, more than double the shoreline of the entire Lower 48 states.

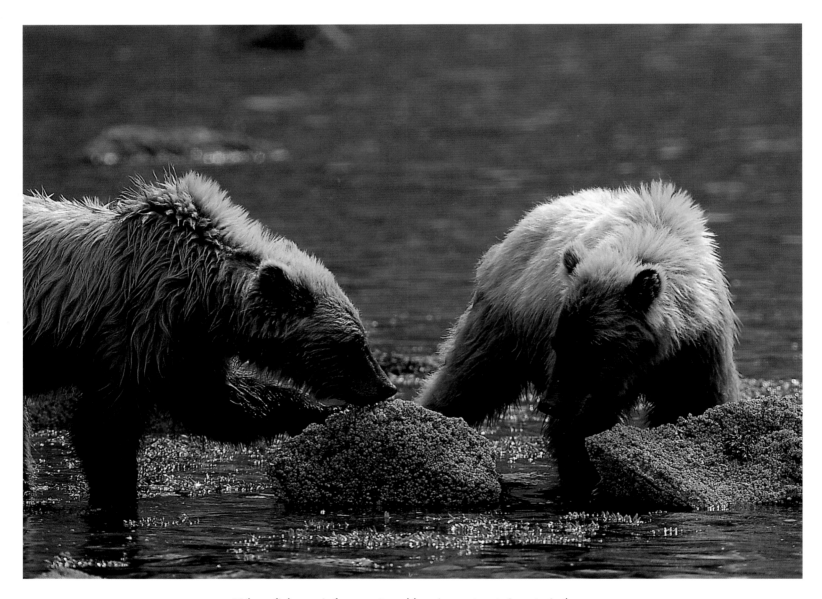

△ When fish are infrequent and berries not yet ripe, twin brown bears chew barnacles off rocks along a shore in northern Southeast Alaska. The same species as the Interior grizzly *(Ursus arctos)*, brown bears inhabit coastal Alaska and can grow roughly 30 percent larger due to a higher protein (salmon) diet.
▷ Brown bear tracks along the Kadashan River prove that some parts of America still exist as they always have, as wilderness, not tree farms and fish factories.

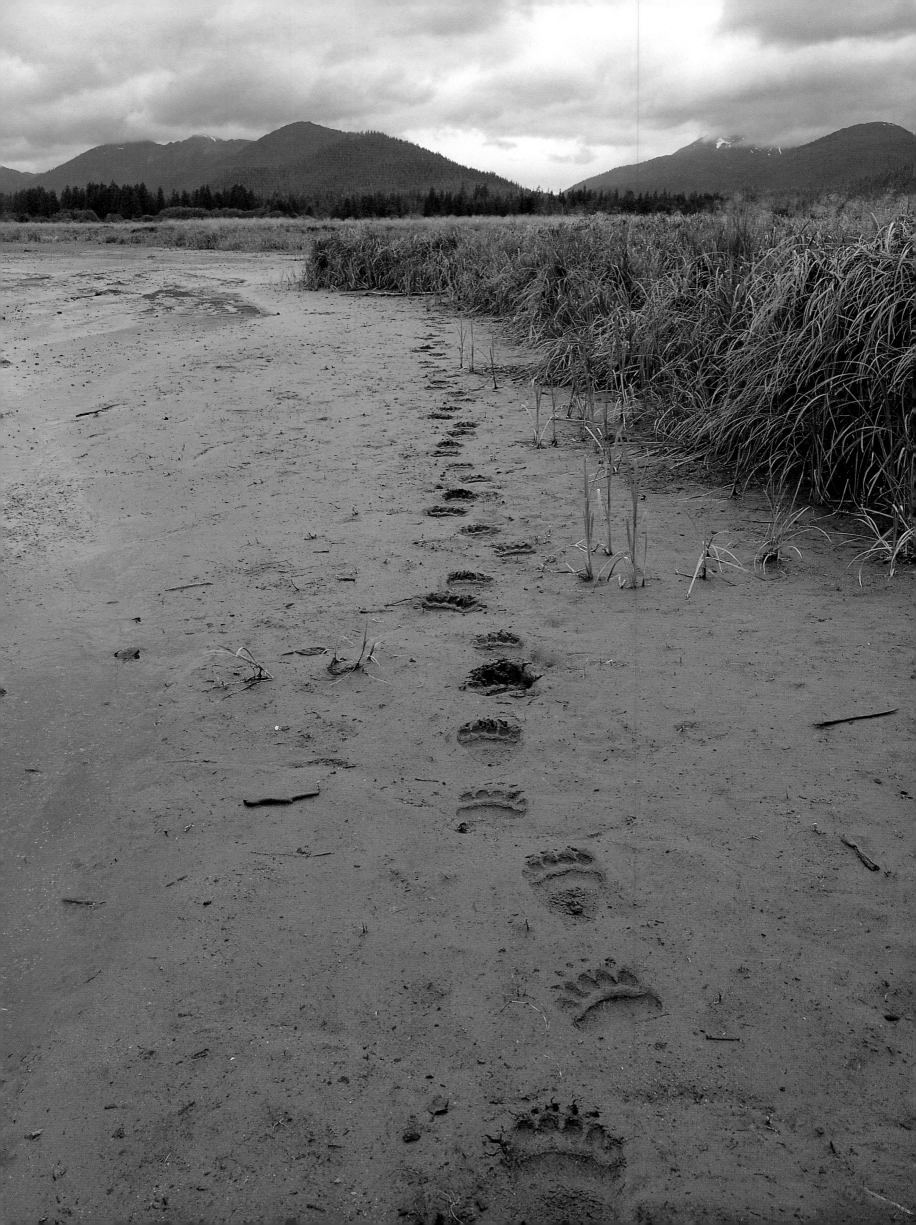

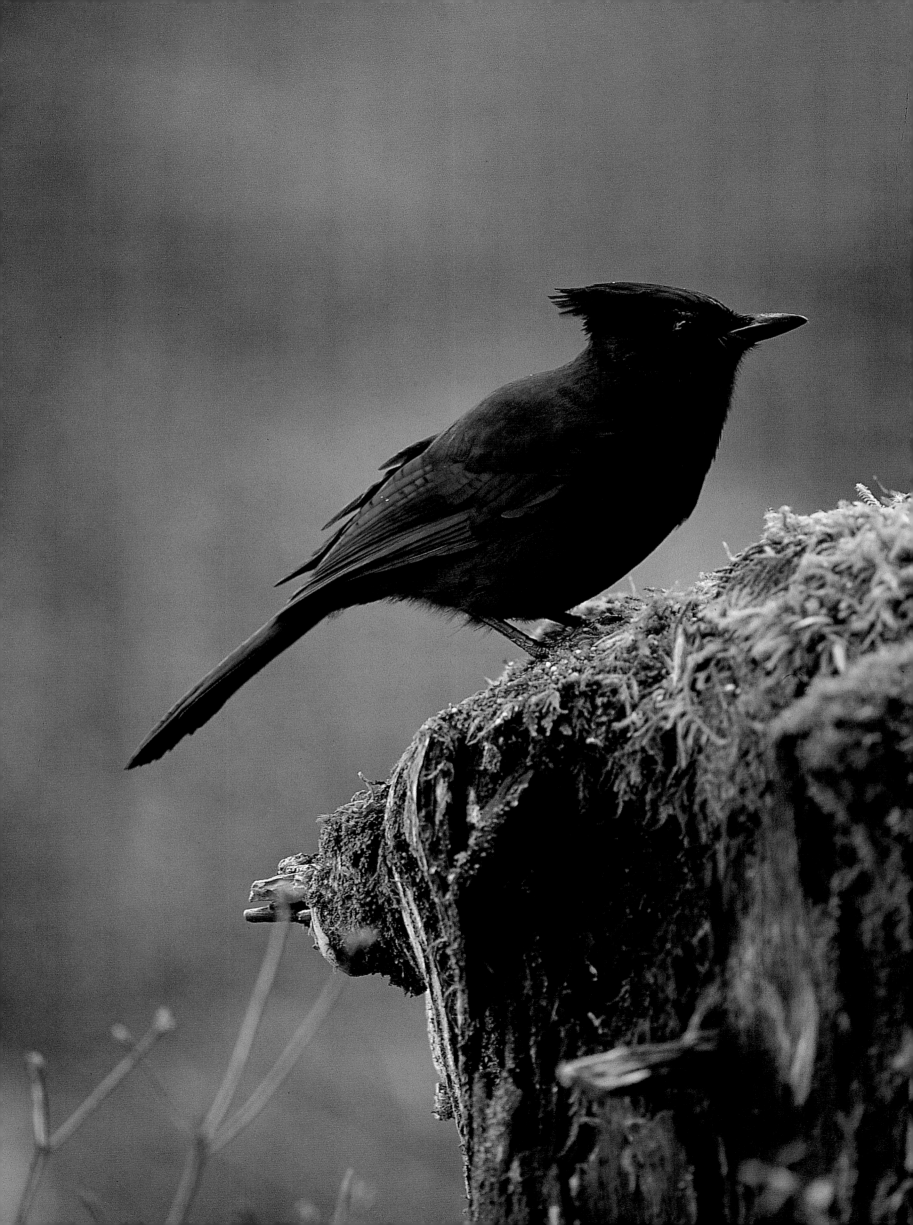

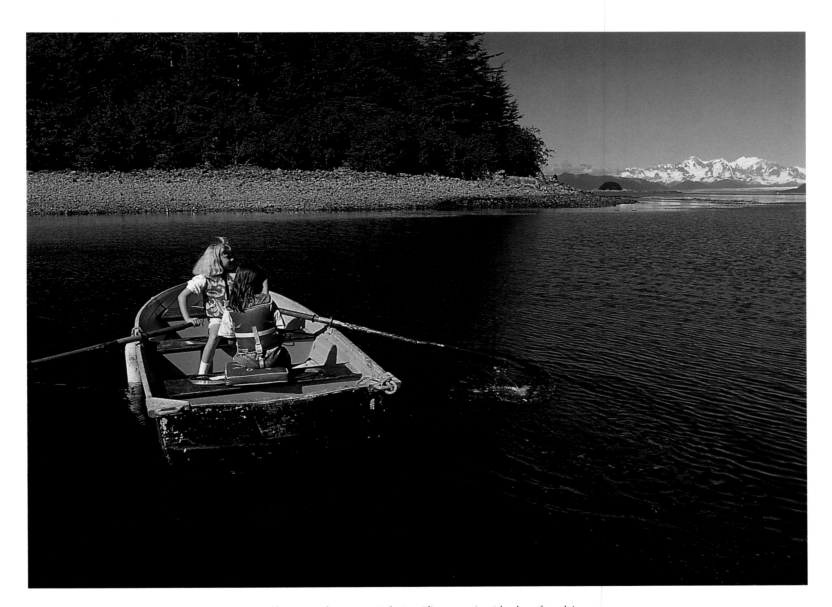

◁ A Steller's jay has special significance in Alaska, for this was the bird that was sighted (shot and studied) by naturalist Georg Wilhelm Steller when he accompanied Vitus Bering here in 1741. Having never seen such a bird before in Europe or Asia, Steller knew that he and Bering had indeed landed in the New World, not the Old. △ Children play in a rowboat in Elfin Cove. Boating is a way of life in coastal Alaska, where people work, play, live, and commute in their boats.

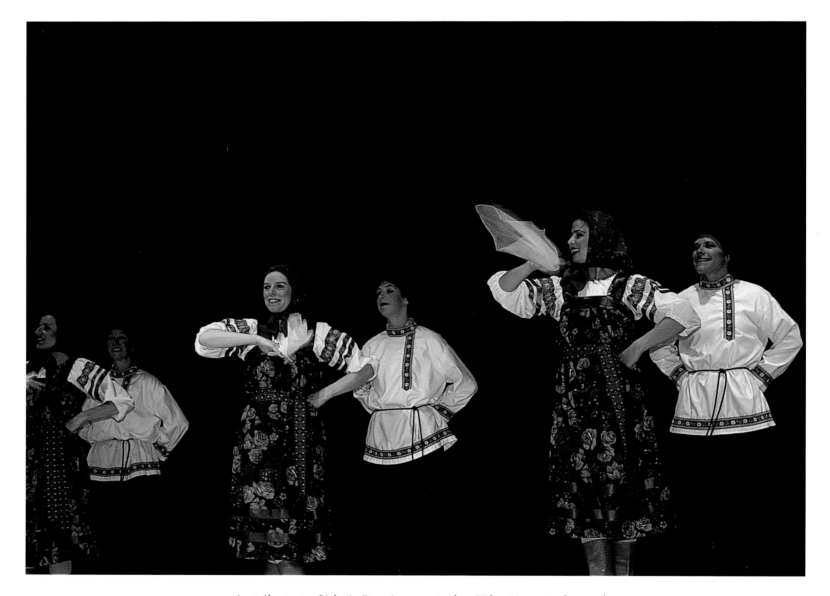

△ In tribute to Sitka's Russian past, the Sitka New Archangel Russian Dancers perform in the Centennial Building. The all-woman dance troupe dresses in traditional peasant costumes and swirls to authentic Russian music. ▷ Late evening light dances on the Coast Mountains above Lynn Canal, where steep slopes force relatively warm marine air upward until it cools and drops its moisture as rain and snow, making Southeast Alaska one of the rainiest temperate regions in the world.

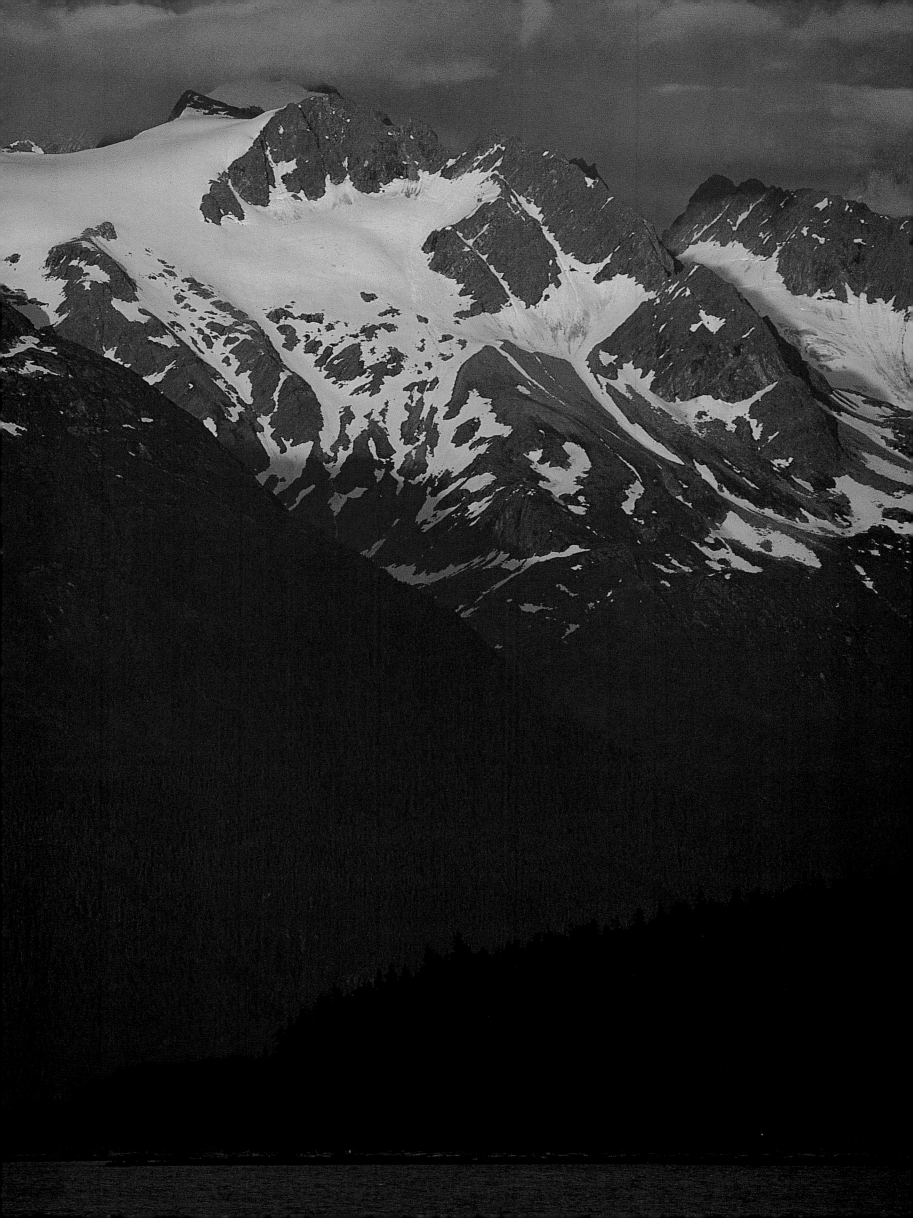

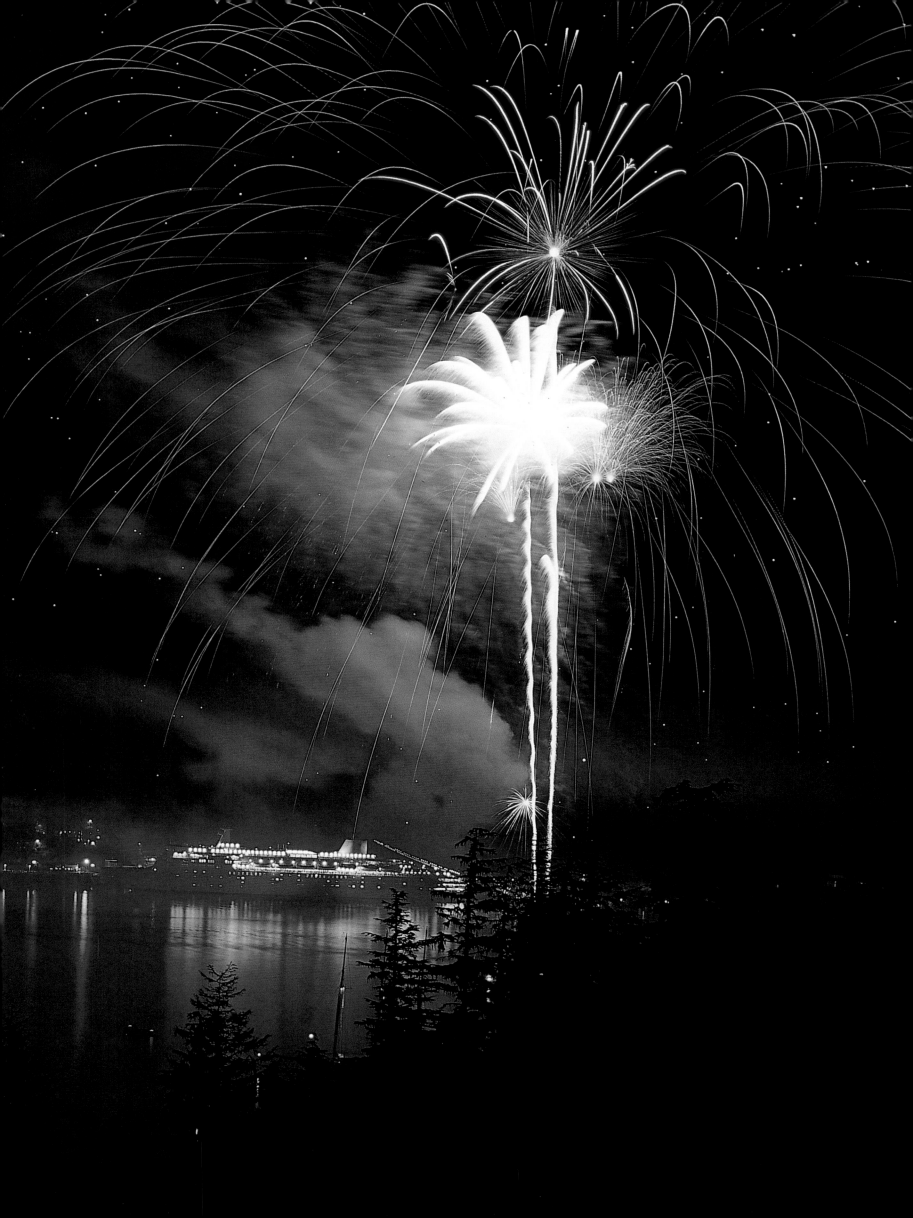

The Fourth of July

Summertime in Alaska; if the livin' ain't easy, it's at least memorable.

In Lisianski Inlet, three fishermen with calloused hands pull up a seine (net) filled with a ton of pink salmon. Two of the fishermen are from Alaska and work without breaking stride. The third is from Washington State. Although he also works hard, he takes none of what he sees for granted. Salmon used to be this plentiful (and taken for granted) in Washington and Oregon, he says, until they were overfished, and their spawning rivers dammed. Won't happen here, the Alaskans say; if anything there's too many salmon, especially hatchery-reared salmon; drives down the market price. The man from Washington shakes his head and tells the Alaskans that's his point: there's more than one way to destroy a fishery. They share a quick lunch, drop their seine and haul up another ton.

In Misty Fiords National Monument, situated near Ketchikan, a pilot banks his Cessna 185 Skywagon over sparkling bays and granite cliffs streaked with waterfalls, while his flightseeing passengers, three people in their seventies from Iowa, drop their jaws in amazement. The pilot plays a Beethoven symphony through their headphones. One woman is near tears, overwhelmed by the beauty. Three thousand feet below, a party of kayakers, having come into Misty Fiords to experience silence, loon song, and other sublime gifts of wilderness, collectively curse the small, whining, buzzing plane that circles above, aggravating as a mosquito. Whose monument is this? they ask. This is your national monument, the pilot tells his passengers. Misty Fiords was created in 1978 by presidential proclamation, ratified by Congress in 1980 (together with many other national monuments, parks, and preserves) as part of the Alaska National Interest Lands Conservation Act, ANILCA. One of the Iowans, a member of his local Audubon Society chapter, is perplexed: if this area is designated wilderness, he asks, how can he come here in a plane? Or in any motorized craft? The pilot chuckles and tells him it's big country—room for everybody. A man's gotta make a living. The kayakers watch the plane and wonder: who writes the rules for progress?

In Thorne Bay, on Prince of Wales Island, a logger with a chainsaw takes two minutes to cut down a six-hundred-year-old Sitka spruce. Forty years earlier it would have taken his grandfather half a day with an axe. That was then, this is now. The tree will be shipped to Japan and turned into cellophane, ice cream stiffener, and guitars. Clearcut logging is good work, say the blue collar men of Alaska. Yet others—their numbers growing as more forest giants fall—whisper that while guitars are fine, they prefer the music of the ancient forest.

In Skagway, where the past is not entirely passé, the White Pass and Yukon Route Railroad chugs up a narrow-gauge track along a route men believed impossible to build a century before. Whereas miners traveled the tracks then, cruise ship tourists travel them today—contemporary stampeders who have come to see the fabled lands of Jack London and that bard of the Yukon, Robert Service, who wrote,

There are strange things done
 in the midnight sun
 by the men who moil for gold.
The arctic trails have their secret tales
 that would make your blood run cold . . .

Peering from the train into Deadhorse Gulch far below, a retired welder from Florida remarks what an exciting and noble thing it must have been to race for gold in the Klondike, leaving timidness and fear behind. His daughter doesn't agree; she's a school teacher from Juneau who says the Klondike Gold Rush

◁ *Fireworks explode over Gastineau Channel and a cruise ship at dockside in Juneau. The festivities begin at midnight, followed by a parade the next day.*

111

was largely a white male adventure, destructive of the land, the Native people, and one another. You've been reading too much revisionist history, her father tells her. I don't read history, she answers, I teach it. In fact, I write it. They agree to disagree. That afternoon she takes him by the arm as they stroll the boardwalks of Skagway, admire the turn-of-the-century building façades, and eat ice cream.

In Juneau, capital city of Alaska—population thirty thousand when the cruise ships aren't in, forty thousand when they are—leaders from the Alaska Federation of Natives meet with two state senators to discuss subsistence hunting rights, while ten air miles north and three thousand feet up, glaciology students take core samples on the Juneau Icefield, a vast sea of ice rimmed by the serrated summits of the Coast Mountains. It needn't be winter to snow up there; the students stay for weeks and love it.

The same cannot be said for kids working the slime line in a salmon cannery in Excursion Inlet. They work hard for little pay and little time off, but make the most of what they get, climbing high one evening to find themselves on the alpine tundra of Excursion Ridge, above treeline, with mountain goats nearby. Three of the cannery kids say they intend to return next summer for another season on the line; they need the money. Three others say never again; they've got other plans. Yet all six agree that not to return to Alaska is unthinkable. Something is different here. You come to Alaska for a summer, and all that following winter you think of returning; when you do you stay longer, telling your family you'll be home for Thanksgiving . . . Christmas . . . Easter, maybe. Another summer comes and goes, and another, another. Next thing you know, you've been in Alaska for twenty years. That's how it happens. Alaskan humorist Tom Bodett says nobody intends to stay here, you just forget to leave.

Riches found here hardly compare with Wall Street. They are neither bankable nor interest-bearing in the strictest sense, but they do offer growth. They sharpen your senses and deepen your spirit. Alaskans are less involved with making a living than in life itself, being aware—robust, brilliant, and intimate; cold, wet, exhilarated.

A salty sea wave in the face, a sudden brown bear on the beach, catkins in spring, cranes in autumn, friends as true as tides—that's Alaska.

Despite their differences, Alaskans along the Inside Passage share deep convictions about where and how they live. For the most part they want little to do with American Mall Culture, merging traffic or fast food. They live on islands and bays, in hamlets and trees, with whales and web sites. They raise individualism to an art form; self-actualization to a trademark. Community spirit is not Neighborhood Watch; it's rebuilding a home after a fire, not your own home, not even a friend's, just a community member who needs help and would do the same for you.

The greatest gratitude for being Alaskan and American—in fact any citizen of this still-wild earth—comes on Fourth of July when communities throughout Southeast Alaska celebrate with contests, food, and friendship. Kids catch candy thrown from the local fire truck—the only one in town, manned by volunteers. Legislators perch over tubs of water as townsfolk pitch softballs to dunk them. Losers in the greased pole contest (there are many) fall into the river amid cheering and applause. Into the night people play music, dance, and forget whatever ideological fences might stand between them. They are one big family on the Fourth of July—fishermen, kayakers, pilots, politicians—a family nurtured in the greatness of Alaska.

Freedom doesn't get any better than that.

▷ *"Day after day we seemed to float in a true fairyland,"* wrote John Muir of the Inside Passage, *"each succeeding view seemingly more and more beautiful."*

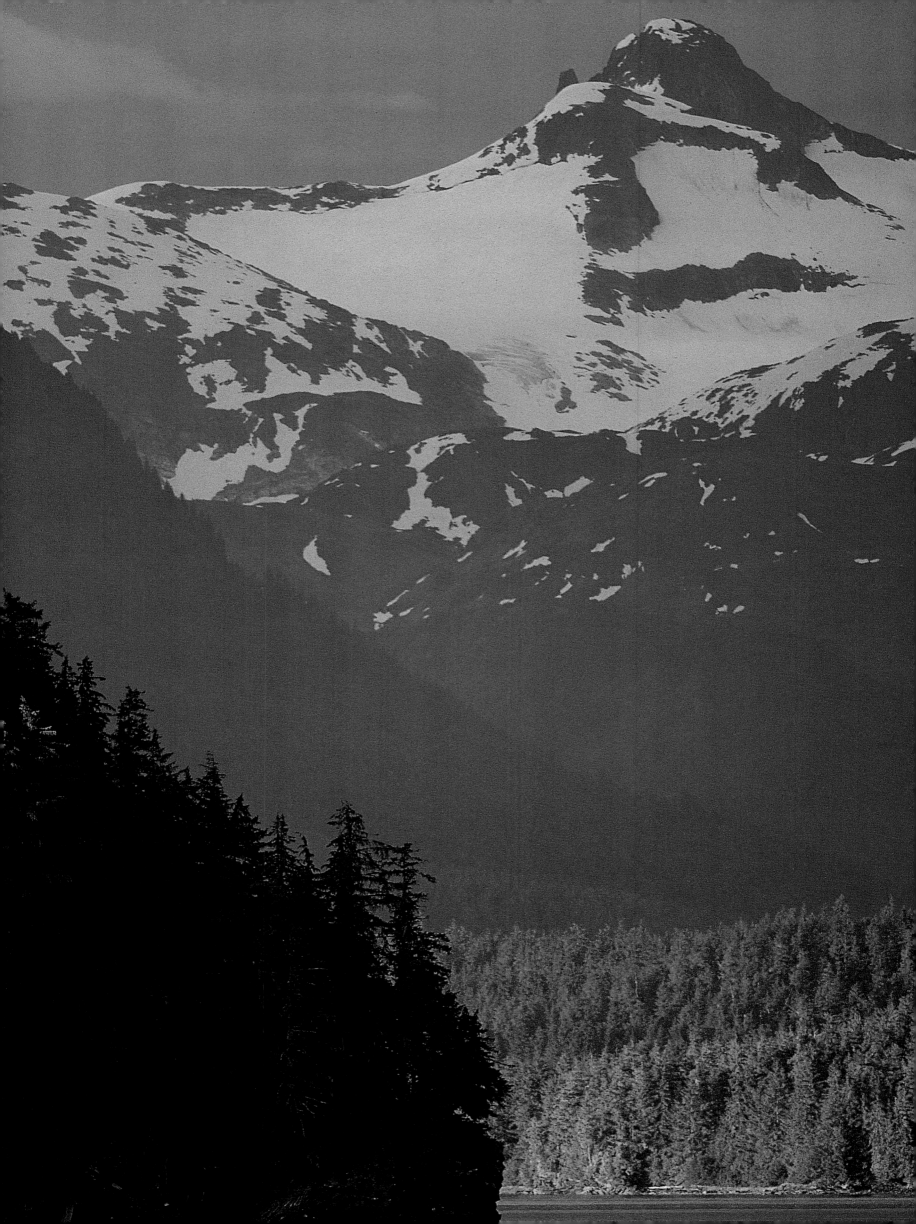

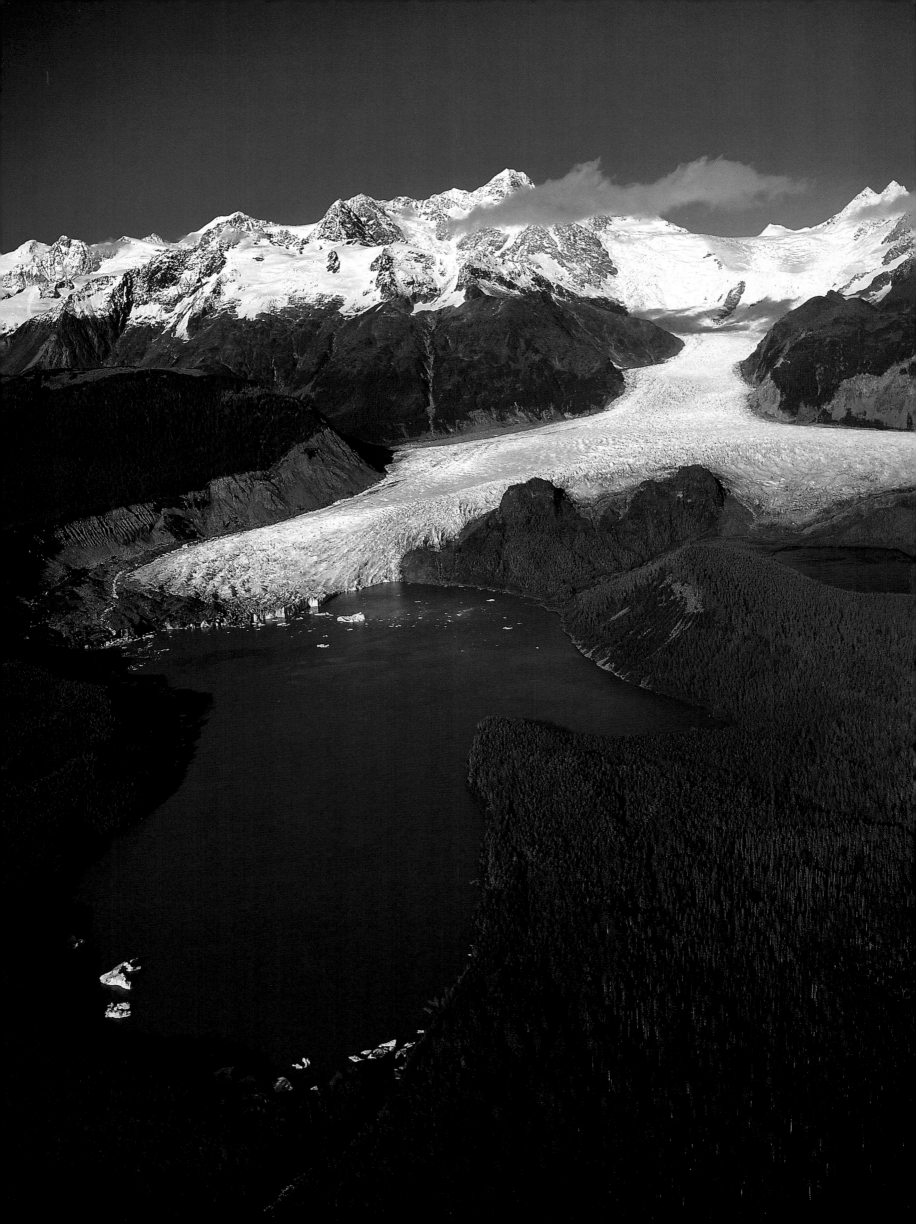

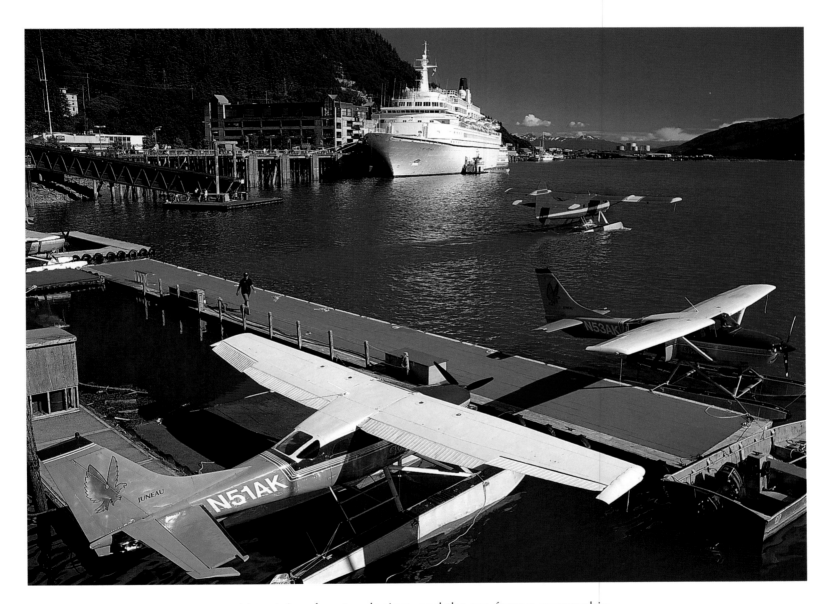

◁ Mountains, forests, glaciers, and the sea form a geographic framework for the Inside Passage. Tectonics lift the land—some mountains to more than ten thousand feet—while glaciers and rivers level it through erosion and deposition. △ A July day dances sunlight off ships and floatplanes along the Juneau waterfront. Air travel is second nature in Alaska, with its 102 seaplane bases, six times as many pilots, and fourteen times as many airplanes per capita as the rest of the United States.

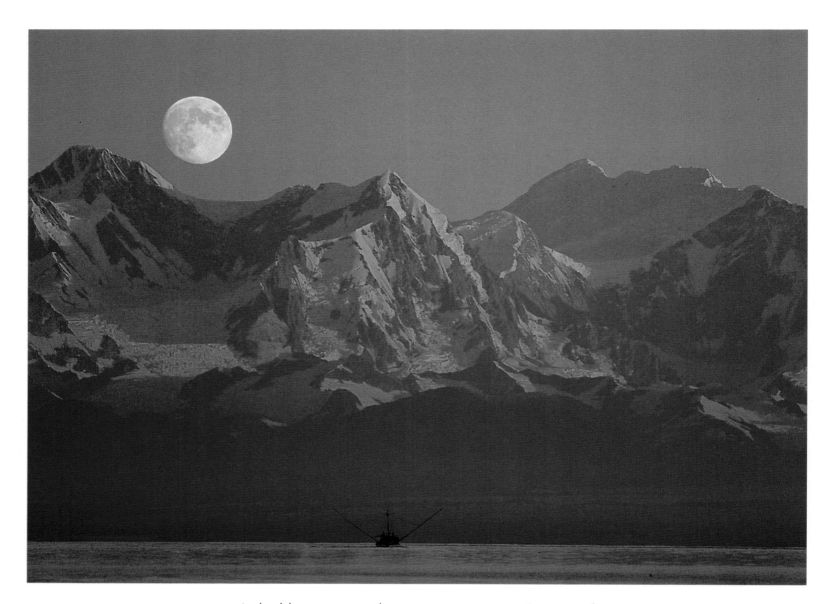

△ A double exposure shows moonset at sunrise over the Fairweather Range and Icy Strait. A troller, dwarfed by ten-thousand-foot mountains, is fishing for salmon. ▷ A waterfall spills down Bullard Mountain onto Mendenhall Glacier, near Juneau. Crevasses form on a glacier's relatively brittle surface as it flows downslope, while deeper ice, which is under more pressure, melts and refreezes to give the glacier flexibility.

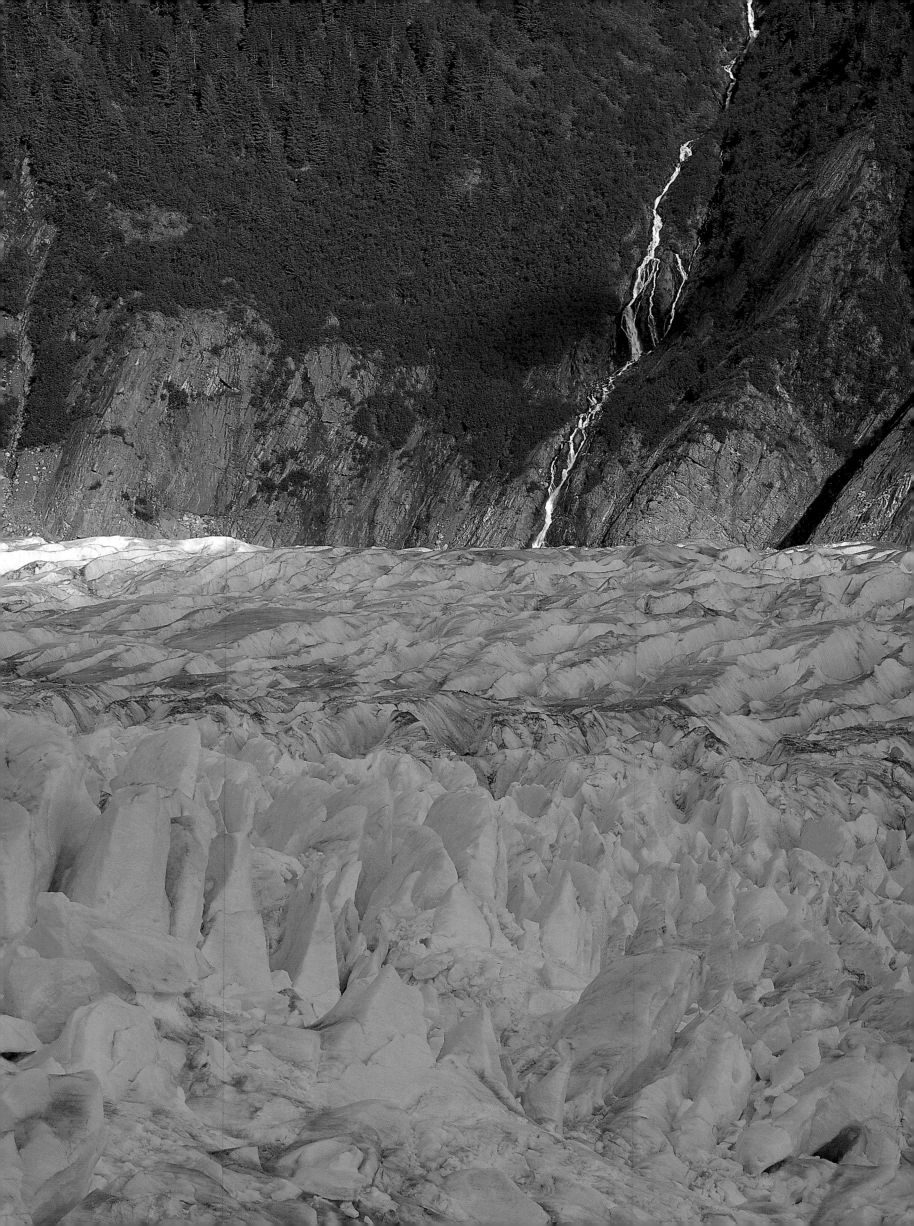

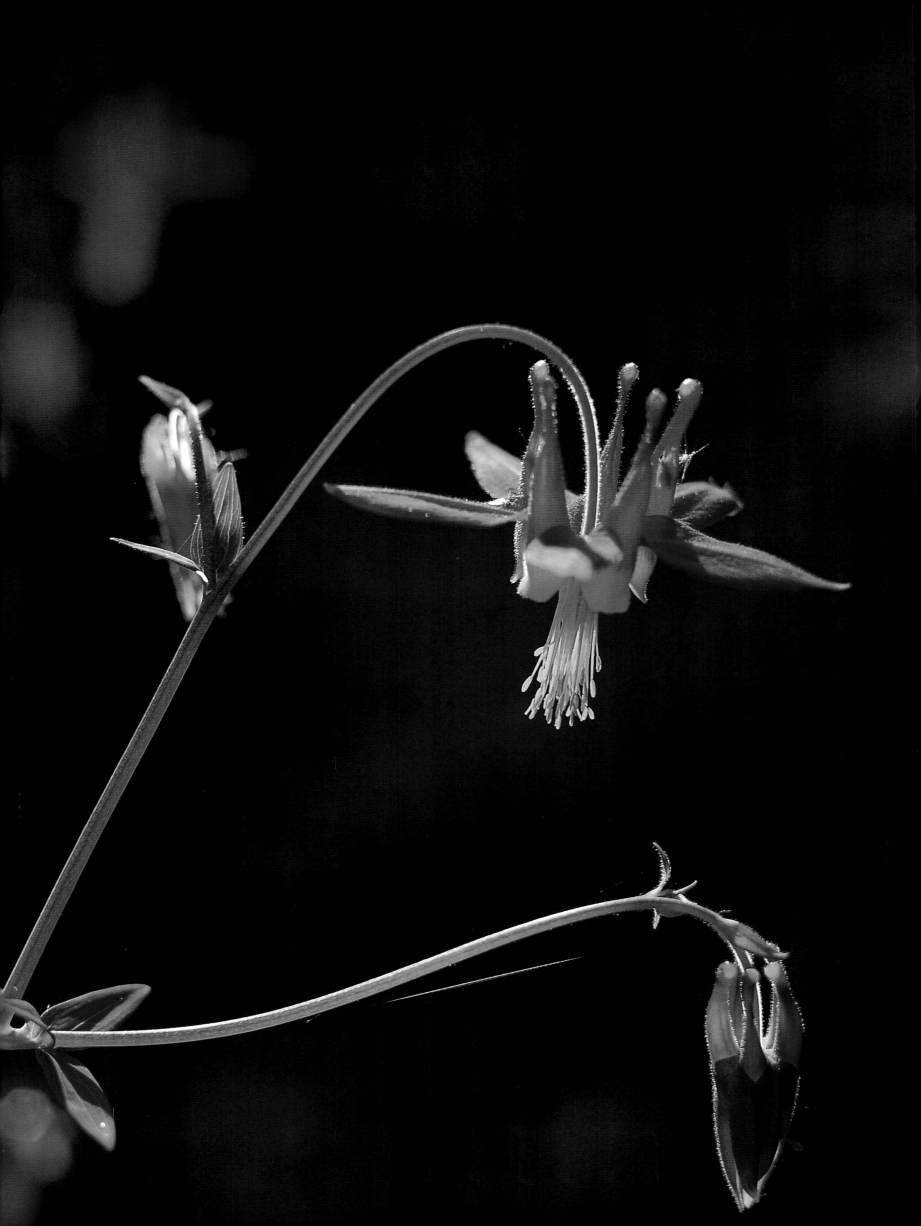

◁ "The world laughs in flowers," wrote Ralph Waldo Emerson; his metaphor is expressed in this bright columbine, a member of the buttercup family. △ A dwarf fireweed colonizes a streambed where one hundred years ago a great retreating glacier unveiled new land. ▷ Steep mountains, hidden forests, intimate bays and waterways—these are the elements of richness and diversity along the Inside Passage, where mountain goats might share the same slope with whales, one above the sea, the other below.

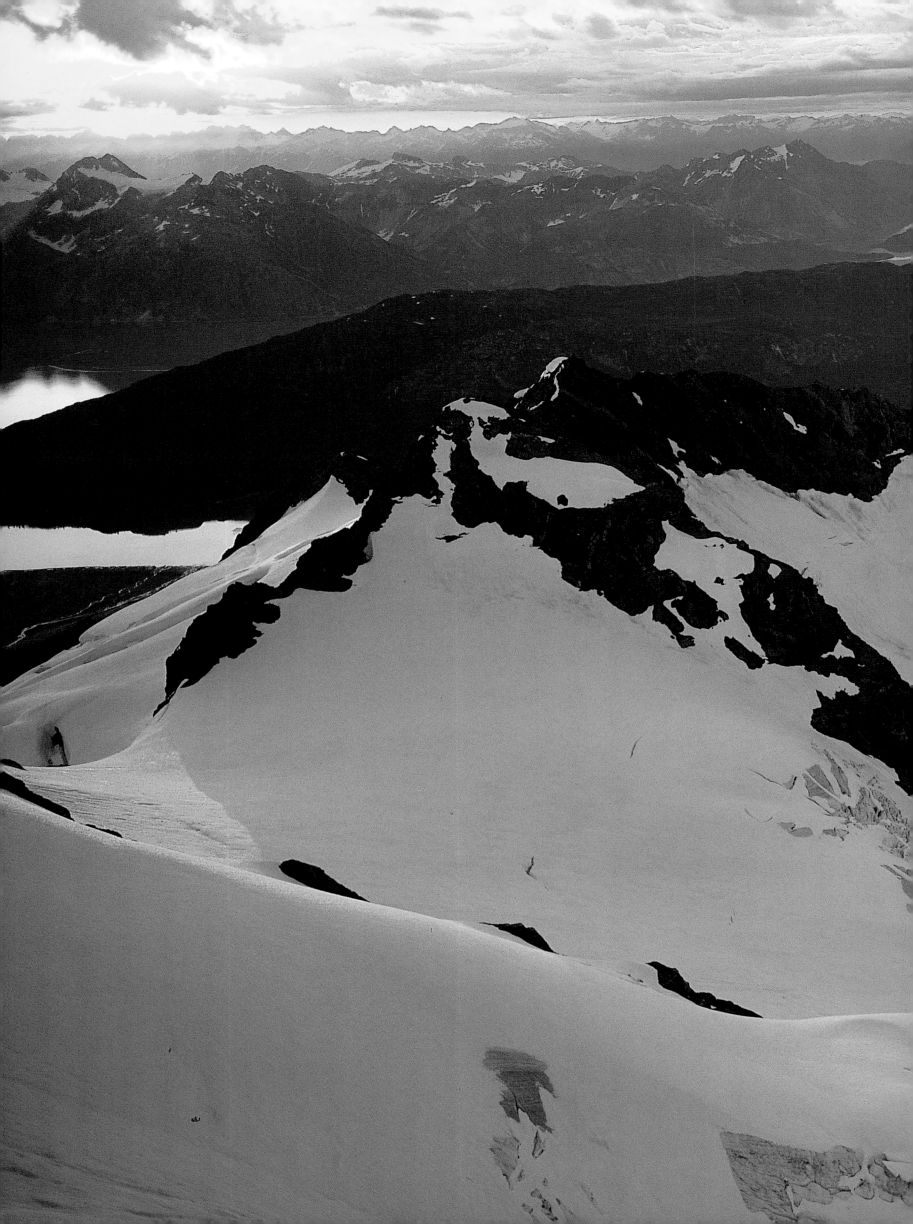

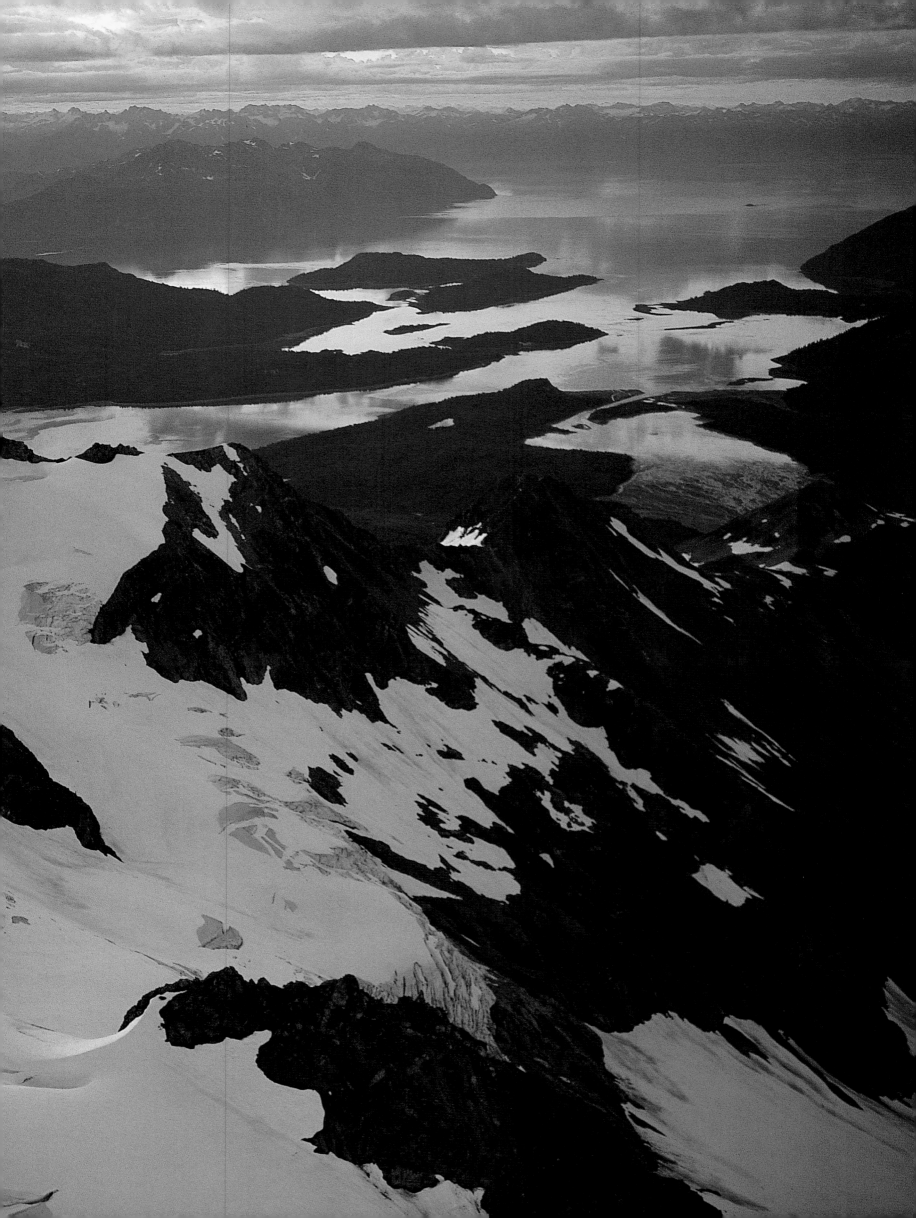

△ Beachgreens pioneer a catchment basin filled with mussel shells thrown above high tide by winter storms. ▷ Seiners raise their net in Petersburg, a busy fishing village on Mitkof Island. ▷ ▷ A de Havilland Beaver idles before taking off on Punchbowl Lake, in Misty Fiords National Monument. Misty Fiords and Admiralty Island, also a national monument in Southeast Alaska, are protected natural areas (most of them designated wilderness) administered by the U.S. Forest Service.

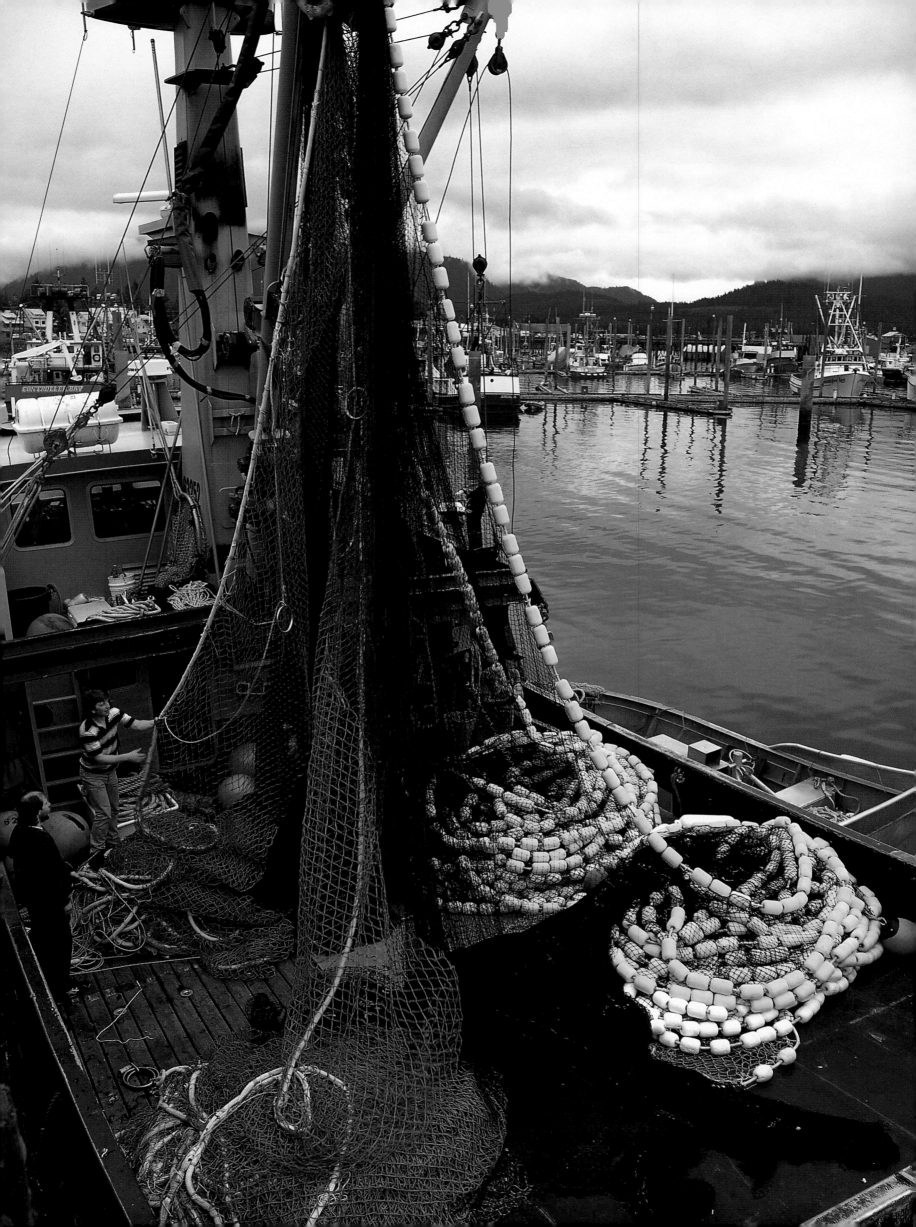

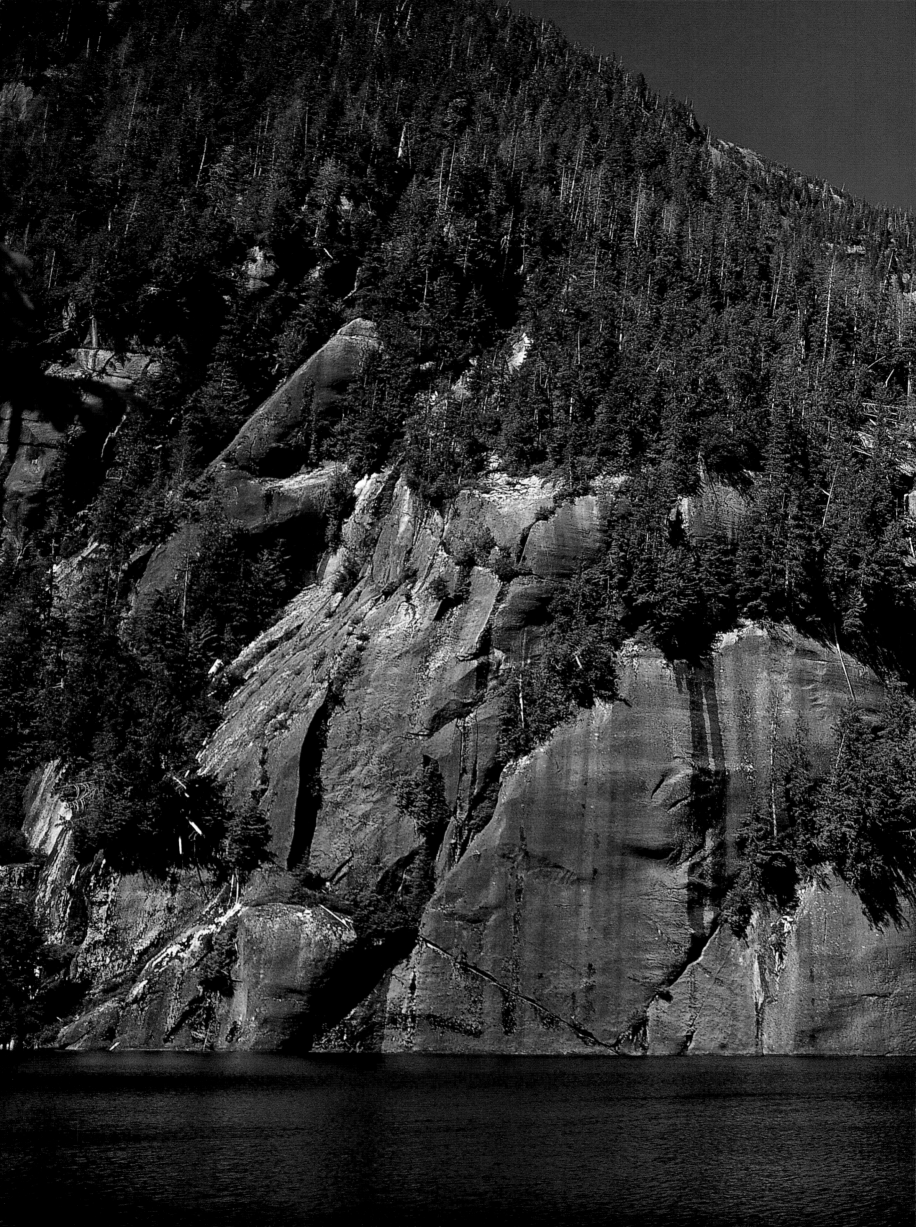

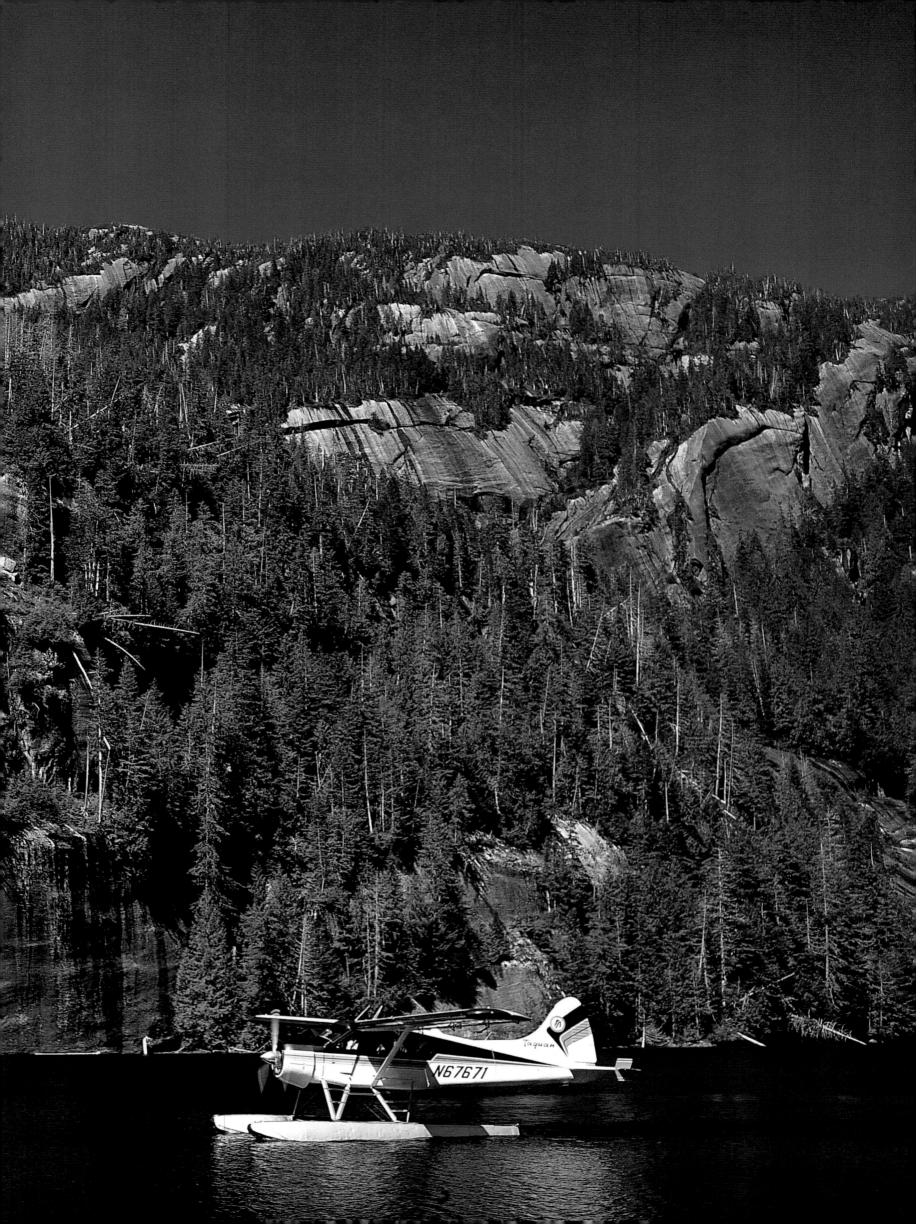

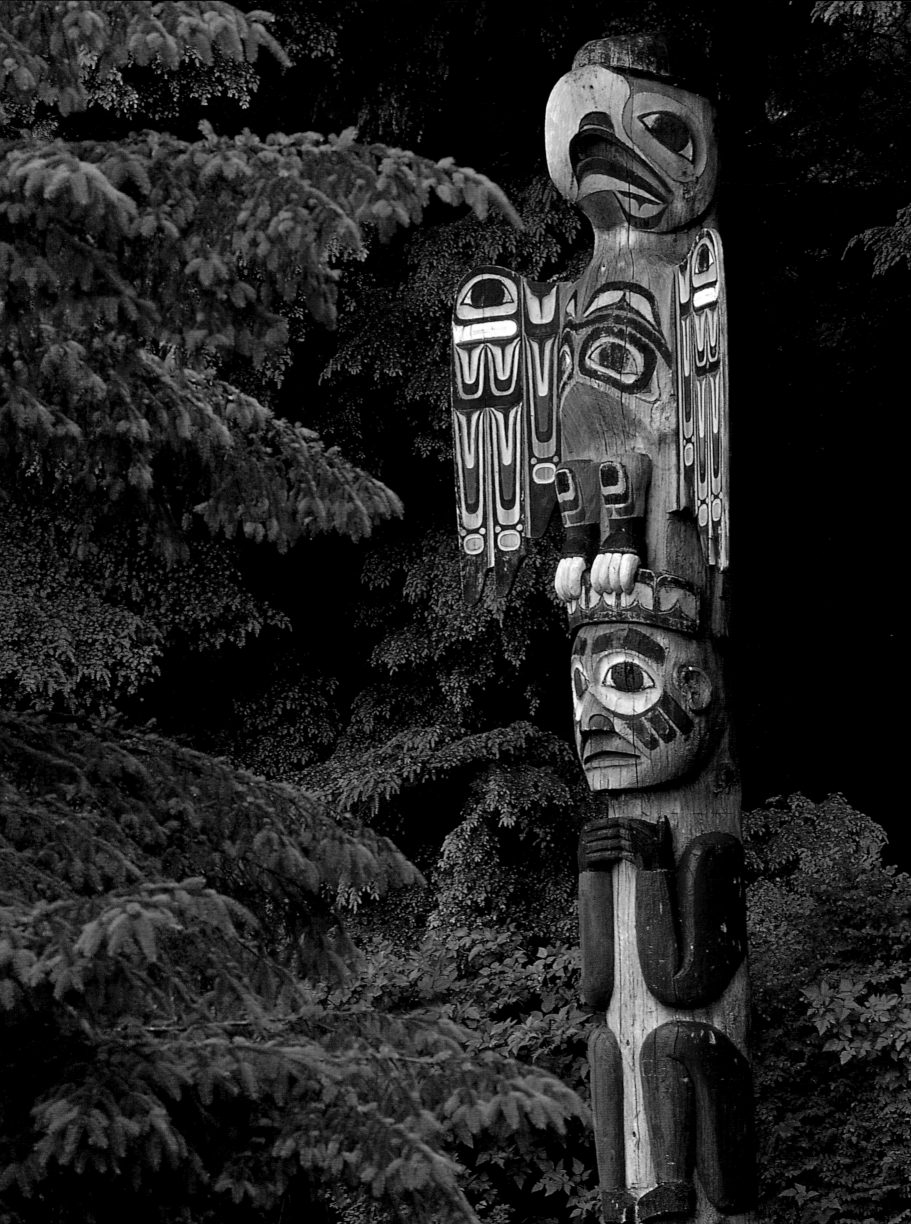

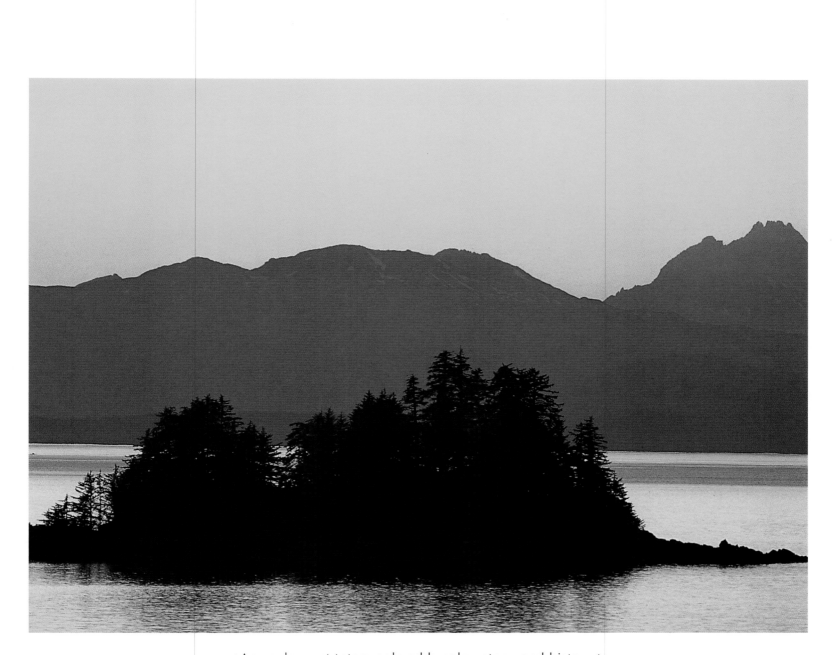

◁ An eagle crest totem pole adds color, story, and history to Totem Bight State Historic Park. A short distance north of Ketchikan, with a salmon stream nearby, Totem Bight was once used by Tlingits as a summer fishing camp. △ Because Alaska is located at high latitudes, the sun rises and sets at low angles to the horizon and immerses the land in prolonged amber light, such as the glow that bathes these mountains above Lynn Canal, in the northern reaches of the Inside Passage.

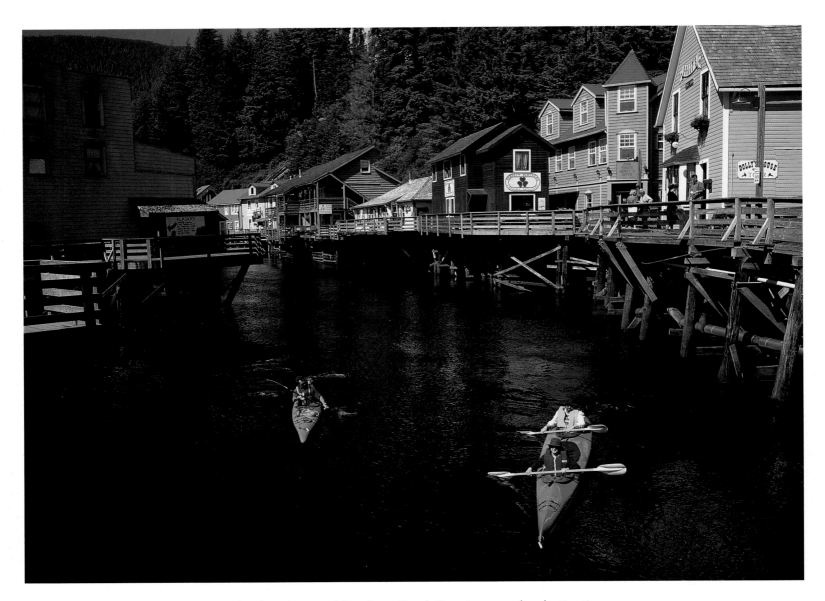

△ Sea kayakers paddle along Creek Street, a popular destination in Ketchikan. The kayakers are tourists off cruise ships, out for a short adventure. Creek Street boasts a boardwalk and a handsome collection of homes, restaurants, art galleries, and shops.
▷ An iceberg drifts through Tracy Arm, part of Tracy Arm-Fords Terror Wilderness, one of twenty-one wilderness areas in Tongass National Forest, largest of the nation's 156 national forests.

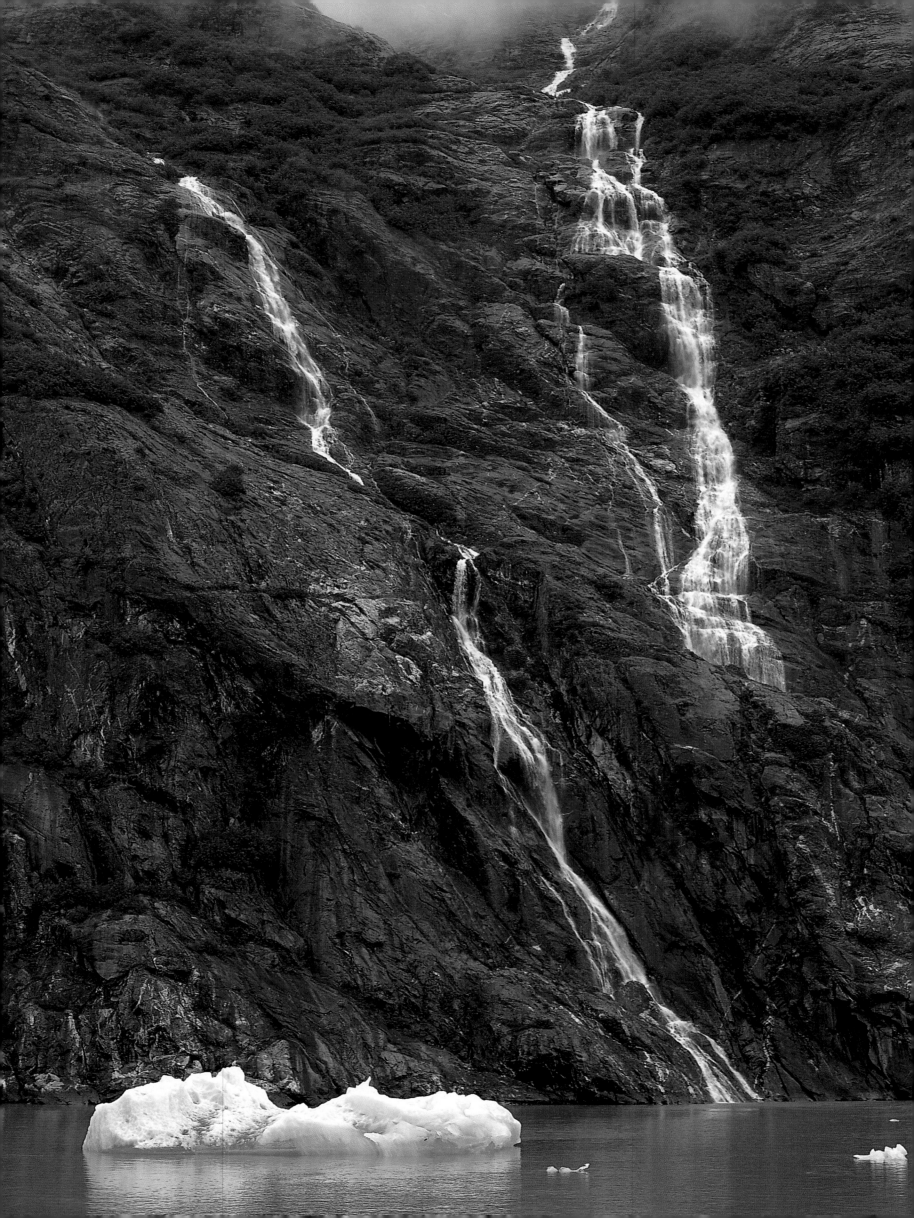

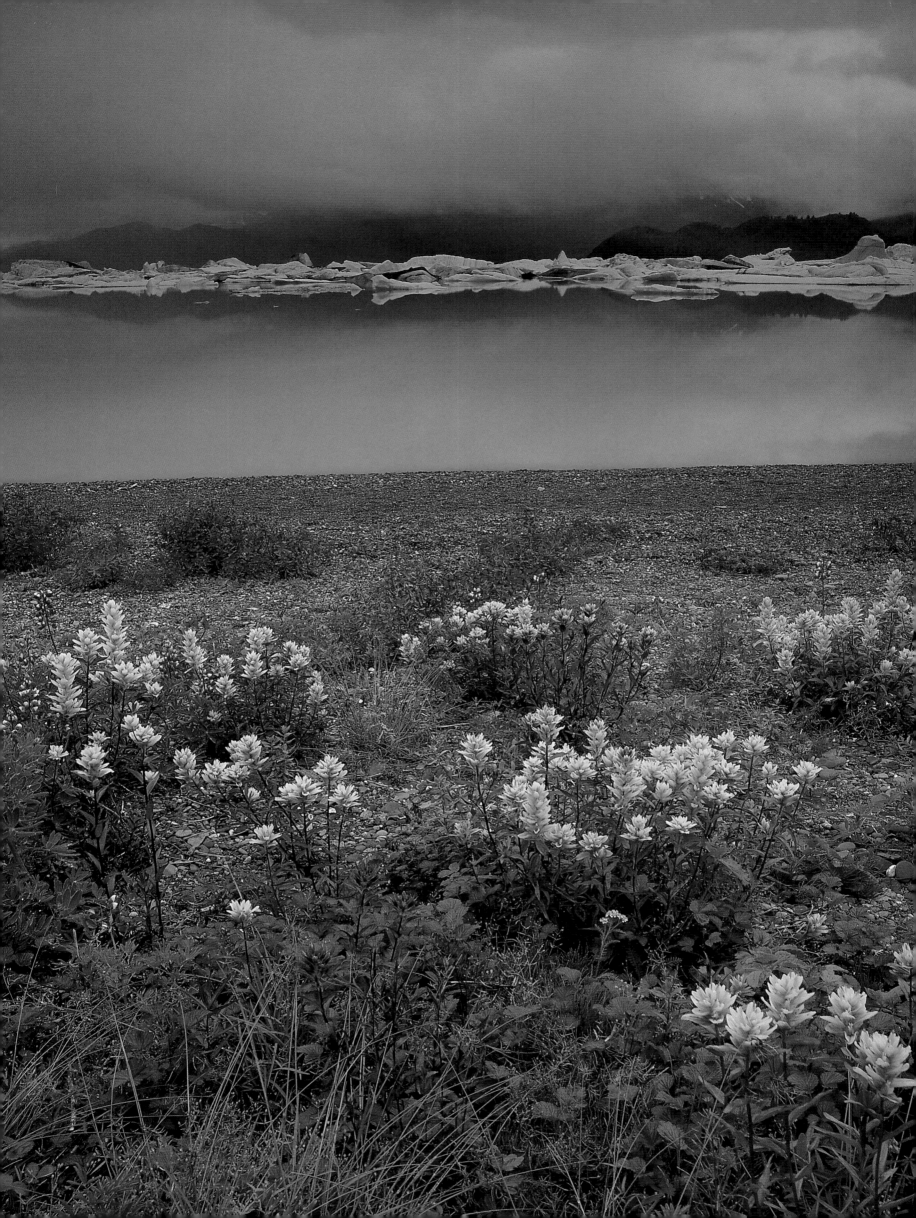

◁ Yellow paintbrush, blue Nootka lupine, and red dwarf fire-
weed make a rainbow shore in the otherwise icy world of
Russell Fiord Wilderness, near Yakutat. △ Bull kelp and rock-
weed texture a shore of Chichagof Island. A species of brown
algae, kelp will grow upwards of a foot in length per day—given
the proper nutrients, sea temperatures, and radiant light from
the lengthening days of spring. Kelp beds offer important habitat
for a full range of animals, from snails to sea otters.

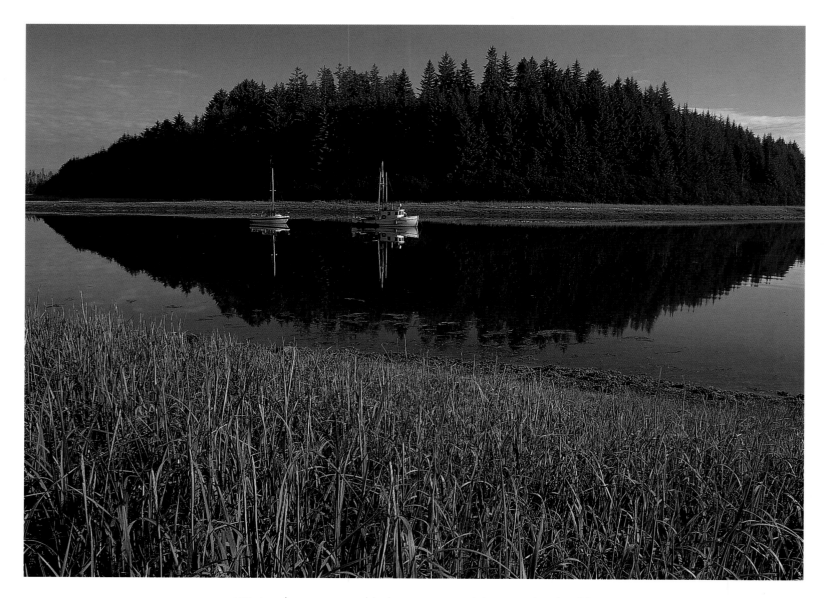

△ Winter shores covered in brown perennial vegetation (and ice and snow) burst into vivid green with the longer, warmer days of summer. ▷ Lynn Schooler, a charter boat operator from Juneau, admires old-growth trees in the Kadashan River Valley, on Chichagof Island, an area threatened with clearcut logging. Vast tracts of Alaskan rain forest—in some cases entire valleys—have already been cut, a practice that has come under increasing criticism not only in Alaska but also nationwide.

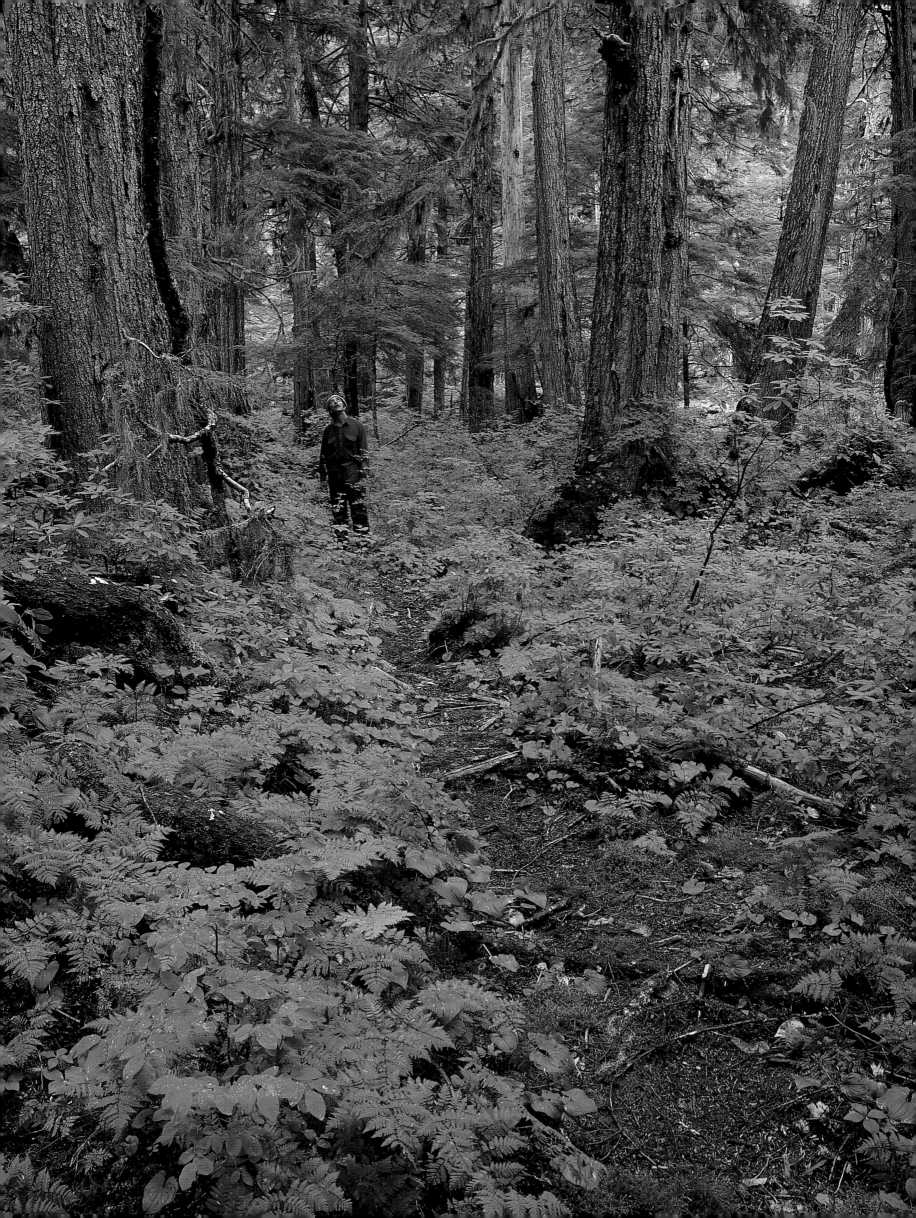

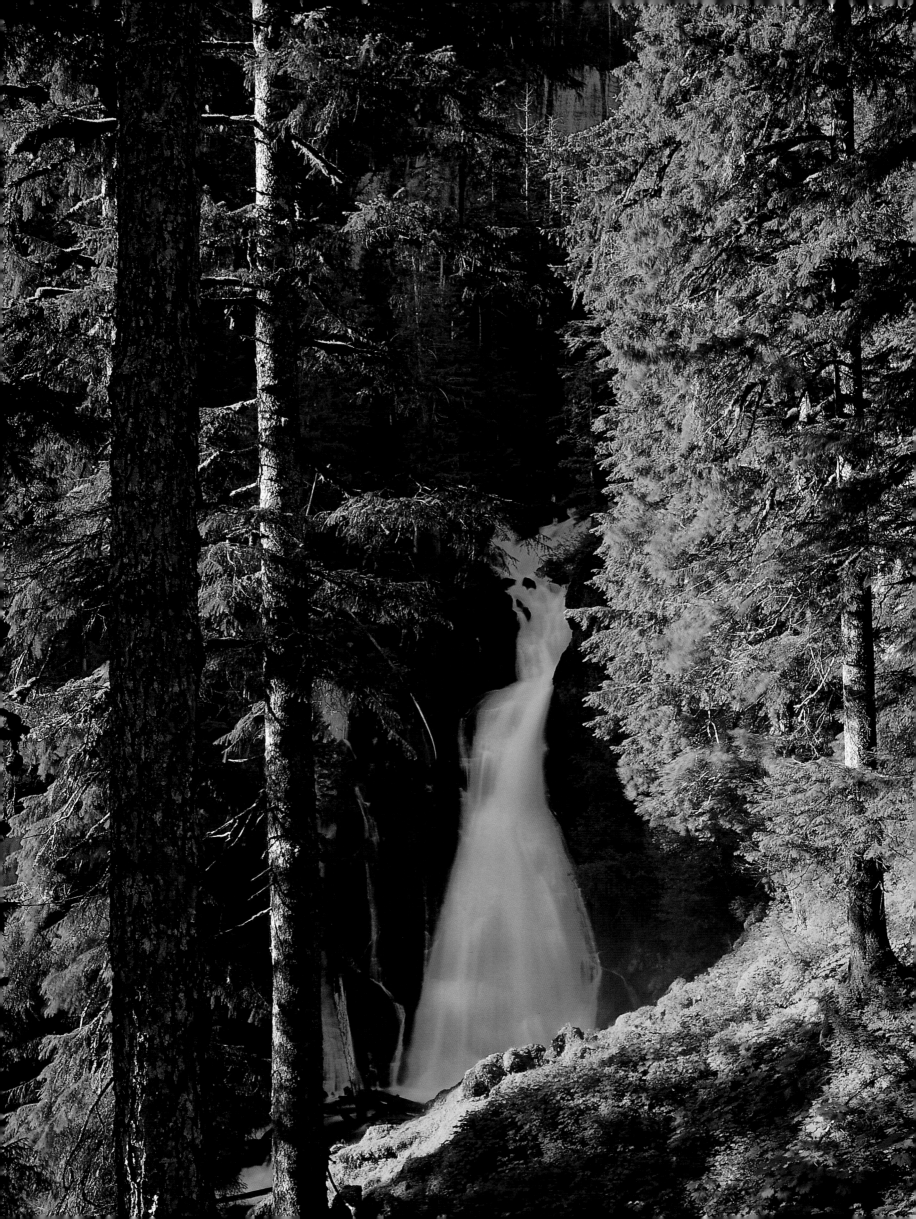

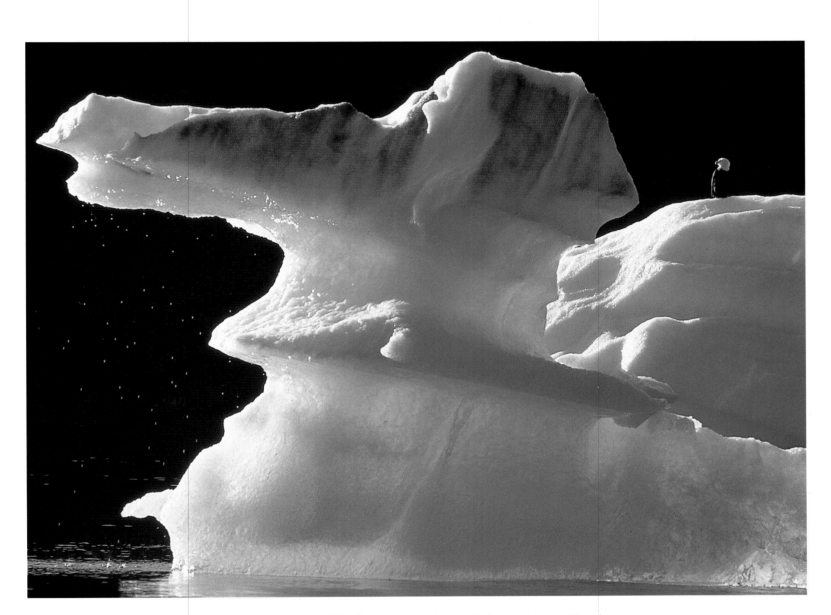

◁ A waterfall spills from Punchbowl Lake in Misty Fiords National Monument, near Ketchikan. △ Ever watchful for salmon and other fish, an American bald eagle perches on a melting iceberg in Kushtaka Bay. ▷ Sea kayaking in Southeast Alaska has mushroomed in popularity, to the point that quotas have been established in some places.

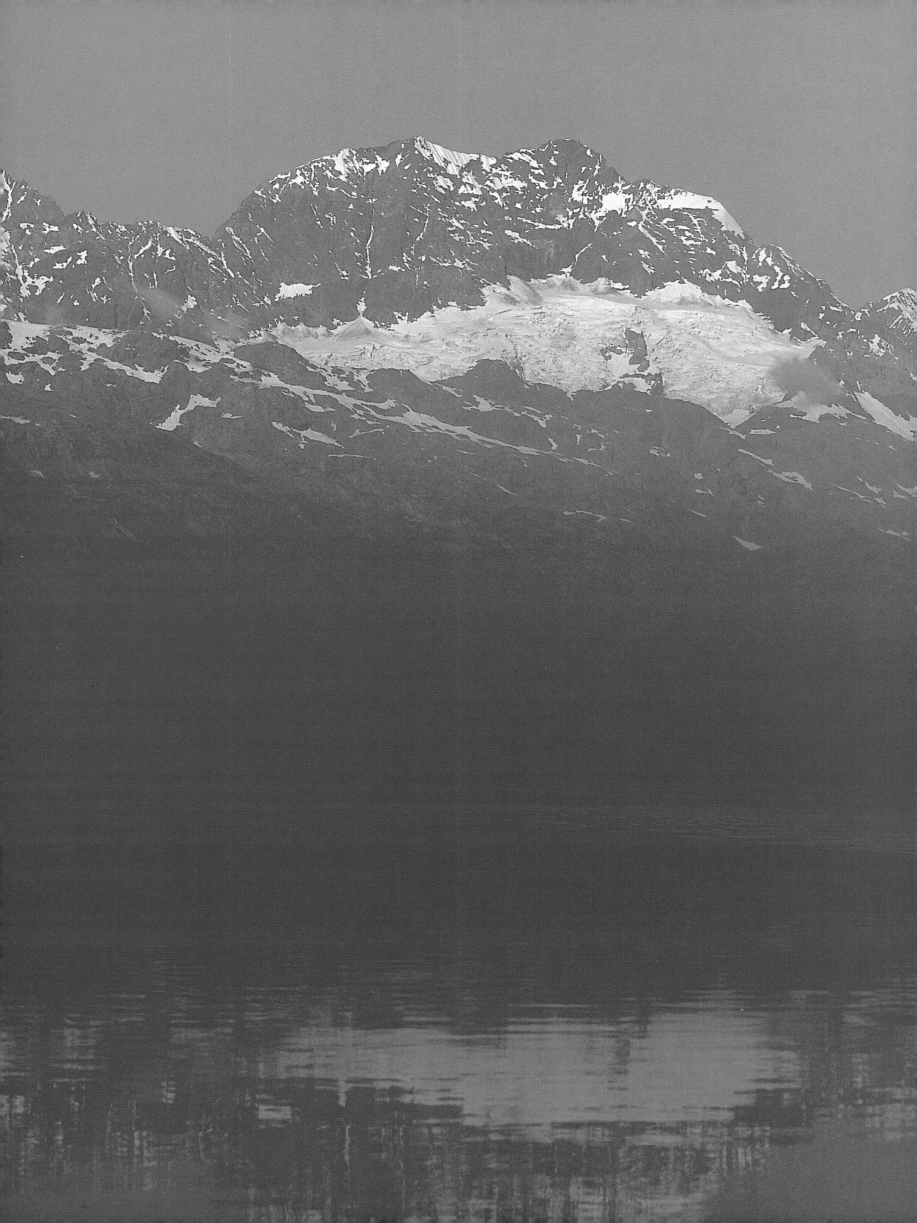

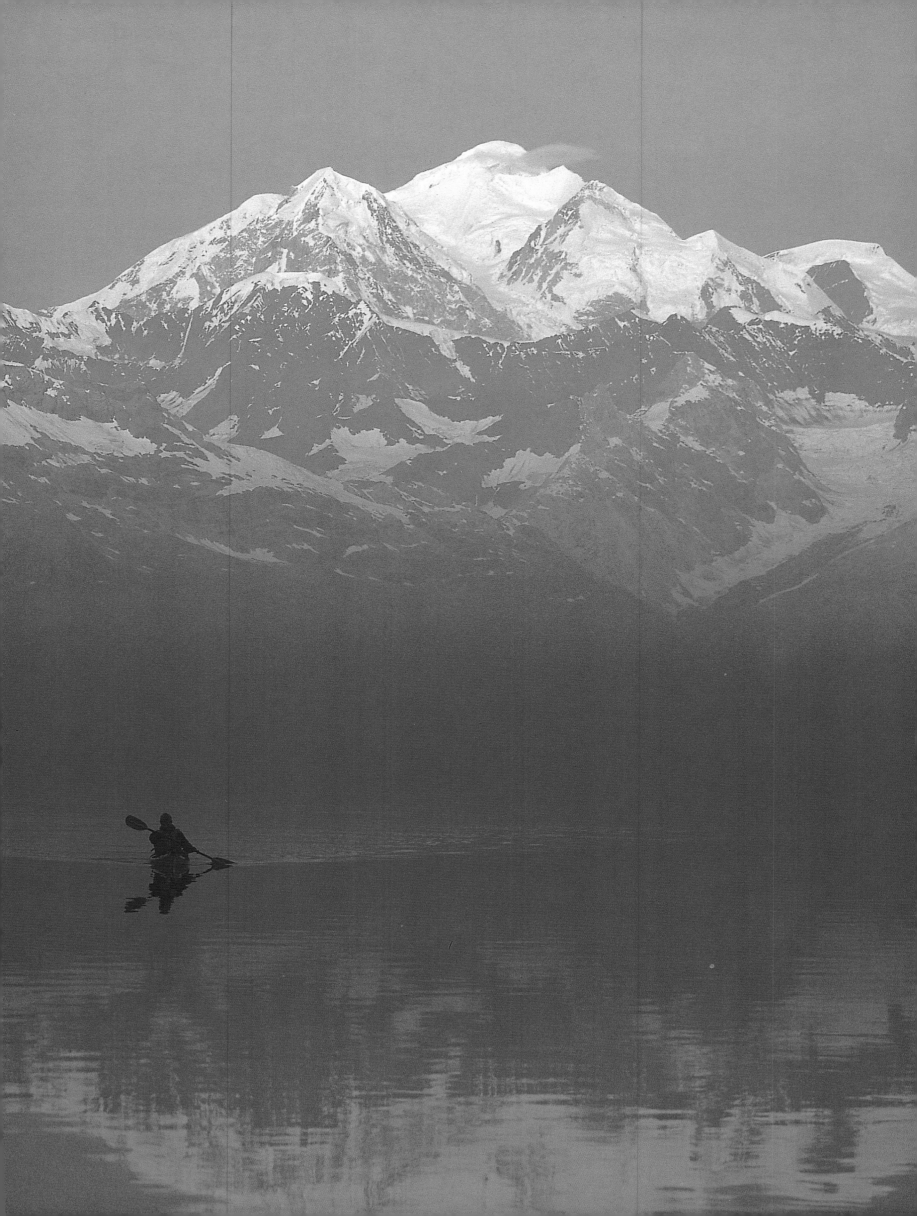

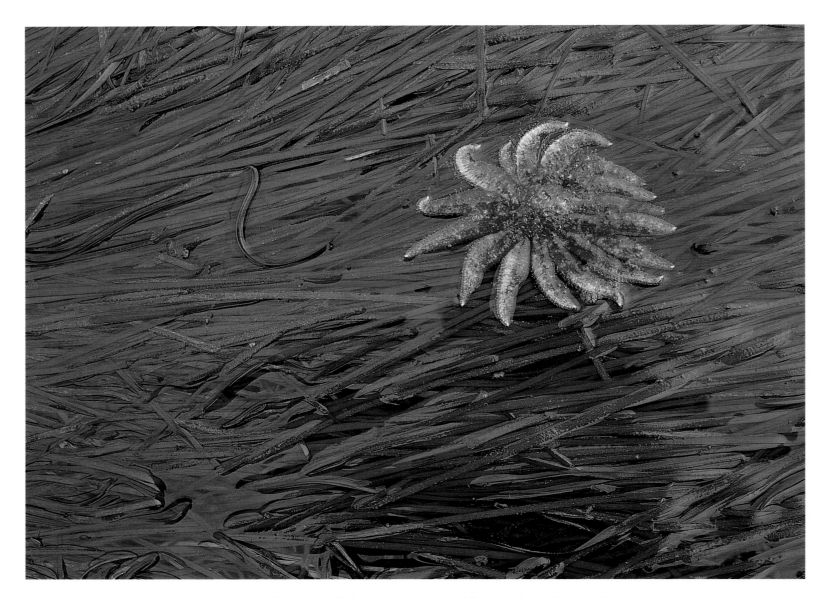

△ A sunburst starfish negotiates an ebbing tide on Baranof Island. Starfish are keenly sensitive to hydrocarbons and can be early indicators of toxic fuel and oil in the sea. ▷ A seiner casts its net for salmon near Funter Bay, along Mansfield Peninsula, at Admiralty Island's north end. ▷ ▷ A humpback whale breaches beneath a brooding sky in Chatham Strait. Whales often return to the same feeding territories in Alaska every summer.

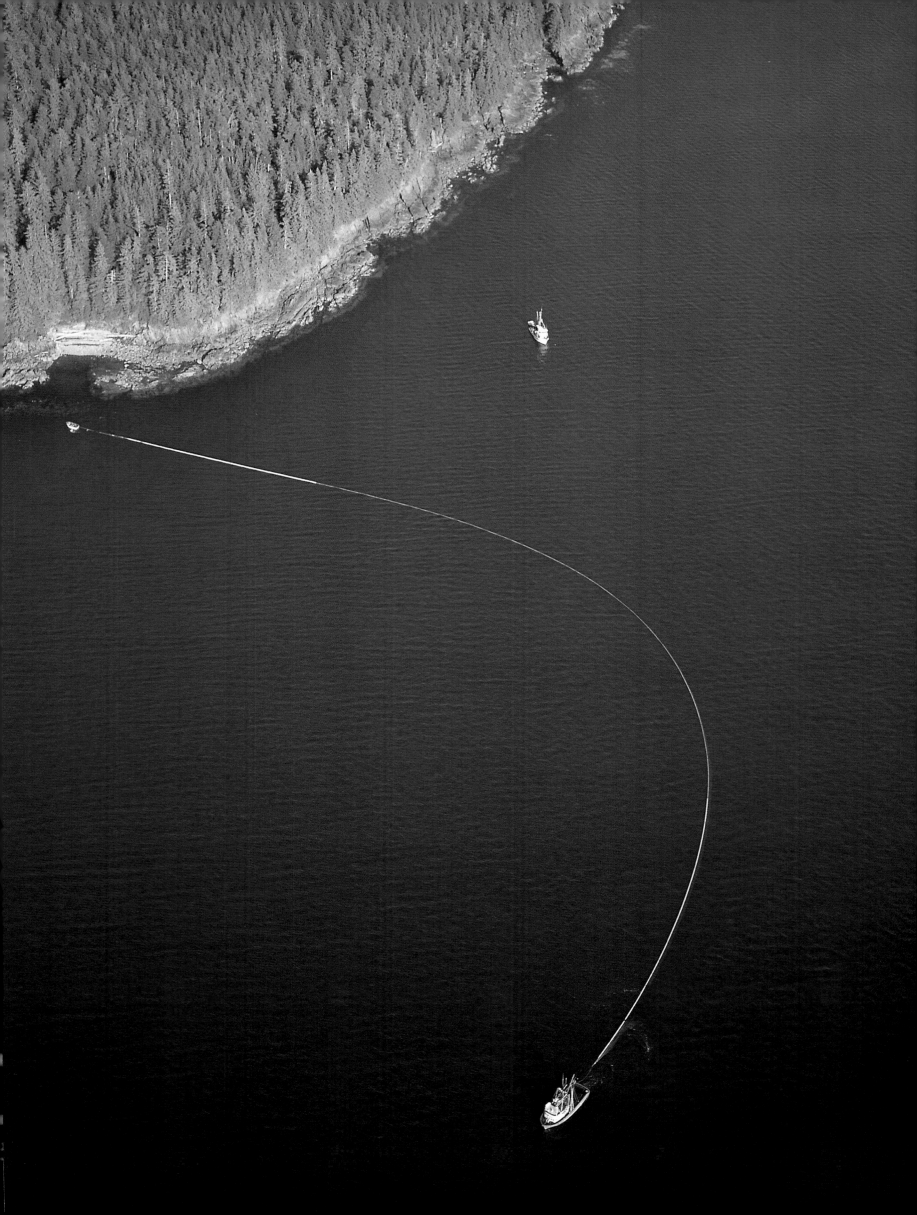

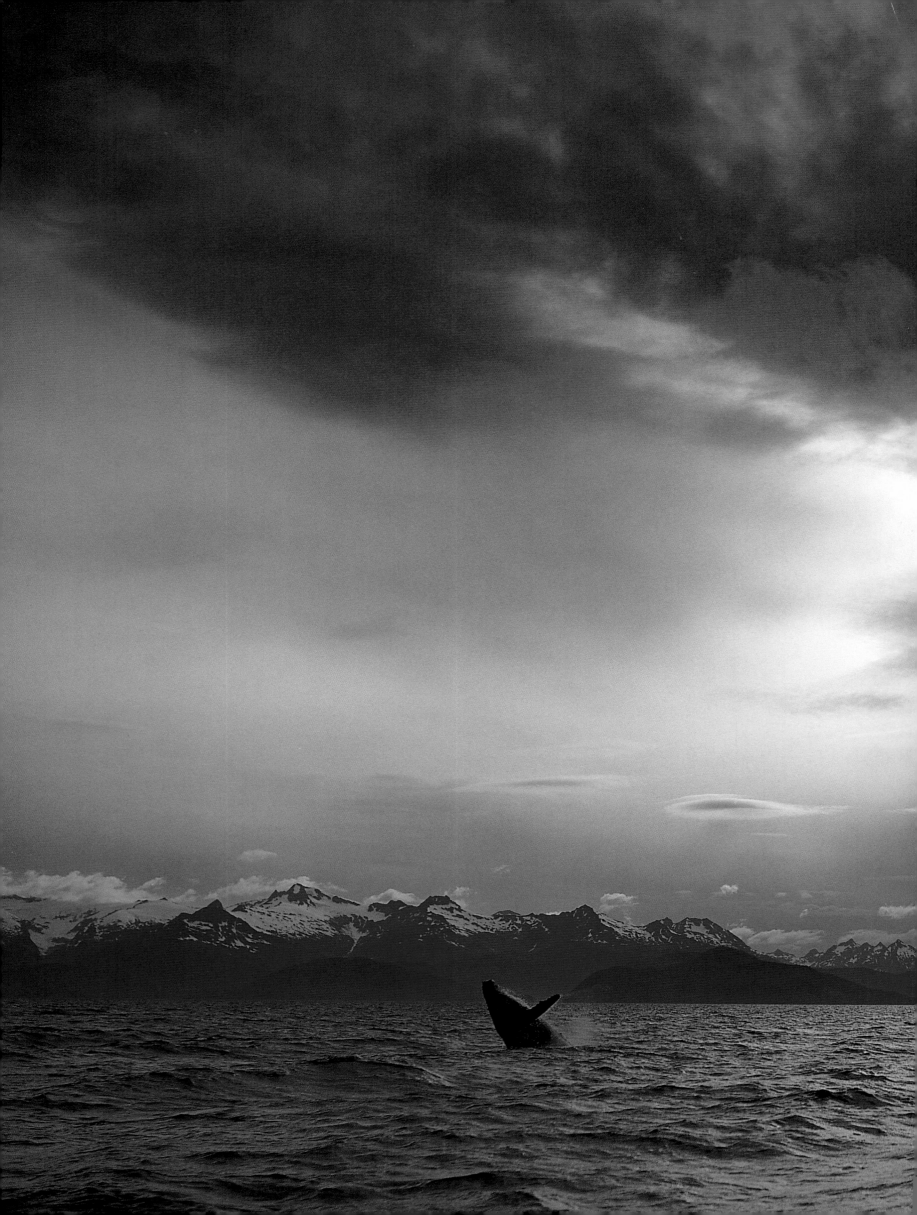

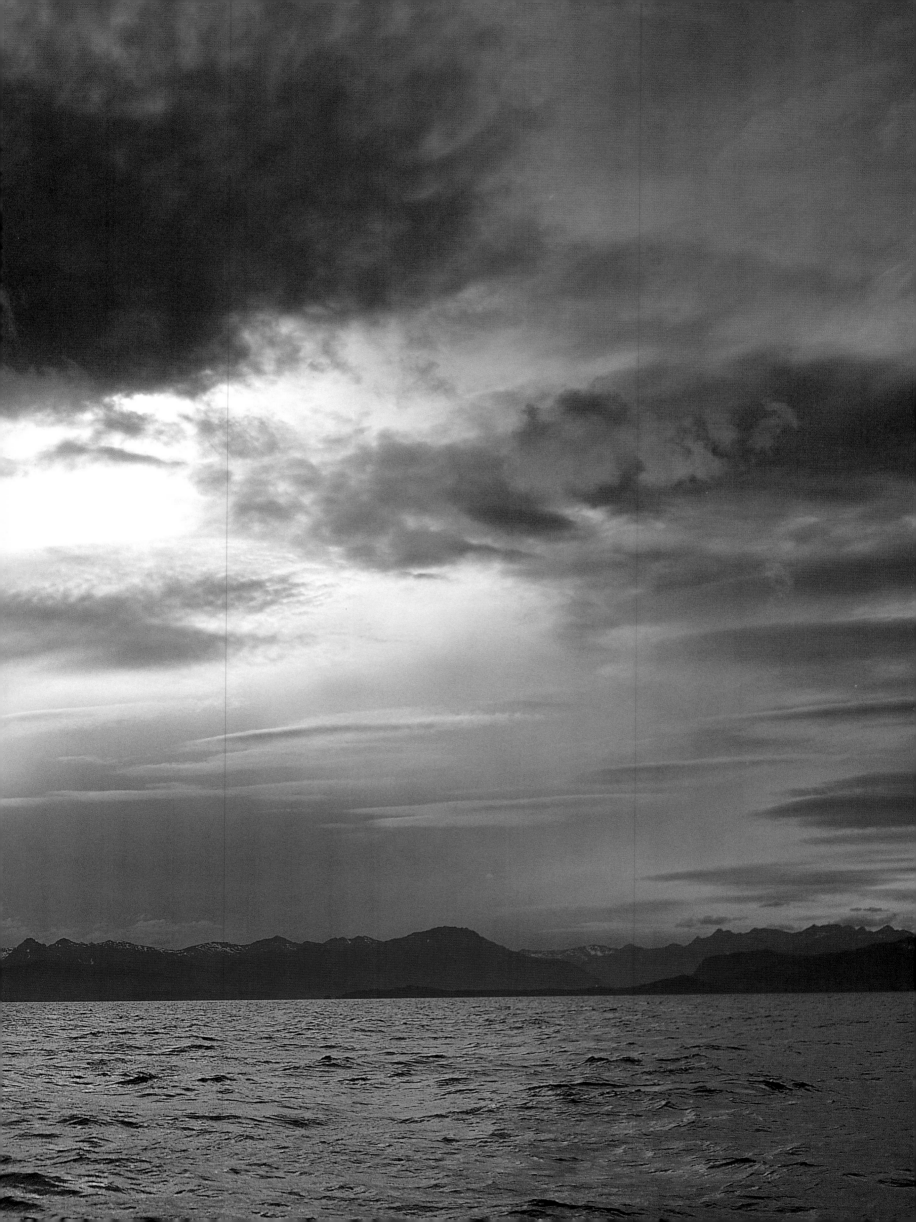

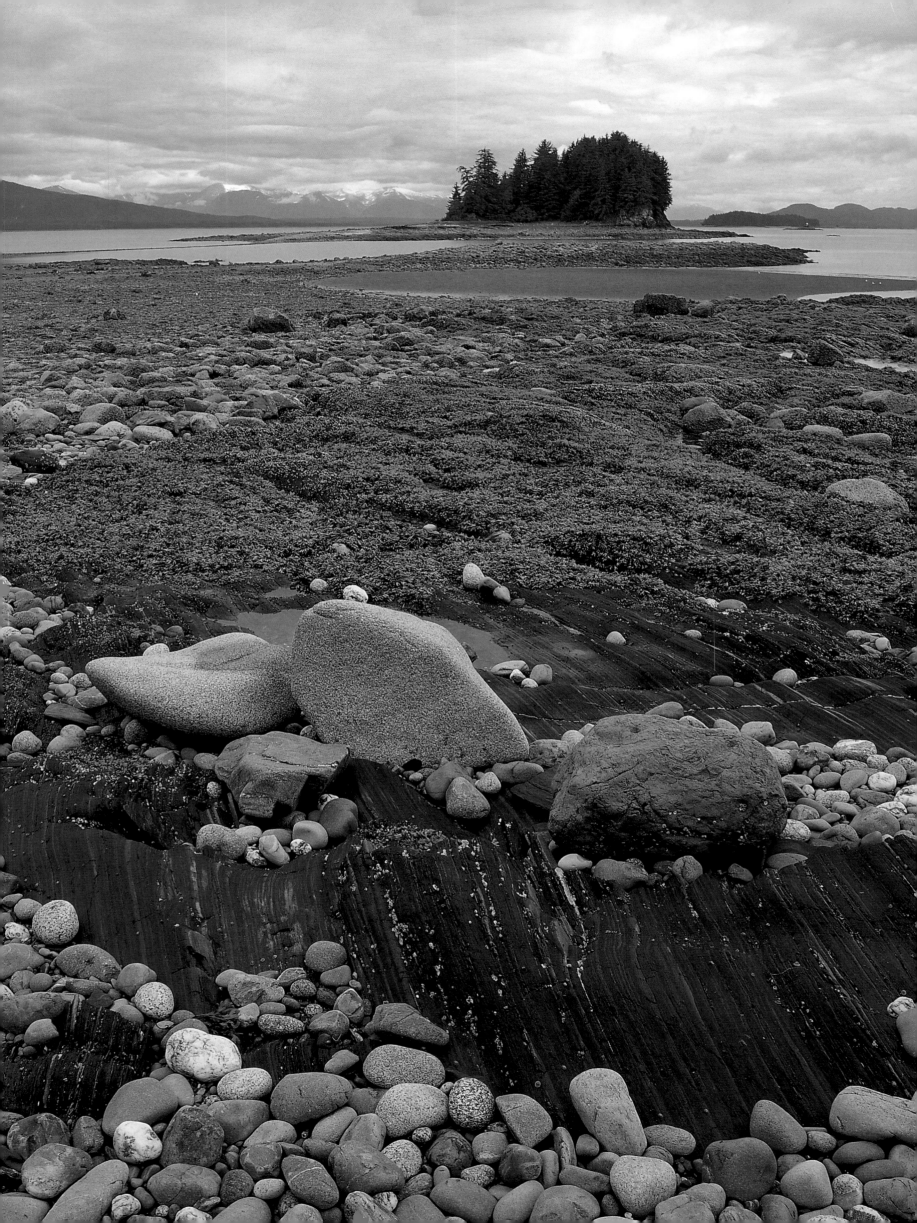

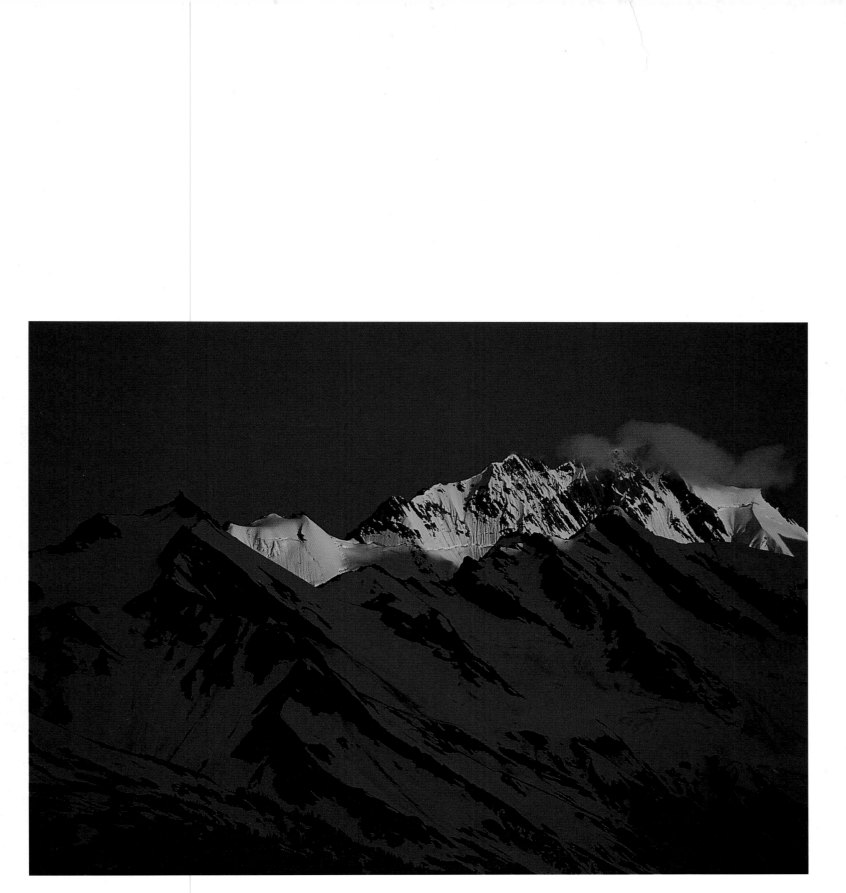

◁ Many residents along the Inside Passage have a favorite island, a cherished cove, a quiet shore, a hidden trail where they can find the magic of bird calls, the promise of tides, the eloquence of patterned ground—a peace of mind in knowing nature still exists unbridled in places, and hopefully will forever remain so. △ With a splash of alpenglow, another day ends on the high summits of the Chilkat Range, above Lynn Canal.

Acknowledgments

For their hospitality and friendship: a lifesaver shower, a night on a sofa, a spare bed, a plate of spaghetti, a cup of tea, a clever witticism (what other kind is there?), a good laugh, a long soak in a hot tub (strictly medicinal), thanks to Patty Brown in Haines; Jim and Judy Hauck in Juneau; Geoff and Marcy Larson in Juneau; Dick and Judi Rice in Juneau; Luann McVey, Richard, Lydia, and Laura Steele in Douglas; George and Lynne Jensen in Gustavus; Hank Lentfer in Gustavus; Dave, Kris, and Kelly Ann Nemeth in Gustavus; Lewis and Ellie Sharman in Gustavus; Bruce and Sharon Paige in Gustavus; Jane Eidler, Mike, Logan, Lauren, and Lincoln Wild in Sitka.

To the following Southeast Alaska artists and photographers who have inspired me with their work and warmed me with their friendship, thank you: Hall Anderson, Donna Catotti, Laurie Ferguson Craig, Jeff Gnass, Rob Goldberg, John Hyde, Charles Jimmie, Sr., David Job, Mark Kelley, Chip Porter, Ray Troll, and Evon Zerbetz.

To the dedicated staff of Glacier Bay National Park and Preserve goes my appreciation for your commitment to protect the beauty of a very special place.

And to Melanie Heacox, my best friend, thanks again for your invaluable love and support.

Thanks also to the capable pilots who got me "up there" and back safely: Ken Tyler at Haines Airways, Steve Wilson and Chuck Schroth at Air Excursions, Buddy Ferguson at Ward Air, and the many skilled pilots at Temsco Helicopters. And to Lynn Schooler, master mariner at Wilderness Swift Adventures, fair winds friend. Keep up the good fight.

Last and most important, for their stamina, vision, and selfless courage to speak on behalf of the wild places, thanks to the staff and members of SEACC—the Southeast Alaska Conservation Council.

KIM HEACOX